ISRAEL RECLAIMING
THE NARRATIVE / Barry Shaw

AuthorHouse™
1663 Liberty Drive
Bloomington, IN 47403
www.authorhouse.com
Phone: 1-800-839-8640

First published by AuthorHouse 12/19/2011

ISBN: 978-1-4685-3411-5 (sc)
ISBN: 978-1-4685-3410-8 (ebk)

Library of Congress Control Number: 2011963092

Printed in the United States of America

Any people depicted in stock imagery provided by Thinkstock are models, and such images are being used for illustrative purposes only.
Certain stock imagery © Thinkstock.

This book is printed on acid-free paper.

ISRAEL
RECLAIMING
THE
NARRATIVE

**EXPOSING THE BIG LIE AND
ITS PERPETRATORS**

A PROSECUTION

Barry Shaw

authorHOUSE®

CONTENTS

ACKNOWLEDGEMENT

This book has been formulating in my mind as I witnessed and experienced the struggle of the Jewish State of Israel to establish itself and become accepted in the region and the world. Much of the criticism, demonization, delegitimization, violence, war, and terror that have been wrought on this tiny country was totally unnecessary and unjustified.

Over the years, as I mused and wrote about our plight, I found sincere voices that echoed my sentiments and thoughts. I read the limited number of books that advocate Israel's position and some of those are listed at the end of this book. As everyone who supports Israel, I am indebted to those authors who express the tainted atmosphere that leaves Israel exposed.

This book is not a defense of Israel. I refuse to be apologetic for a country that is forced to fight for its legitimate place in this world. Rather, it is a prosecution against those who libel and create an injustice against the Jewish state. As evidence of who those perpetrators are, and the exposure of their fraud and hypocrisy, I have called upon a rich bank of people who have helped me express our case against them.

I have quoted Jonathan Rynhold, research associate at the Begin-Sadat Center for Strategic Studies, who outlined for me how Israel's supporters should respond to the false veil that hides the insidious intentions of the BDS Movement. I am grateful for their permission and honored to include notable intellects such as Booker Prize winner Howard Jacobson and noted journalist Melanie Phillips who have passionately and eloquently argued about the danger of boycotts and the ills of a world that allow or

support such an intellectual assault to degrade their democratic societies as well as harming Israel.

Although I have placed religious leaders in the dock for their misguided links to an enemy that will, and has, turned on them I have also applauded and shown gratitude to the millions of Christian Zionists whose support has been a source of comfort to Israel during dark periods in our recent history. I am particularly grateful to Pastor John Hagee for allowing me to reprise a notable speech he gave to the David Horowitz Freedom Center in late 2010.

This book is more a narrative than an academic history lesson. I did, though, feel the imperative for accuracy. I developed a rare friendship with Nissan Boury and enjoyed our exchanges of information during coffee breaks at IDC Herzlia Conferences. We were particularly amused by involving Professor Shlomo Avineri to referee one of our history disputes while grabbing a quick desert.

Phil Golan is a gifted photographer and artist. I hope his collaboration with me on this book cover will inspire him to produce his own books and give us the pleasure of sharing his amazing work. I appreciate the patience of Ezra Narkis in the frequent changes, editing, and production of the book.

Finally, let me say thanks to all my Facebook friends who participated, with your comments, to various issues raised in the book. Originally, I intended calling this book IF YOU'RE GOING TO BOYCOTT ISRAEL DO IT PROPERLY! This was the title of an article I wrote a few years ago that struck chord and went around the world. It was suggested to me that the title was too long and tended to confuse the potential reader. Instead, I turned to my friends on

Facebook who collectively suggested alternative titles. I am indebted to one person who deserves a free copy for suggesting the title I have selected. It's up to you to raise your voice and join us in prosecuting those who defame and harm my country.

Thank you all.

PREFACE

War is a dirty business, and information warfare is a dirty extension of physical warfare.

So far, in the information war that is an integral part of the Israeli-Palestinian conflict, Israel has not appeared on the battlefield.

All the attacks have been directed by the Palestinian side ably supported by associated forces, useful idiots, diplomats, and a misguided and malevolent media.

To win the information battle it is vital to assess the propaganda tools being used by one side and how the use of these weapons are being applied to weaken, and defeat, Israel.

"Israel Reclaiming the Narrative" is a prosecution of Israel's enemies. This book is suggested as a valuable resource for Israel's fight back against the lies and deceit of the Palestinian camp that has succeeded in captured the high ground in the information war that is an integral part of the Middle East conflict.

I realize that I may have put myself at risk by quoting our enemies words and beliefs. I use the word *"enemy"* advisedly because those who come to destroy Israel and

deny its heritage and values must be perceived as an enemy. How could they not?

Such is the danger for any foot soldier in the battle for truth in the war for our nation's legitimacy.

In Europe people like Theo van Gogh have been killed for doing so in his cause while others, like Elisabeth Sabaditsch-Wolff and Geert Wilders, have been placed in the dock for doing nothing more than quoting original sources as evidence of what is transpiring in their countries and in Europe. The establishment in their native countries, through their justice systems, have tried to muzzle free speech. The truth, it seems, must not be allowed to speak its name in many Western societies. So it has been for those brave souls who try to present Israel's case. There are, thank goodness, many on various sides of the political spectrum who do speak out for freedom and justice. Some are quoted in this book.

Perjury has been performed against a beleaguered Israel whose voice has been stifled by those with dangerous agendas. The time has come to expose the deceit behind their rhetoric.

In this book I quote Palestinians Arabs in their own words, as well as other witnesses to the critical events that have led to the impasse between Israel and the Palestinian Arabs.

I also give my personal perspective of how matters have deteriorated to the state they are today.

Details in this book expose the true intent of the Palestinians and their supporters that runs contra to the

narrative they have imposed on the world by their aggressive diplomacy. It will show how and why the world has bought their deception. It is only by reading these facts that you really appreciate the size of the injustice that has been heaped upon Israel.

This prosecution against the fraudsters, liars, hypocrites, and their helpers, who have led a deceitful campaign against Israel, is an attempt to assist Israel regain its rightful place on the high ground of public opinion.

The Palestine issue has been a concoction of myths solidified into recognition by those supporting the notion that Israel can be removed by a gradual process of replacement ably backed by a naïve world in love with a utopian dream of peace and brotherhood.

Any nation supporting the establishment of a Palestinian state at this time must be made to realise that they are being duped into aiding and abetting the plan for the demise of Israel.

Israel should not be pressurized or forced to make serious concessions until the true nature of the Palestinian political character is known and until it can be proven, to Israeli's satisfaction, that their nation-building is pragmatic and reasonable.

This book will clearly show that the jury is still out on this vital question.

It points to clear evidence of rejectionism against the Jewish state that is racist and scarred with violent intent.

This book will explain why any recognition of Palestinian rights to statehood opens the door to the final solution of the Jewish state.

Vacuous proclamations by members of the international community that they will prevent this from happening must be dismissed as yet another empty promise by a diplomatic community that will be as impotent then as they have been in keeping their word in preventing Iran from going nuclear.

This, then, is the premise of this book. To those who say that Israel must continue to take risks for peace I say no more, not when the status quo is so precarious.

My response to the do-gooders, to the boycotters, to the well-wishing international community is that they must first put pressure on the Palestinian Arab leadership and their people to renounce their continuing ambitions to eradicate Israel, openly teach and preach recognition and respect for the Jewish State of Israel, and to agree to live in peace and security.

Only then by their words and deeds, and not before then, will Israelis be able to consider releasing land and approving the establishment of yet another Arab state in the region.

Criticize Israel with reason and fairness. That is legitimate. What is not legitimate is the wholesale and one sided condemnation of Israel that they fail to apply to the other side.

Why is that? Is it because they know that Israel has the intellectual capacity to listen and weigh their argument and the other side doesn't? I don't think so.

Or is it because they can find nothing to condemn them for, that only Israel's faults are apparent to them?

When they apply their intellectual violence and arrogance exclusively against Israel that is the time when conversation stops.

This book. however, attempts to redress some of the bias by exposing the false arguments of the hate campaigners and the iniquities of the Palestinian argument.

The latent Palestinian ambition is the critical crux of this book. It is a significant issue that dare not speak its name for to do so will annihilate the policies and arguments of those who would weaken Israel with their appeasement to the Palestinians and their incessant pressure on Israel.

This book attempts to speak the truth about what is happening in the Israel-Palestinian conflict. this is likely to make our protagonists as livid as they are in Europe.

As a private individual I am not tethered to any political party. I am not anchored to any political dogma. I share all the traits of a left wing liberal. I am heartland Israel.

My sense of social justice is as strong as anyone else. The only difference is that my social justice starts with my own people. As a concerned citizen, these are the principles that have driven me from being a left wing socialist to what appears to be a right wing hard liner. In fact, I am the centre of the Israeli political spectrum.

I am a free spirit. How far right I go depends on your support, or lack of it.

If you are with me I move to the centre. If you are against me I shift to the right.

This is the natural rhythm of things.

I can still be persuaded to drift in either direction but the winds are not favorable to blowing me left any day soon.

The swirling dangers that batter Israel will not end there. They will, inevitably, affect your world for the forces at work have global ambition that will turn its attention to the way you live.

Am I hostile to revolutionary Marxism? You bet I am. Am I hostile to radical Islam? You got it! Are you? Or don't you care? If you don't care, close this book and read something else, something shallow and meaningless..

If you are neutral you have no reason to be reading this book. Put it down and buy another one.

Barry Shaw

IF YOU'RE GOING TO BOYCOTT ISRAEL – DO IT PROPERLY !

OK. I understand that you have an issue with Israel and you are in love with the Palestinians.

That's OK, but I understand that, because of this, you want to boycott Israel?

As an Israeli I'll be sorry to miss you but, if you are going to do it, do it properly.

It's easy to tell people to picket stores selling Israeli products, but don't you think you ought to set a personal example?

Don't you think it's wrong for you to be telling others to stop using Israeli products when you yourself are using them? That would be hypocritical, don't you think?

So look around you. Let's see what you have. Together, we can make sure you are holding true to your cause.

I had thought of sending you this letter by email but that would have compromised your principles and we wouldn't want to do that, would we?

Most Windows operating systems were developed by Microsoft-Israel. The Pentium NMX chip technology was designed by Intel in Israel. Both the Pentium microprocessor and the Centrium processor were entirely designed, developed, and produced in Israel.

Voice mail technology was developed in Israel. The technology for AOL's Instant Messenger ICQ was developed in 1996 by four Israeli whiz kids. That, I guess, cuts out all your voice and text messaging to me and your friends and supporters.

Both Microsoft and Cisco built their only R&D facilities outside the United-States in Israel.

So, sorry! You have to throw away your computer.

Your bad news does not end there. Get rid of your cellular phone! Cell phone technology was also developed in Israel by Motorola. Motorola has its biggest development centre in Israel. Most of the latest technology in your mobile phone was developed by Israeli scientists and technicians.

If you are thinking of selling your computer and IPhone on eBay, forget it! Their shopping technology is Israeli. Deal Time.com was founded in Israel in 1998 by Dr.Nahum Sharfman and Amir Ashkenazi. It became Shopping.com and was acquired by eBay in 2005. Since then it operates the Pay Pal payment system.

So now you are computerless, and unable to communicate by mobile phone. Pity!

You will miss the new Altair chipset that is at the heart of the 4g cellular revolution. It will enable people to do things you can do at home on your IPhone such as play interactive games, download mp3 and video files. You'll miss it, but that shouldn't bother you because Altair is an Israeli company.

By the way, I know you stored your data in your diskonkey. I have to take it off you. Yes, you've guessed it. Diskonkey is an Israeli invention.

Feeling unsettled, nervous of your future? You should be. Part of your personal security rests with Israeli inventiveness. This is borne out of our urgent need to protect and defend our lives against the terrorists that you support. A phone can remotely activate a terrorist's bomb, or it can be used for tactical communications by terrorists, bank robbers, or hostage takers. It is vital that official security and law enforcement authorities have access to cellular jamming and detection solutions. This is where Israel's network communications technologies, with its security expertise, helps in the fight against global terror.

Not feeling secure? Sorry to hear that your health is breaking down. However, before you reach out for your pills, watch out! All the generic brands for your heartburn derive from Israeli laboratories. In fact, check the labels in your medicine cabinet. Make sure you don't have any tablets, drops, lotions marked Teva, or Abic. They are the Israeli pharmaceutical companies that are world leaders in prescription drugs.

It may mean you will suffer from colds and flu this winter but, hey, that's a small price to pay in your personal crusade against Israel, wouldn't you say?

While we are on the subject of your Israeli boycott, and the medical contributions given to the world Israeli doctors and scientists, how about telling your friends to avoid the following:

An Israeli company has developed a simple blood test that distinguishes between mild and more severe cases of multiple sclerosis. So, if you know of anyone suffering from MS, tell them to ignore the Israeli patent that may, more accurately, diagnose their symptoms. Somehow I think they are going to ignore you.

An Israeli-made devise helps restore the use of paralyzed hands. This device electrically stimulates the hand muscles providing hope to millions of stroke sufferers and victims of spinal injuries some caused by terror attacks by the people you support. If you wish to remove this hope of a better quality of life from these people, go ahead and boycott Israel.

Young children with breathing problems will soon be sleeping more soundly thanks to a new Israeli device called the Child Hood. This innovation replaces the inhalation mask with an improved drug delivery system that provides relief for child and parents. Please tell anxious mothers that they shouldn't use this device due to your passionate cause.

Boycotts often affect research. A new research centre in Israel hopes to throw light on brain disorders such as depression and Alzheimer's disease. The Joseph Sangol Neuroscience Centre in the Sheba Medical Centre at Tel Hashomer Hospital aims to bring thousands of scientists and doctors to focus on brain research. But you would prefer depression and Alzheimer's disease to go unchallenged until they can be cured by non-Israeli scientists and researchers.

A new molecular-level imaging technology from Israel can detect diseases in cells and target cancer cells directly without harming healthy cells. This device can detect the process of cell death, known as apoptosis, at the earliest phase of a disease. In numerous clinical trials with patients being treated for brain tumors at the Rabin Medical Centre in Petach Tikva, Aposense diagnostic technology predicted the shrinkage of tumors with ninety percent accuracy. Founded in 1997 by Israeli neurologist, Ilan Ziv, and being developed by Teva Pharmaceuticals, Aposense is taking a two-pronged approach – both diagnostic and therapeutic - for the good of cancer sufferers.

Talking of human cells, two Israelis received the 2004 Nobel Prize in Chemistry. Doctors Ciechanover and Hershko's research and discovery of one of the human cell's most important cyclical processes will lead the way to DNA repair, control of newly produced proteins, and immune defense systems.

Israel's Hadassah Medical Centre has successfully eliminated the physical manifestations of Parkinson's disease in a select group of patients with a deep brain stimulation technique.

For women who undergo hysterectomies each year for the treatment of uterine fibroids the development in Israel of the ExAblate 2000 system is a welcome breakthrough, offering a non-invasive alternative to surgery.

Making the desert bloom and providing better crops to deprived parts of the globe, reducing pollution, developing solar power.

These are just some of the leading Israeli research projects that will benefit the world. You can help stop with your Israeli boycott. Think of the massive contribution that Israel is giving to the world, including to the Palestinians and to you, in science, medicine, communications, security, environment. Pro rata of population, we are making a greater contribution than any other nation on earth. We can't be all bad....

What is bad, what is deceitful, is the so-called BDS Movement which purports to support a boycott on Israel as it applies to commercial and industrial activities in *"the occupied territories."* Let's be perfectly clear on this point. Occupied territory to them means the State of Israel.

The initials BDS, to them, means boycotts, divestment, and sanctions. To Israelis, these initials stand for blackmail, demonization, and slander.

To a large extend their campaigns are counter-productive. Their public actions, as when they campaign outside stores selling Israeli products, encourage anti-boycotters to support the stores even more. The boycotters, by highlighting the stores they intend to attack often promote extra business to those businesses as has happened to Marks & Spencers and the Ahava stores in London, the Dead Sea products stands in American shopping malls, and at the family-owned Le Marcheur shoe store in Montreal. There is a joke going around that, in many cases, people appreciate the BDS campaigns against stores selling Israeli products because, without their publicity, they wouldn't have known where to buy them.

The sinister truth is that the leading activists behind the BDS Movement do not advocate this policy to force Israel into a two-state solution through peaceful civil protest. Instead, their deep intention is for a one-state solution. This is frequently advocated by the likes of Omar Barghouti and more so by Ali Abunimah who pushes this agenda at any opportunity. He addressed a One State Solution Conference in Boston 2009 where he laid out his case eloquently in front of an adoring audience by using the usual emotional and deceptive expressions.

Omar Barghouti, a founder of the BDS Movement, argues that Palestinian Arabs have inalienable rights, something that is barred to Jews, even though the Jewish nation has received national legitimacy and recognition. His proposition introduces the principle of inequality for the Jews. It attempts to make the Palestinians more equal than the Jews. Historically, legally, this is wrong. Barghouti claims that the Palestinians and the Arabs have nothing to do with the Nazi persecution of the Jews. As such, he tries to smudge history hoping you won't notice the crimes against the Jews perpetrated by the Arabs and certain key Palestinian Arab leaders. He omits the Nazi support of the Arab revolt in Palestine in 1936, the Arab role in the introduction of the British White Paper of 1939 which effectively blocked a vital escape route for European Jewry during the Holocaust. He fails to mention the infamous Haj Amin al-Husseini, the Grand Mufti of Jerusalem, who lodged himself in luxury in Berlin during the Second World War, met Hitler, toured Auschwitz, collaborated with the

Nazis, formed a Muslim fascist militia, broadcast Nazi propaganda in Arabic, and called for a holy war against the Allies and the Jews.

Barghouti tries to claim that the Palestinian movement, for which he represents the radical BDS Movement, does not harbor anti-Semitic sentiment. He should begin by quoting al-Husseini's speech on Balfour Day on 2 November 1943 when he said, *"Germany recognized the Jews exactly and decided to find a final solution to the danger that came from the Jews which will end their mischief in this world."*

If Barghouti would be honest with himself and the world, something that is unlikely to happen any day soon, he would admit that he shares the Mufti's thought that the wonderful Jewish State of Israel is, for him, mischief in this world. On a more threatening note, Barghouti is, like the Palestinian inspiration whose identity he hides, seeking a final solution to the Jewish problem in the Middle East and working toward that goal.

The BDS venom is exclusively aimed at Israel. If the principles that it applies solely against Israel were honest why are they not aimed at Turkey, for example? Here is a country that is guilty of genocide against the Armenians and is carrying out a war of oppression and genocide against the Kurds. If occupation is a cause for a boycott then why isn't the BDS Movement boycotting Turkey for their occupation, not only of Kurdish territory, but also in northern Cyprus? If building an illegal wall is reason for a boycott why isn't the BDS

Movement boycotting Turkey for the illegal divide between their occupied part of Cyprus and the rest of the island? If ethnic cleansing is a reason for a boycott why isn't the BDS Movement boycotting Turkey for the ethnic cleansing of the Greek Cypriots that they murdered or drove out of their homes in the occupied north of Cyprus? If it is legitimate to boycott Israel for being racist by calling themselves a Jewish state why isn't the BDS boycotting the forty member states of the United Nations that consider themselves *"Muslim"* or *"Islamic"* ? Why is it the one and only Jewish state that is the victim of denigration? It is worth mentioning the Methodist, Protestant, and Anglican churches. Why are they not divesting from Turkey, Egypt, and the Palestinian Authority for that matter who are killing and tormenting their fellow Christians and desecrating their churches?

The Methodist Church in Britain, with seventy million members worldwide, has accepted the inaccuracies of the BDS claims. Its leaders, hooked on the replacement theology that insults Jewish history and Israel's policies, have engaged with forces that have them in their sights for future targeting. Who was it that once said *"there are none so blind as those who cannot see."* ? He clearly had misguided church leaders in mind. See my chapter on Replacement Theology.

Bigotry against the Jewish state is so entrenched in contemporary British society that juries have begun to acquit criminals merely if they can show that they acted

23

against Israeli interests, No other defense is necessary. So said Robin Shepherd, the director of European affairs at the Henry Jackson Society in London, and author of *"A State Beyond the Pale."* He was referring to a case in which a group of anti-Israel activists admitted vandalizing a Brighton company that supplied Israel with military spare parts. Despite their admitted guilt their judge directed the jury to find them not guilty.

Judge George Bathurst-Norman was later formally reprimanded by the office for Judicial Complaints when a small number of individuals led a campaign to appeal his dubious summation.

Britain's largest higher education union was prevented, by British anti-discrimination laws, from passing a resolution to boycott Israeli academics. This is not, however, stop them from supporting the BDS campaign against Israel and sever ties with the Histadrut, Israel's national labor union. They have maintained ties with every other union in the world, including those in repressive regimes that support their leaders.

War in Want, on their website, depicted Israel as having a policy of *"ethnic cleansing,"* committing *"slow genocide"* by building an *"apartheid wall,"* imposing *"collective punishment"*, and being guilty of violations of international law. This charity is indifferent to the truth that their demonizing of Israel are totally at odds with the facts on the ground.

The battle rages. For every pop idol that embraces the bias against Israel there are others that refuse to be cowed. Elton John ignored the boycott pressures and played to a

sell-out crowd in Tel Aviv. Referring to artists such as Elvis Costello, who cancelled his Israeli gig, Elton John said, *"Musicians spread love and peace, and bring people together. We don't cherry-pick our conscience."*

Ronnie Fraser, the founder of Academic Friends of Israel, exposed the fact that Britain has embraced academic, cultural, trade union, media, medical, religious, and architectural boycotts of Israel more than any other country. It is clear that the Palestinian activists have forged effective ties with the far left, on the university campuses, and in the trades unions. They have also recruited certain key media outlets. Their ideas are eagerly adopted by organs such as The Guardian newspaper which has become the mouthpiece for left wing causes and the mailbox for open letters calling for actions against Israel.

All is not lost, however, with British left wing activists. John Pike and David Hirsh founded the Engage Movement. They have an effective website, and they hold events in their fight back against the boycotters. They have become an intellectual clarion call for debate and activism in opposition to the BDS Movement.

The BDS has to be seen in the right perspective. They make a lot of noise and attract media coverage, especially from the channels that support their cause. Their cost effectiveness is, however, dubious. Their public displays, outside certain stores or inside some supermarkets are more an irritant and street theatre rather than a cause of real financial damage to Israel. What they do, as seen in all their

actions is intimidation and violence. As such they frighten off open minded and reasonable people.

Where ever you find the BDS boycotters you rarely find anyone seeking a peaceful pragmatic solution to the Israeli-Palestinian confrontation. Rather, they have already taken one side of the conflict and are using boycott and divestment campaigns as a battering ram to further a deeper political agenda, namely the delegitimization and eventual removal of the Zionist state.

In the current situation the victims are silenced and portrayed as the aggressors while the aggressors portray themselves as victims This violence of bias finds expression on the campus. Anyone with opposing views, anyone wishing to propound Israel's side of the debate, is subject to intimidation, insult, and violence. There have been cases where professors have intimidated and publicly embarrassed Jewish and pro-Israeli students in front of their class mates for disputing slanted teachings that leaves Israel automatically the tyrant. These professors and the academic boycotters must be taught that freedom of speech does not include the freedom to silence other opinions. Academic freedom should represent all points of view including Israeli and Zionist views. Academic freedom must allow a truly free and open discourse without intimidation and insult.

On the campus the victims are silenced and portrayed as the aggressors while the aggressors portray themselves as victims. This is true with everything related to the Palestinian narrative and the activists associated with that

message. It, they turn, truth on its head, which is the subject of my next chapter. Their dishonesty is wrapped in violence and intimidation. This is applied against students. It is also applied against Israel.

Just as the Nazi brown shirts and storm troopers prevented people from shopping at Jewish stores, using Jewish doctors, employing Jewish teachers in Germany prior to the outbreak of and during the Second World War, so too do we see today the tactics of the BDS storm troopers as they position themselves in front of shops selling Israeli products, encourage universities and conferences to cease contacts with Jewish Israeli medical researchers and educators.

This is not the end game to a peaceful outcome. It is, instead, a precursor to the next, more radical stage, of the systematic program of elimination of the Jewish state. The same driving political agenda that encourages activists to campaign outside stores and offices doing business with Israel also campaign on behalf of Hamas in Gaza.

The ultimate goal of the BDS founders coincide completely with the deadly ambitions of Hamas which I have outlined in a later chapter that deals with the hypocrisy of the so-called *"human rights"* activists on behalf of the Palestinians.

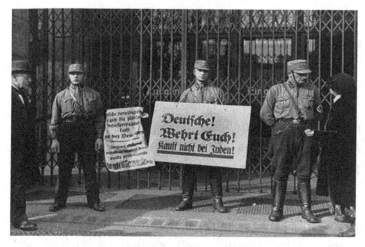

Boycotters – 1936 style

Hold that thought, will you. Let it sink in. I'll get back to you later in the book. For now, I want to make one final point. That point relates to academic boycotts.

An academic boycott is the nadir of intellectual property. It is the pivotal moment when reason becomes dogma. It is the time when enlightenment becomes creed. It is the closing of the mind as described by Howard Jacobson in my chapter *"Inspiring Speeches."* When the brain refuses to tolerate opposing thought it is no longer academia.

The notable English novelist and screenwriter, Ian McEwan had little problem resisting the pressures of the boycotters when he came to Israel in February 2011 to receive the Jerusalem Prize for Literature. The author declared himself *"for dialogue, engagement, and ways in which literature, with its impulse to enter other minds, can reach across political divides."* He said that if the

28

boycotters, who had signed a letter that had been reproduced in The Guardian newspaper appealing to him not to go to Jerusalem, were against this project *"then clearly we have nothing more to say to each other."*

Academic boycotts must be fought, and fought vigorously. To its credit the British Government, in its BIRAX program, seeks to create a bridge between British and Israeli scientists for the common good. A top level delegation of British scientists visited Israel in January 2011 for the inaugural meeting of the UK-Israel Sciences Council held at the Israel Academy for Sciences and Humanities in Jerusalem. The British Ambassador to Israel, Matthew Gould, said, *"The UK and Israel are both global superpowers when it comes to science and research so it makes sense that our scientific communities should work closely together. It also sends a powerful and positive signal about how our two countries see each other and about the sort of relationship we want between us. The British government is opposed to boycotts of Israel and this council is an expression of that."*

The British Government, though it still funds NGOs that conduct boycotts of Israel, should be applauded for appreciating the universal benefits derived from mutual academic cooperation. Their positive steps should be enlarged to include joint academic research in sensitive fields such as political science and international law. British universities have become a hotbed of radicalism. Part of this is down to professors who have a particular political bent,

and heads of faculties who prefer the quiet life rather than regulate biased teaching.

AXIUS (Academic Exchange Israel-United States) is an NGO founded by Professor Chuck Freilich and is extending and adapting its mission to include British academia.

Their program, of which I am an Israel board member, is to bring heads of faculties and professors in specific fields on one of their study tours and seminars to Israel. They can ask critical questions to leading political, security, academic, media, and community figures. They are also introduced to Palestinian leaders. The AXIUS program is intended to encourage open debate and have these influential educators return to their lecture halls and present their subjects to their students in a more balanced fashion. Projects such as these are to be welcomed and encouraged.

In his classic work *"On Liberty"* the British philosopher, John Stuart Mill, observed *"all silencing of discussion is an assumption of infallibility."* When academia becomes infallible it becomes totalitarian. At that moment it no longer needs to learn anything more. It knows everything. It is the closing of the mind. It is no longer academia. This gloomy prediction reminds me of the result of an indolent world that accepts, at face value, the lies and myths of a Palestinian narrative as it chooses not to listen to an Israeli narrative, and leaves Israel and Jewish heritage lying bleeding and wounded in its brutal thoughtless wake.

It is a narrative that says "the best way to forge the future is to reinvent the past." It is a false narrative.

TURNING TRUTH ON ITS HEAD

Yes, there was a war. Yes, there were civilian deaths. Yes, there was destruction. To turn these truths into the club with which you beat Israel is to deliberately and knowingly turn the truth on its head. And you do it to achieve a political objective.

Hating war is a wonderful philosophy but, if you truly believe in it, you must criticize or condemn both parties to a conflict, not just one. To say that only one side is wrong is to approve of the violence of the other side. In which case you do not detest war. You only protest against a particular war that you don't approve of, or one side of a war that leaves your side damaged.

In other words, your disapproval of war or violence is defined by your personal opinion on who is doing the violence. This means you are reflecting your own political bias on to a war. It is not a puritan philosophy or rejection of war as a whole.

As for me, I hate war but there are circumstances when it is necessary, even inevitable.

The fight against Hitler and Nazi Germany is one classic example of the need for war. America's response to Japan following Pearl Harbor is another.

It was inevitable that Saddam Hussein would only be removed by force. Any aggressor who not only threatens

death and destruction but carries it out calls on us to take up arms and defeat him. This may be the inevitable fate of Ahmadinajad and his regime in Iran. War is also inevitable and necessary when your country is attacked not once but ten thousand times as Hamas and Hizbollah did with rockets and mortars against Israel. When the international community pumps billions of dollars into such regimes, directly or indirectly, war is an inevitable result.

In other conflicts the death of civilians is called *"collateral damage"*. In wars that involve Israel it is called *"war crimes"*.

To turn Israel's legitimate response to the incessant rocket and mortar bombardment coming out of Gaza and interpret this into a deliberate and premeditated attack on civilians turns truth on its head. Showing the bodies of dead and injured children is a sad sight, but to claim that they were individually targeted for death by Israeli soldiers is turning truth on its head. It is, in short, a deliberate lie.

There are masses of evidence to the contrary. Yet, despite this, the world chose to believe the Palestinian version including false casualty figures. This was used as another club to beat Israel. The United Nations employed the notorious Goldstone Commission to turn false evidence into official doctrine. The subsequent Goldstone Report became a celebration of lies and exaggerations used to condemn Israel. Civilian casualty figures, especially inflated numbers of dead children were used as emotional propaganda to accuse Israel of war crimes. Israel's contrary

claims were dismissed, drowned out by the raucous pillorying of the Jewish State.

The false figures were produced by NGOs as *"proof"* that Israel had acted illegitimately. Israel's military operation to stop rocket attacks on its civilian population served as the basis for *"war crimes"* charges. The dominant pillar of their allegations was the Goldstone Report replete with expressions such as *"disproportionate force,"* *"indiscriminate bombing,"* and *"deliberate targeting of civilians."*

Notable NGOs inflated Palestinian casualty figures. B'Tselem alleged that 75% of those killed were civilians. Palestinian Centre for Human Rights changed their original figure of 70% to 85% to be ahead of the trend. In the one-upmanship game, Defense for Children International – Palestine Section claimed that 352 children had been killed in the Israeli bombing. These figures were accepted as facts and echoed officially by major international NGOs such as Amnesty International and Human Rights Watch who used them in their reports to condemn Israel. Some NGOs, particularly B'Tselem, used an incident to boost civilian casualties and accused Israel of war crimes when it targeted what Hamas called *"a police force."* B'Tselem claimed they were civilians, and not combatants, because they were on a *"training course on first aid and human rights"* at the time of the IDF attack. After Israel produced the names and identities of many of those killed as proof that they were also members of various Palestinian terror organizations, B'Tselem belatedly revised their report in September 2009

admitting *"that many police officers in the Gaza Strip were also members of the military wings of Palestinian armed groups."*

By this time the damage had been done as their original report had been adopted as fact by the Goldstone Commission. The PCHR had named Nizar Rayan and Said Siam as civilians when they had been leading operatives in the Hamas terror organization. The media, the United Nations, and other NGOs blithely accepted the PCHR statement.

Israel always maintained that the vast majority of those killed had been militants and their assistants. This was suddenly confirmed by a surprising source in November 2010 when Fathi Hamad, the Hamas Interior Minister told the Al-Hayat newspaper that Hamas acknowledged that seven hundred Hamas members had been killed in Operation Cast Lead in the Gaza Strip. This figure is more than double the number of combatants published in the Goldstone Report and repeatedly quoted to this day by leading NGOs.

Following the Hamas revelation, Robert Bernstein, the founder of Human Rights Watch, said at a lecture at the University of Nebraska that the Hamas revised numbers impacted on the credibility of NGO reports. *"It will be interesting to see if the Goldstone Report and Human Rights Watch reports are re-evaluated by them."*

The jury is still out on this issue. One thing is for sure. Israel still bears the scars and the stigma inflicted on it by prejudicial condemnation.

Israel dropped two million leaflets and made over a hundred thousand phone calls in advance of Israel attack to warn civilians to clear the area. This was unknown in military warfare. Many military experts say that this is poor military tactics as it warns the enemy in advance of an impending attack. This is true but, for Israel, reducing civilian losses is always a prime consideration. Pilots have had terrorists in their sites and chose to abort their mission due to the proximity of civilians.

Colonel Richard Kemp, a former commander of British forces in Afghanistan, told the UN Human Rights Council in Geneva on October 16, 2009: *"During Operation Cast Lead, based on my knowledge and experience I can say this, the Israeli Defense Forces did more to safeguard the rights of civilians in a combat zone than any other army in the history of warfare."* It is safe to assume that Kemp is not holding a candle for any side and that his independent professional assessment on warfare is valid.

In discussing military operations involving Israeli forces there always seems to be a conflict between biased media coverage (which is usually based on Palestinian explanations) and facts on the ground. As a further example, *"On October 8 during a clash in Hebron, an IDF force killed two of the Hamas terrorist operatives who carried out the shooting attack at the Bani Naim junction (southeast of Hebron) on August 31 in which four Israeli civilians were killed. The two, Nashat al-Karmi and Ma'mmun al-Natshe, opened fire at the IDF soldiers, who*

35

returned fired. One of the terrorist operatives was wounded and the other hid in a building. He refused to surrender and continued shooting, and was ultimately killed. Four Kalashnikov assault rifles were found in the two terrorists' possession."

That was the IDF Spokesman's report dated October 8, 2010 of one counter-terror event in Israel. It is typical of hundreds such incidents. But here is how this was commented on by leading Palestinians.

Nimr Hamad, Mahmoud Abbas' political advisor, claimed that the action had been carried out *"in cold blood"* and took place *"because of the growing racism and hatred in Israel."*

<div align="right">Wafa News Agency, October 8, 2010</div>

PA Prime Minister Salam Fayyad said of the incident, *"The way to peace is not for Israel to kill Palestinians or to build in the settlements, or for the settlers' terrorism."*

In other words the settlers are the terrorists, not the Palestinian gunmen who killed innocent Israelis.

Fayyad failed to denounce Palestinian terrorism by deflecting the issue on to "settlements." Such is the twist of language among the Palestinian leadership.

Calling Israel a racist state is also turning the truth on its head. Israel is the one Middle Eastern nation where freedom of religion is a given. Try being a practicing Jew in Saudi Arabia, or a Christian in Iraq.

Arabs in Israel are better educated than in most Arab countries. They reach the highest echelons of the country's political, academic, and medical life.

Israel airlifted eight thousand Ethiopians to safety in Israel one night in 1985. They repeated this exercise in humanity when they plucked fourteen thousand Ethiopians from danger in a brilliant one day airlift in 1991.

Some racist state!

On the other hand precious little is being done to stop the racial incitement by Palestinians, including at officially sanctioned events, in media coverage, and in children's education against Jews.

The statement that building a few Jewish homes is the main obstacle to peace not only smells of anti-Semitism, it crumbles into disrepute when faced with the fact that not one new official settlement has been inaugurated since 1999 and that all new construction has been within the confines of existing towns and villages. Regarding the false claims that Israel is an expansionist regime, this is clearly wrong after Israel physically removed eight thousand people from their homes in the Gaza Strip in 2005.

The withdrawal of its population was immediately following by an increase in terror violence when thousands of Hamas rockets and mortars began to rain down on Israeli towns. These rockets and mortars were launched from the very locations that had been vacated by the Israeli population.

The unilateral withdrawal from Gaza proved that buildings are not a barrier to peace from an Israeli standpoint. Settlements were not the prime issue then. They are not the stumbling block today. Using them as an excuse is, again, turning the truth on its head.

Selective media coverage does not promote the truth. It tells a lie. If an Israeli chops down a tree this instantly becomes news:

10 November, 2010. Time. *"The war of the olive harvest. Palestinians –v- Settlers."*

10 November, 2010. The Telegraph. *"Olive tree wars. Israeli settlers do battle with Palestinians over olive groves."*

24 October, 2010. The Guardian. *"Most troubled harvest yet has seen attacks by Jewish settlers on Palestinian farmers and trees, say human rights group."*

1 November, 2010. The Australian. *"Olive branch out of the question as Palestinians see their trees die."*

In the same month that these anti-Israel headlines were appearing in international broadsheets and on the internet, Palestinian Arabs and international anarchists were filmed setting fire to a forest near Bat Haim in Israel. Although this was covered by Israel news no international media outlet considered this newsworthy. Surely this is one side of the story of the battle for the land?

The media instantly publishes news if an Israeli does something wrong. Why do they seldom balance this with equal reporting when Palestinians and their supporters commit similar offences, including violence and murder? Is there a motive at play here?

The St. Petersburg Times senior correspondent, Susan Taylor Martin, wrote a highly critical report about Israel's *"oppression of Gaza."* In November she wrote that *"although Israel has slightly* (!) *relaxed its*

blockade on Gaza, cement is among the many items still not legally allowed into the area except under rare circumstances."

In October 2010, Israel allowed into the Gaza Strip 223 trucks laden with cement, iron, and other building materials. In the same month a further 4,356 trucks brought food, fuel, and other items from Israel into Gaza.

This was confirmed in November by the Irish Times, a paper not known for being overly pro-Israel.

In November, at the same time as Martin's article was published in the St. Petersburg Times, the Hamas Housing Minister confirmed to United Press International (UPI) that approval had been given for the construction of a massive new residential apartment complex in central Gaza. This project will include three high-rise apartment blocks, a mosque, playground, shopping centre, and schools.

It is difficult to understand how such a large and expensive project can be built without money and without Israel permitting the much needed cement and building materials from entering into Gaza.

Something is clearly wrong here. Either the Hamas Minister was lying, or Susan Taylor Martin was either ignorant as to the facts, negligent in failing to gather proper information, or not reporting the truth that cement and building materials were in sufficient supply in Gaza to be able to construct Olympic size swimming pools, luxury houses and apartments, five star hotels, shopping malls, mosques, restaurants for fine dining, public facilities,

commercial buildings including banks, offices, stores, gardens and public squares.

Danny Seaman was the head of the Israeli Government Press Office for ten years up to November 2010. Israel is a hot spot for journalists and reporters and Seaman saw hundreds of them pass through the country. He claims that a lot of reporters come here without knowing anything about what is going on here.

As he told David Horowitz, chief editor of the Jerusalem Post, *"When you have a conversation with them you find they have a complete lack of knowledge of the elementary issues."* He explained to Horowitz, *"They come with the Palestinian narrative. They talk about "the Palestinian right of return." There is no such thing. They talk about what Palestinians call "Israel's violations of Oslo." What exactly are they talking about? They have no knowledge of the facts."*

Journalists, reporters, come to the region with a simplistic morality. It is difficult to know what came first. It's like the chicken and the egg. Do the journalists form public opinion with their biased, misinformed, reporting? Or do they come to the region reflecting and quoting the public opinion of their society?

Israel has the frustrating discussions that usually start with being accused of illegal acts of warfare such as using phosphorous weapons. When told that the use is, in fact, legal and that other countries use them we are told that it may be legal but it's immoral. That is to say that it is immoral when used by Israel but not when used by

American or British forces. Our only recourse if to remind them that terrorism and war is also immoral but we are forced to fight a war that we did not start.

Most of the journalists are unqualified to report on modern warfare, especially against the background of a trained army seeking out terrorists fighting among a civilian population in a confined area. Their sympathy is always with the population in a war zone, and almost always siding with the Palestinian population. Consideration of the suffering on the Israeli side that drove the IDF into places like Gaza in defense of its people seems to have no relevance or importance.

In Israel, visiting journalists get a press card and are free to go where ever they like.

In the Gaza Strip they cannot move without a Hamas minder. They are not free to go where ever they want. They get taken to the places that Hamas wants them to see and talk to people that Hamas has selected. Often there is an armed Hamas member close by to remind the Palestinian being interviewed to toe the line.

Any reporter chancing to write an investigative piece of journalism criticizing the Hamas regime or exposing unpleasant truths about Gaza will find it impossible to enter the Strip a second time and his employers may lose their privilege of reporting in the Gaza Strip in the future.

Hence, the editorial hierarchy has a vested interest in promoting Hamas propaganda. It's easy to criticize Israel. It is not easy to criticize Hamas or the Palestinian Authority.

That is not because there is nothing to criticize. The opposite is true. There is far more to criticize and condemn on their side than on Israel's.

The reason journalists will not criticize Palestinian society is that the regime there does not tolerate criticism or truthful exposures.

In 2007 British journalist, Paul Martin, was detained and held for twenty seven days in Gaza. His crime was wanting to report on the trial of a Hamas rocket firing operative who had refused to continue his terrorist activities claiming it was counter-productive and wrong. Martin felt himself to be in real danger describing his experience as *"27 excruciating days."* He said that a journalist has a duty to report a story accurately. Any reporter wishing to do this in Gaza risks detention or worse for defaming the reputation of the Palestinian people.

Any journalist wanting to survive the Palestinian regime must blur honest journalism by portraying the interest of the authority.

In the same year, BBC reporter, Alan Johnson, was grabbed off a Gaza street and held for one hundred and fourteen terrifying days. He later admitted that he suffered *"very dark passages of depression."* This is understandable when his captors told him that he may be killed *"the Zarqawi way."*[1] This meant by beheading. And Johnson was pro-Palestinian in his coverage. Israel expects journalists to be as courageous in exposing

[1] 'BBC journalist Alan Johnson; "I visualized being beheaded" '. Daily Mail. October 25,2007.

42

crimes and misdemeanors in Palestinian society as they are with Israeli society. What Israel should demand is not censorship. Israel always expects journalists to report the truth and expose abuse and crimes. Israel does expect, and should demand, a fair crack of the whip.

It does expect to have its voice heard and reported often and fairly. There are those in Israel who feel that newspapers or TV media that consistently broadcast biased journalism should be sanctioned and their competitors be given preferential treatment.

Danny Seaman was an advocate of sanctioning journalists that repeatedly issued untrue reports from Israel. This is not taking steps against the freedom of the press. However, if the press is biased, continues to issue stories from the perspective of the other side, and refuses to accurately produce the Israeli side of a story, it reflects a basic dishonesty. In cases like this some sort of reprimand is in order after polite persuasion to fair and balanced reporting fails.

The problem is that a lot of journalists covering the conflict share the Palestinian platform. One journalist said to me, *"If your problems were solved the whole world would be quieter."*

"So what do you propose? The end of the Jewish state?"

"Yes," she replied.

Israel shares a pact with the Jewish people worldwide. While Israeli Jews share a responsibility to defend its borders and build the nation, it also feels a responsibility to

reach out the Jews in dire need. In 1976, the long arm of Israel reached out into the African continent to rescue Jews trapped and facing death at the hands of terrorists representing the Palestinian cause, protected by the brutal regime of Idi Amin in Uganda.

In 1985, Israel airlifted 8,000 Ethiopian Jews out of their country and brought them to Israel. This was repeated when, on 25 May, 1991, Israeli Hercules aircraft swooped out of a night sky and carried fourteen thousand Ethiopian Jews away from their war zone in Africa to the safety of a new life in the Jewish State of Israel. Israel was maintaining the tradition that had began in 1949 when, in Operation Magic Carpet, they airlifted fifty thousand Jews from Yemen to Israel. This was followed by Operation Ezra when, in 1951, they airlifted one hundred and twenty thousand Jews out of troubled Iraq to the safety of Israel. In all these operations Israel fulfilled the biblical command:

> *"For I will take you from among the nations, gather you out of all countries, and bring you into our own land."* [Ezekiel 36:24].

If the anti-Israel moralizers had held sway in those days these epic acts of heroism would have been characterized as criminal acts. They would have accused Israel of breaches of international law. Israel does what is right for its people, where ever they are. Just as Israel holds a moral responsibility for the fate of Jews in peril, so Jews in the Diaspora must hold to a responsibility to defend Israel

from those who seek to defame and destroy it. In the propaganda war that is being waged against Israel the Jews of the Diaspora have a responsibility to protect Israel and not be sold the snake oil that is being peddled by those who are harming the Jewish state. Jews, who champion the Palestinian cause against Israel, have to see that they are turning the truth on its head. They should learn the facts, discern the real truth, and support Israel's case. For Jews, one basic truth remains. There can be no Jews without the truth of Judaism, and there can be no true Judaism without Israel.

ARAFAT AND THE MEDIA – DRIVING NAILS IN ISRAEL'S COFFIN

Yasser Arafat's life may be interpreted by many as a leader and unifier of the Palestinian cause and a nation builder. In an Israel that has seen the fruits of his work up close and personal he is seen as something completely different. Israelis will tell you that he was the father of modern terrorism, the first Islamic arch-terrorist, a corrupt egoist who stole from his people, and a leader who failed his people by not bringing them the statehood that was within his grasp.

Palestinian lies lead them to be unable to tell the truth about Arafat's birth and death. This may surprise you but Yasser Arafat was not Palestinian. He was born in Cairo and studied there before heading for Kuwait.

It is more than a conspiracy theory to suggest that Arafat died of Aids. A Romanian intelligence report noted that he had a preference for young boys. This was confirmed by people close to him.

In an interview with Hizbollah's Al-Manar TV, Ahmed Jibril, founder and leader of the Damascus-based Popular Front for the Liberation of Palestine-General Command, revealed a shocking conversation he recently had with Palestinian Authority President Mahmoud Abbas and his

staff. Said Jibril: *"When Abbas came to Damascus with his team, I asked them: 'What happened to the investigation into the death of Arafat? Is it conceivable that when* [former Lebanese Prime Minister] *Rafiq Hariri was killed, all hell broke loose, but the death of Yasser Arafat, is not investigated?"*

Jibril, like many Palestinians, readily accepted the notion that Israel had assassinated Arafat, and wanted the Palestinian Authority to conduct an official investigation concluding as much. The response from Abbas's aides changed in an instant Jibril's view of his deceased mentor.

"They were silent, and then one of them said to me: 'to be honest, the French gave us the medical report, that stated that the cause of [Arafat's] death was Aids.'"

Arafat eventually died in a Paris hospital after being airlifted out of Ramallah. Many speculated that the Palestinian leader, who was said to have had numerous homosexual relationships, had in fact contracted Aids.

A clearly angered Jibril said that Abbas and every other member of Arafat's Fatah faction *"should be happy that we got rid of the plague, which had been imposed upon them and upon the Palestinian people. The Fatah movement now has an opportunity to renew itself."*

John Loftus, author and intelligence expert, said on the John Batchelor Show on WABC radio on October 26 2007, before Arafat's death, that it was widely known in CIA circles that Arafat was dying from Aids. Loftus further said that was the reason the us kept preventing Israel from

killing Arafat – to allow him to be discredited by the ailment.

A 1987 book by Lt.-General Ion Pacepa, the Deputy Chief of Romania's intelligence service under Communist dictator Nicola Ceausescu, explained how Arafat may have contracted the sexually transmitted disease. In his autobiography "Red Horizons," Pacepa relates a 1978 conversation with the general assigned to teach Arafat and the PLO techniques to deceive the West into granting the organization recognition. The general told him about Arafat's nightly relations with his young male bodyguards and multiple partners *"beginning with his teacher when he was a teenager and ending with his current bodyguards. After reading the report, I felt a compulsion to take a shower whenever I had been kissed by Arafat, or even just shook his hand."*

Homosexuality is an accepted norm in modern free societies but it is condemned under punishment of death in Arab and Moslem regimes. This was not the image that the Palestinians wanted to have of their dead hero.

This was not exactly the best image that the Palestinians wanted projected to the world. It was better for them to secrete away the official documents, now in the care of his nephew, Nasser al-Qidwah, and build the lie that he was a martyr to Israeli poisoning.

Nobody has bothered to put Arafat under a microscope. The charisma has been allowed to linger in the air. At the time of his death leader writers in major newspapers wrote of him that *"rarely has a leader*

blundered more and left more ruin in his wake" and *"he was a man who threw away the best chance in a generation for an honorable settlement to the Middle East conflict."*

Despite this, BBC reporter, Barbara Plett actually cried, and that was prior to his death. *"When his helicopter rose above his ruined compound in Ramallah I started to cry,"* she admitted.

No tears for innocent Israelis slaughtered by this man from Barbara Plett. When she interviewed me in Netanya following the Passover Massacre no tear fell from her eye. No tears were shed by her on the death of Yizhak Rabin from BBC's Plett, only for Arafat.

It is frightening to Israelis how the western world made a legend out of a villain.

Arafat was a White House guest more often (President Clinton met him twenty four times in an eight year period) than any other international figure.

To commemorate his death the United Nations flew its flag at half-mast, something they did not do when President Ronald Reagan died a few months earlier, and despite the fact that no state of Palestine existed.

This was the man who addressed a United Nations General Assembly meeting in 1974 dressed in military uniform and wearing a gun in a holster. *"I come bearing an olive branch and a freedom fighters gun. Don't let the olive branch fall from my hand!"* he threatened to warm applause.

I wonder. What would be the reaction if an Israeli leader addressed the United Nations in this fashion? What if

49

an Israeli leader said to the Palestinian Arabs *"I come with an olive branch and a gun. Don't let the olive branch fall!?"* Would he be treated with warm applause?

Israel bears the scars of the reality of Arafat. Families still grieve. Others are still maimed. Israel reached out in peace to him, knowing deep down, the reality of this man.

Israel's Ehud Barak offered him concessions that left the country stunned by the enormity of its generosity. Yet Arafat could not bite the bullet and give up on his legend as the liberator of all the Palestinian land. He once told Israeli reporter Ehud Yaari that he would never be *"a prisoner in a gilded cage."* By that he meant he could not bring himself to accept a rump state alongside a powerful Zionist entity in which he would have to undertake the macro-management of his people. This was not his image. He was, in effect, a prisoner in a gilded cage of his own ego. Better to continue being adored by the West and pursue the dream of Palestinian liberation than be a peacemaker.

He ruled by anarchy. He personally and tightly controlled the flow of funding.

Forbes magazine noted him as one of the world's wealthiest leaders. Yet, he stole from his people as he stashed away billions of dollars in private banks accounts spread around the world. This money could have been constructively put to nation building. Instead, he set up and financed competing terror organizations.

His *"extortion, payoffs, illegal arms-dealing, drug trafficking, money laundering and fraud,"* to quote a 1993 report by British intelligence, were known about for years.

After his death, and according to Palestinian estimates, over nine hundred million dollars of Western aid money had gone missing. On top of that, and according to Salim Fayyad, Arafat paid out twenty million dollars a month to his various terror organizations. If the Palestinians claim to be poor they know who to blame.

Arafat, though portrayed as a freedom fighter and peace maker, was guilty of war crimes and more if the numbers of innocent Israeli dead and maimed are taken into account. From an Israeli perspective he was a deceptive terrorist who knew how to play the publicity game while murdering Israelis.

His brand of terrorism was Islamic in nature. Not by chance he named a couple of his terror groups Islamic Jihad and the Al-Aqsa Martyrs Brigade. He rabble roused his people with Islamic phrases and exhortations.

When criticized for signing the Oslo Accords in 1993 Arafat said that by signing this agreement he was *"hammering the first nail in the Zionist coffin."*

Over coffee, a few years back, I asked a local political pundit for his assessment of Arafat. He is not the most erudite of men. Like a typical hardened Israeli he said; *"Arafat! The guy was a fucking bastard! He screwed young boys, he screwed his wife at least once, he screwed his people all the time, but most of all he screwed us big time."* Not the most eloquent of men, but he was on the button.

In researching this chapter I delved into the BBC reporting archives on Yasser Arafat. I could find no

reference to him as a terrorist. What I did find was that in 2002, a year when Arafat-sponsored and ordered terrorism was at its peak in Israel, a year that included the infamous Passover Massacre at a Netanya hotel and the Hebrew University bombing, a year that two hundred and ten Israelis were murdered and over one thousand five hundred were maimed, the BBC made a Panorama profile of Arafat that described him as a *"hero"* and an *"icon."* It said he had *"a performer's flair," "charisma and style,"* and displayed *"personal courage."*

I can't help thinking that if the BBC's *"political correctness"* had applied in 1938 they would have said exactly the same things about Adolph Hitler.

Further proof of this is the BBC profile also said that Arafat was not only *"respectable"* but *"triumphant"* and the *"stuff of legends."* Was Hitler?

This portrayal of Yasser Arafat was in contrast to an earlier BBC report on Israeli Prime Minister, Ariel Sharon.

In a 2001 Panorama program the BBC projected Sharon as a war criminal. This was based on the Lebanese Christian massacre of Palestinian Arabs in Sabra and Shatilla during the Lebanon war against Arafat's forces in 1982.

In a strange twist of retrospective fate the BBC had misquoted Judge Richard Goldstone in its report leading him to accuse the BBC of badly distorting his words.

The report led a leading British politician, Iain Duncan Smith, head of the Conservative Party at that time, to

declare *"surely it is time that our national broadcasters, including the BBC, stop referring to Hamas and Islamic Jihad with such euphemisms as radical and militant. Let us call things as they are. They are terrorist organizations. Such fudging of what Hamas and Islamic Jihad really are confers some sort of legitimacy on people who are terrorists."*

If only the current governments would speak with such clarity instead of kow-towing to political correctness.

One of its own reporters exposed the BBC bias when Fayad Abu Shamala, the BBC Gaza correspondent for ten years, said at a Hamas rally on 6th May 2001 *"journalists and media organizations are waging the campaign shoulder to shoulder together with the Palestinian people."*

Trevor Asserson was a tireless campaigner for fair and balanced reporting. Undertaking exhausting research by analyzing BBC news he assessed BBC's adherence to its own guidelines in respect to its obligations, under the Royal Charter under which they are licensed to operate of impartiality and accuracy.

He found that the BBC fell short consistently and showed a marked pro-Palestinian bias.

"The persistent failure to treat the Middle East in an impartial way constitutes a breach of the trust which license payers have placed on the BBC. Some of the breaches are quite glaring. At times, by a mere selection or omission of facts the BBC provides a report which shows the very opposite of the truth. Frequently BBC reporting is

misleading. At times it appears to invent material to suit its own bias."

The BBC refuses to label Hamas and Islamic Jihad as terrorists even though the British Government does.

When suicide bombers killed twenty six Israeli civilians in Jerusalem and Haifa on 1^{st} and 2^{nd} December 2001 the word *"terror"* was, incredibly, used by the BBC only to describe Israel's retaliation against the sources of the attacks on its citizens.

> *"Terror overhead in Gaza today and panic below... Israel is pounding Gaza for a second day.."*
>
> (BBC1 News, 4 December 22:00)

According to the BBC, Israelis merely die. They are never killed, murdered, or slaughtered. This epithet only applies when Palestinian die, and frequently the media does not distinguish between civilians and terrorists referring to them all as Palestinians. Palestinian terror organisations never commit heinous acts of murder. They are always *"accused"* of such things by the Israelis.

> *"Over the years, Hamas has been blamed for scores of suicide attacks on Israel."*
>
> (BBC1 News, 4 December 18:00)

The BBC language suggests that Hamas is perhaps wrongly accused of attacks even though they proudly claim responsibility for them.

It is well known in the Arab Middle East that Al Jazeera has developed a bias in favor of the extremists, especially the Muslim Brotherhood, against the moderates,

and especially Israel. This became patently obviously by the slanted manner in which it exposed the leaked *"Palestinian papers."* Thousands of secret documents and reports were stolen from the Palestinian Authority offices and sold to the Arab TV station. Al Jazeera published the documents over several days in January 2011 to the embarrassment of the Palestinian leaders in Ramallah. The disclosures were also printed in the British Guardian newspaper. The Guardian has long had its own slant on Middle East reporting. It may be fair game for news outlets to divulge leaked or stolen secret documents but it should do so in an impartial manner and not display its own political bias. In the case of the *"Palestinian Papers"* both Al Jazeera and The Guardian quoted biased headlines. The Guardian boldly stated *"Secret files show slow death of Middle East peace process"* when, on the contrary, the leaked papers showed the flexibility, compromise, and understanding of the other parties positions in the negotiations that had been conducted between the Israeli and Palestinian leadership during 2008. The article wreaked of this paper's disapproval for the type of compromise that will personify any future peace deal between the two sides. The fact that the peace talks collapsed due to the eventual rejection by the Palestinians of compromise proposals was not mentioned by The Guardian.

Al Jazeera displayed its venom at the Palestinian Authority with a headline that read *"PA selling short the refugees."* It went on to castigate the Palestinian leadership

55

for not holding to hard line positions that would lead peace talks nowhere. In fact, the Palestinians turned down generous and flexible conditions offered to them by the Israelis.

What was equally troubling for the Israeli public from this affair was the knee-jerk response from Palestinian leader, Mahmoud Abbas. Instead of boldly saying that negotiations had been held in an atmosphere of good will and pragmatism for the sake of a peaceful solution leading to independence for the Palestinian people, he accused the Arab news channel of falsehoods.

He denied the contents of the documents and claimed that he maintained an inflexible position on all the important issues in talks with Israel. The truth got lost in the cause of political survival.

Assuming the leaked documents to be genuine, the PA leadership, by their lack of courage, publicly distanced themselves from any potential for peace and placed themselves in the same rejectionist camp as Hamas. Such public statements by so-called *"partners for peace"* leave Israelis to despair of ever reaching a compromise with the Palestinians.

The media has become a Third Party to the Middle East conflict. It has adopted a biased and prejudicial image that has caused public opinion, fed on a one sided view of the conflict, to adopt an anti-Israel position. One sees this reflected in articles, news pieces, and discussion programs. This was epitomized by The

Guardian's Polly Toynbee's appearance on BBC TV's *"DateLine"* program of January 29, 2011, in which she accused Israel as being the guilty party in the Palestinian dispute.

More and more you see radically anti-Israel audiences on political TV talk shows. A typical example is the BBC's *"Doha Debate"* TV program. How is it remotely possible that Israel can receive a balanced hearing from an audience in Doha whenever any subject arises that affect the Jewish state? Granted, the *"DateLine"* program I referred to included the eloquent Jonathan Sacadoti, who truly represented Israel's viewpoint. Normally, however, you will see the Palestinian-Israel issue debated with three carefully selected talking heads in the TV studio. There will be a Palestinian spokesperson, a journalist from a left wing newspaper, and the *"Israeli"* opinion will be given by either a left wing Israeli politician or journalist (usually from the left wing Ha'Aretz paper), or an Israeli representative of an anti Government NGO. Such programs, and there are many, generate a competition between these talking heads over which individual condemns Israel most forcefully. This adds to the effect of misinforming public opinion?

Abdel Bari Atwan is a regular on BBC's *"DateLine"* program. He is also the editor of the influential Arabic *"Al-Quds Al-Arabi"* paper based in London. The BBC have selected him as their studio expert on the Middle East. Atwan has a habit of attacking

anyone who points to his bias as conducting a smear campaign against him. Allow me to add my own smear. When speaking about Iran's nuclear project on ANB television in Lebanon in 2007 he said, *"If the Iranian missiles ever strike Israel, by Allah, I will go to Trafalgar Square and dance with delight!"* Atwan was invited to address the London School of Economics in late 2010 on the subject of the influence of *"the Zionist lobby"* on US and UK foreign policy. This is the *"expert"* that the BBC chooses to have as their talking head on all things Middle East, including Israel.

By siding with our enemy, the BBC and other misguided media outlets are joining Arafat and hammering another nail in Israel's coffin.

MY LETTER TO A PRO-PALESTINIAN HUMAN RIGHTS ACTIVIST

You tell me you are pro-Palestinian and a human rights supporter. So am I.

So you support Palestinian rights.

So do I, but we have to define what those rights are.

Would you consider Jews, descendents of those who lived here during the Ottoman Empire or the British Mandate, as Palestinians, or Israelis?

I have met a number of Jews in Israel who held identity cards given to them by the British that defined them as Palestinian.

Do you, I wonder, fight for their rights?

Would you call an Arab, born in Israel post 1948, Palestinian or Israeli? Interesting questions, don't you agree?

These questions should define what you mean by being pro-Palestinian.

You tell me you are a human rights supporter.

That's great. So am I.

You live there. I live in here, in Israel. Let's try to understand each other - clearly, fairly, honestly. At the outset, I have to ask you why your activism for human

rights is confined to the Palestinian cause? Don't know what I mean? Let me ask it differently.

Why have you not expressed your outrage for other, far more critical, human rights disasters, as I have done?

I understand you like political adventurism, like flotillas to free Gaza? Why have you not joined a flotilla to feed and care for the thousands of dying children in Africa?

Oh. I forgot. There aren't any.

Why is that, I wonder? Why are there no flotillas and convoys to save lives in Africa?

Why is it that all the flotillas want to head for middle class Gaza? Ever thought about that?

The Palestinians are replete with wonderful shopping malls, five star hotels with fine dining, luxury houses and modern apartment blocks. Nobody is objecting to Palestinians enjoying a high standard of living. That's fine.

Why have you not turned your attention to the horrendous human rights crimes of the Iranian regime against their own people? Beatings, tortures, killings, stoning and lashing women to death, the executions of homosexuals and student protesters do not seem to move you.

Why are you not demonstrating against, or boycotting, Turkey for their vile slaughter and oppression against the Kurdish people that far exceed in desolation, destruction, and death that of the Palestinians?

Don't you stop to consider that there are millions who urgently need your activism and support far more desperately than people in Gaza?

What is it about the Palestinians that gets your juices going over all other humanitarian tragedies?

Could it be that you cannot incriminate Israel in human rights crimes perpetrated in Iran, Iraq, Lebanon, Kuwait, Saudi Arabia, Syria, Jordan, Egypt, Sudan, Zimbabwe, Burma, Russia, China, Pakistan, China, Turkey, Kurdistan, Cuba, so these abusive regimes do not get you emotionally involved?

You say you support the Palestinians and are upset by human rights abuses against them.

I tell you that your support is limited, and tainted. I tell you that my support is far broader, and more international, than yours. You are ready to take action in support of the human rights abuses of the Palestinians in Gaza.

You are ready to demonstrate, march, participate in flotillas, and really get involved on behalf of the Palestinians, when you feel it is the Israelis that are doing the abusing.

For me, I question the abusing by Israelis. I also suggest that you consider that the Israelis have a really good case when it comes to being abused by Palestinians, especially from Gaza. I admit that the killing of Israelis is not confined to Gaza. They are also being killed in the West Bank (what we traditionally call Judea and Samaria), and this is under the control of the official Palestinian authority. I can also send you a very long list of terrible crimes committed against innocent Israelis by Palestinians for decades, but let's put that aside for now.

Let me concentrate on the issue of your limited support for Palestinians. It seems to be confined to Gaza these days. Why? Why is it that, with the rapid improvement in the living conditions of Palestinians, you have to increasingly exaggerate a false picture of Gaza to make your point to the world? You shout, in emotional terms, about the condition of Palestinians in Gaza. Give me your email address and let me send you the numerous photographs I have on Gaza today.

In fact, go to Google Earth and find them yourself. You will see Palestinian kids having fun among the slides in the water park, and the rides in the lunar park. By the way, Hamas destroyed the water park.

Here's a report by human rights activists in the Gaza Strip on this incident:

"The attackers stormed the resort using a four-wheel drive vehicle, one of the guards told a human rights group. "They and another group of gunmen set fire to the two main buildings, a Bedouin tent and 300 nargilas (water pipes)." The Hamas government had ordered the closure of crazy water park for three weeks under the pretext that it did not have a proper license. Last month, Hamas policemen raided the resort and expelled dozens of men and women who had gathered for a fast-breaking meal during Ramadan.

The owner of the facility was summoned for questioning and warned not to hold events where men and women sit together.

Sources in the Gaza Strip said that Hamas has been targeting the water park because the owners violated an order banning women from smoking nargilas in public places.

Last week, the Hamas authorities closed down the Sama seaside restaurant, also in Gaza City, where a woman was seen smoking a nargila. Human rights activists said that Hamas has recently stepped up its efforts to impose strict Islamic observances in the Gaza Strip."

The clamp down is another outward sign of the increasing oppression of Islamization that Hamas is imposing on the Palestinian territories under their regime.

You may not consider human rights abuses against women smoking and men and women partying are not serious violations. I say that they are part of a symptom that lies deep within the Palestinian character. It is part of their Islamic moral code.

I don't agree that this is a minor and therefore acceptable form of oppression.

Would you like to live in a society like this?

If this was the limit of their abuse it would not be an issue between us. Their abuses, however, go way beyond smoking. There is photographic and video evidence of Palestinian terrorists grabbing kids and using them as human shields in their fight against IDF soldiers.

I didn't hear your outrage at these human rights abuses against Palestinian children by Hamas terrorists. Why not? I did.

I suppose you will dismiss Hamas members murdering rival Fatah members as an internal dispute and this doesn't warrant your human rights involvement, not even when they

drag their victims to the rooftops of high rise buildings in Gaza and throw them to their deaths.

Fatah officials complained in January 2009 that Hamas had attacked fellow Palestinians, members of rival Fatah, and that at least seventy five had either had their hands broken or shot in the legs as a warning not to challenge their brutal regime. This doesn't faze you at all.

Maybe it's because you don't consider Hamas as a terrorist organization? If not, where do you draw the line between freedom fighter and terrorist?

Do you not consider suicide bombers deliberately targeting innocent Israelis, as terrorists? Are they not terrorists under any definition of the word? Are they not committing the most heinous human rights crimes when they target buses, bars, shopping malls, and killing grandmothers with their grandchildren at ice cream parlors?

You scream blue murder when Israel targets terrorists in the Gaza Strip, but stay silent when Hamas fires tens of thousands of rockets into Israeli civilian areas. How come? If you're truly a human rights activist, where is your humanity? Or is it a one-sided morality?

But let me return to my pictures of Gaza.

I see the mansions and luxury apartments, fine restaurants, beautiful five star hotels, the new Gaza shopping mall, and the crowded and well stocked stores and markets.

They clearly have the funds and the materials to build and equip these wonderful buildings. They also prove a source of income and employment for the Palestinian population. That's how it should be. But this raises two

questions. You protest that Gaza is the biggest humanitarian crisis on earth, but this is somewhat in conflict with the facts on the ground. The Palestinians are enjoying an increasingly good lifestyle, certainly in the West Bank, and evidently in Gaza. How have they managed this if Israel's *"brutal occupation is preventing basic needs from getting through to the Palestinians"*?

Clearly someone has not been telling the truth here. You can't build without supplies of building material and equipment. They are not living in tents. They are living in nice apartments and beautiful houses.

They do not walk. They drive. The market for new and second hand cars is huge in The Gaza Strip and in the West Bank. There is obviously plenty of cash sloshing around the Palestinian system. Clearly, statements about Palestinians being deprived of building materials, equipment, furniture, appliances, vehicles, is a lie. Did you help to spread that lie?

They drive modern cars and trucks. I thought you told the world that they are barely surviving? How are they able to buy, drive, and maintain these vehicles? Off charity?

Maybe the United Nations are giving them driving lessons? You can't complain about Palestinians not having the most basic needs when the markets and shops are brimming with the widest variety of produce and products. They are not starving. They are eating well. International statistics show that Palestinians live longer than Turks. Their infant mortality rates are better than most other Arab countries. A survey conducted by Britain's Channel 4 confirmed that people in Gaza live longer than people in

Glasgow East. This may come as a shock to people in Scotland. Things aren't at all bad for Palestinians living in Gaza or the West Bank.

The January uprising in Egypt exposed what many of us had been saying for years. That the Palestinian condition is superior to much of the Arab, African, and Asian worlds. Suddenly people began to hear that the Egyptian unemployment rate was greater than that in the Palestinian controlled territories, that Egyptians earned less than Palestinians. The Egyptians people had to riot in the streets to make their voices heard. You were too fixated over the your false claims that the Palestinians were the world's basket case to notice that there are billions of people in far more dire straits than them. Things will be even better for them when they turn away from supporting an Islamic terror regime in Gaza, sponsored by Iran and ably supported by Islamic Jihad and other unsavory gangs equipped and controlled by Hamas in Gaza. Things would be a lot better for them if their leadership would decide, once and for all, to sit down with Israel and agree a permanent peace agreement without making further demands that prevent progress for themselves and for us.

It is not only Hamas that abuses their own Palestinian citizens. The official Palestinian Authority security forces in the West Bank have been torturing fellow Palestinians in a widespread and systematic manner for years. According to a report issued by the Arab Organization for Human Rights in Britain torture techniques used in Palestinian prisons include shabh (hanging), whipping with cables, pulling out

finger and toe nails, suspension from ceilings, flogging, kicking, electric shock, sexual harassment and the threat of rape.

The AOHR is associated with Hamas and other radical Islamic groups, so it can hardly be described as spouting Zionist propaganda.

They claim to have documented crimes, which included six deaths by torture by the Palestinian Authority between October 2007 and October 2010. According to this report, during that period 8,640 Palestinians were detained and *"everyone suffered humiliating and degrading treatment and stayed in their cells for more than ten days."*

The report described the various forms of tortures including being left hanging upside down from the second floor of detention buildings.

"The analysis shows that an astonishing ninety five percent of the detainees were subjected to severe torture, others feeling the detrimental effects of their health for varying periods."

During the reported period, six men died during torture in Palestinian Authority prisons. They were named as Majd Barghouti, Shadi Shaheen, Muhammad al-Haj, Haitham Amr, Kamal Abu Ta'eima, and Fahdi Hamadna. They were Palestinians tortured and killed by Palestinians under the watchful eye of the *"moderate"* Palestinian Authority.

I ask you. Where is your outrage? If you truly care about the Palestinians, rather than expressing your biased hatred of Israel, why have you been so silent? You claim to be a human rights activist? Where are you on this issue?

The Independent Commission for Human Rights, based in Ramallah, reported that executions are being carried out by Hamas in Gaza. What is strange, let alone brutal, about these killings is that Hamas is executing them according to a law they don't even recognize. The ICHR recorded that *"Hamas is trying them based on the PLO revolutionary penal code which Hamas is not a part of and doesn't recognize."* This surely makes Hamas executions illegal as they do not have their own legal jurisdiction. Sanir Zaqout, a coordinator for the Gaza-based human rights organization, Al-Mezan, thinks this is in order. He has said that Palestinians have no problem with the death penalty since it is sanctioned by Islam. Over a hundred people have been sentenced to death since the Palestinian Authority came into existence and Hams took power in Gaza. Amnesty International said that Palestinians executed at least twenty people during Operation Cast Lead. Palestinians follow closely in the footsteps of Iran, Iraq, and Egypt in the number of executions of its citizens for political reasons. Where is your human rights outcry?

But here's the part that really gets to me. Nowhere, in your pro-Palestinian human rights activities, do you mention peace. Do you think there will be peace if Hamas, God forbid, takes over the West Bank from the Palestinian Authority?

Will you continue to champion the Palestinian cause if that happens? Probably, you will.

It is here that I will prove to you that I care more for the Palestinians than you do. You are completely silent on

the condition of Palestinians outside of the Palestinian territories. I, on the other hand, have written and spoken out about the inhuman conditions in which they are forced to live in places like Lebanon, Kuwait, Iraq, Saudi Arabia, and Jordan. After decades living in these and other countries they are still denied citizenship. They are prevented from entering into the national work force. They are not allowed the proper education that would allow them to study and become useful professionals in many fields. Isn't this ethnic discrimination? Forced to live separately from the indigenous population is, surely, apartheid?

Where is your protest in support of the people you claim to love? Why aren't you blaming these Arab countries for their apartheid system against the Palestinians? If you really care about the Palestinian condition you should be demonstrating about the continuing saga of confining them in refugee camps in these so-called *"friendly"* Arab states. Instead, you are silent. Why is that? Are you simply echoing the Palestinian narrative when it is applied against Israel while ignoring the gross abuses they suffer from their own leadership and other Arab regimes? Why is it that the Palestinian leadership itself does not speak up against the terrible abuse of the people they represents in other Arab countries? Like you, they seem to be remarkably silent on this issue. So who is more international about human rights for Palestinians? You, or me?

It's great that Gaza has wonderful sports and cultural facilities, but don't deceive the world how much they are suffering.

I live in Netanya. We have been hit by repeated Palestinian terror attacks that include shootings, car bombings, and numerous suicide bombers that have killed about fifty of our citizens and maimed over three hundred. We don't have a municipal Olympic swimming pool. Neither does Sderot, the target of thousands of rockets and mortars fired on them by Palestinians in the Gaza Strip.

Aren't they worthy of your sympathy? Don't they deserve to enjoy facilities such as Olympic swimming pools? Sderot, the constant target of Palestinian terror, does not receive the massive amounts of aid and funding that is pumped into Palestinian society by the international community.

True, diplomats make sympathy pilgrimages to Sderot, but they limit their huge budgets exclusively to the Palestinian cause. There is clear evidence that Palestinians enjoy an increasingly middle class lifestyle, while the kids of Sderot barely receive trauma treatment.

Palestinian society is radically split. The internal violence is shocking. Palestinians hate Palestinians to the point of brutality, including torture and murder.

I share your concern for innocent civilians. But, where was your voice, as I said, when Hamas activists were throwing Palestinians to their deaths from rooftops, shooting political rivals, torturing them, killing Palestinians who champion the cause of peace, firing rockets from schoolyards and from heavily populated areas? I spoke out. I did not hear your voice of protest.

If you really stand up for human rights abuses why have you remained silent over the abuse of women's rights in Palestinian society?

I have written and spoken out about the repression of women under Arab and Palestinian control. Why haven't you?

Khaled Abu Toameh, a local journalist who covers Ramallah and Gaza, wrote in New York's *"The Hudson"* on November 23, 2010,

> *"It is not easy to be a woman living under a fundamentalist Islamic regime like the one in the Gaza Strip. Over the past three years, women in the Hamas-controlled Gaza Strip have been facing a campaign of intimidation and terror that has forced many of them to sit at home and do nothing. The fact that women are oppressed under radical Islamic regimes is of course very disturbing. But what is even more disturbing is the silence over abuse of women's rights in the Gaza Strip.*
>
> *Has anyone heard prominent Palestinian spokeswoman Hanan Ashrawi come out in public against Hamas's repressive measures against Palestinian women? Where are local and international human rights organizations, especially those that claim to defend rights of women in the Arab and Islamic world? Has any major media outlet in the West thought of making a documentary about the suffering of women*

under Hamas? Or are they so obsessed with everything that Israel does [or does not do] that they prefer to turn a blind eye to what is happening in the Gaza Strip? Has anyone dared to ask Hamas why sending women to carry out suicide bombings is all right, while it is not OK for them to walk alone on the beach or be seen in public with a man? Have "pro-Palestinian" groups in North America and Europe ever thought of endorsing the case of these women by raising awareness to their plight?"

Why do you condone, by your silence, honor killings as respectable behavior in Palestinians households, not to mention the genital mutilation of girls? If you truly stand for Palestinian human rights you should be demanding the major human rights organizations to investigate this serious tradition of abuse against women and girls.

Men convicted of honor killings get a maximum sentence of six-months imprisonment if caught and prosecuted.

A woman has to be hospitalized for at least ten days to press serious assault charges and she requires the testimony of two witnesses who are not related. Furthermore, rape is not recognized as a crime within marriage in Palestinian society. Domestic violence is taboo in Palestinian society.

Mashoor Basissy, director of the Palestinian Authority Ministry of Women's Affairs (MOWA), told Mel Frykberg in an IPS report on 8th April, 2009, that, *"As a Palestinian man I have to tell you that women are not regarded as*

equals in our society. The courts enable the male perpetrators of domestic violence and honor killings to get off very lightly if they are even brought to justice in the first place which is unlikely in most of the cases."

Frighteningly, he continued: *"Many women were still murdered, and continue to die, because once the family has decided that these women are going to die, all the protection in the world, and all the laws backing are rendered void when the women eventually returns home."*

Why don't you join me in protesting these abuses? Or is your advocacy for Palestinians confined only on issues that allow you to attack Israel?

By the way, Khaled Abu Toameh is an award winning journalist. He is also a Muslim and lives in Israel. He is the first to admit that, as an Israeli Arab, he enjoys a freedom of the press that would be unheard of in any of the Arab or Muslim countries.

Talking of Israeli Arabs, Judge George Kara led a panel of Israeli judges in finding disgraced president Moshe Katzav guilt of sex crimes. How's that for the peak of democracy for human rights?

I'd love to see a Christian or Jewish judge bring judgment against the leader of any Muslim state. They wouldn't survive long enough to bring down the gavel on the verdict. Oh, I forgot. There aren't any! Just look at what's happening in Lebanon where Said Hariri has to go genuflecting himself before his father's murderers. And he's the President of his country! So don't go lecturing Israel about our internal human rights record.

If you care about human rights surely you care about children. I know you do because I have heard your outrage at Palestinian children killed and injured in the crossfire between our soldiers and their Palestinian terrorists.

18 year old Ayat Akhras walked into a Jerusalem supermarket on 29 March, 2002 and detonated a bomb concealed under her clothing. She killed a security guard and ended the life of 17 year old Rachel Levy who she had never met. She also wounded 22 others.

Three teenagers - Anwar Hamduna, Yusef Zakut, and Abu Nada from Gaza, attempted to crawl under the perimeter fence and attack the residents of the nearby Jewish community of Netzarim, only to be shot dead by guards.

For over a month, Palestinian children as young as ten barricaded themselves in Bethlehem's Church of the Nativity, alongside Palestinian gunmen and desecrated the church.

A 16 year-old Palestinian boy was arrested in a taxi near Jenin with a bomb strapped to his body. A 15 year-old Palestinian girl, arrested for throwing a firebomb at IDF soldiers, admitted during interrogation that she had previously been recruited as a suicide bomber. Israeli security forces arrested another 15 year-old Palestinian girl who admitted to having agreed to carry out a suicide attack in Israel.

The Palestinian culture of indoctrination of children and martyrdom is a violation of human rights. What do you say about the Palestinian indoctrination of children in their

74

"armed struggle against the Zionist entity?" Do you condemn it and speak out against it? Or do you justify it?

This is inculcated by the Palestinian regime in all aspects of children's lives within Palestinian society. From school education to their TV screens to their summer camps, Palestinian kids are incited and trained that killing Jews is holy imperative.

Where are your values of human rights when small children are dressed as suicide bombers in military-type parades and rallies? What hope for peace can there be until Palestinians turn away from this lethal lesson of death to the hope of a better and peaceful future?

I can guarantee that Israel does not have this hate indoctrination in our official educational system. As Golda Meir once said: *"When Palestinian mothers learn to love their children more than they hate us will be the time we will have peace."*

As an Israeli, I can tell you that the Palestinians could have achieved their own state decades ago. They could have it today if having their own state alongside the Jewish State of Israel was a priority for them. But it's not.

Just read the Hamas Charter and you will learn what is really at the heart of the conflict here. In fact, have a look at the Palestinian national covenant as well. They share the same aims. Have a glance at Article 7 of the Hamas Charter. If the Palestinians want their state to be an Islamic republic that's fine with me, as long as they respect my rights to my Jewish democratic state, but Article 7 reads:

"The time will not come until Muslims will fight the Jews and kill them; until the Jews hide behind rocks and trees, which will cry: O Muslim! There is a Jew hiding behind me, come on and kill him!"

As a human rights activist, don't you find that racist?

Doesn't that national charter sound to you like incitement to genocide against my people?

And, as for peace, go to Article 13. Here it is written:

"Article13. Peaceful solutions, [peace] initiatives and international conferences: The so-called peaceful solutions, and the international conferences to resolve the Palestinian problem, are all contrary to the beliefs of the Islamic resistance movement for renouncing any part of Palestine means renouncing part of the religion; the nationalism of the Islamic resistance movement is part of its faith, the movement educates its members to adhere to its principles and to raise the banner of Allah over their homeland as they fight their jihad."

I ask you. Do you share these resolutions? Is this an integral part of your support for Palestinian rights?

If you share these points, you also support Articles 14 and 15:

"Article 14: The Three Circles: The problem of the liberation of Palestine relates to three circles: The Palestinian, the Arab and the Islamic. Each

76

*one of these circles has a role to play in the
struggle against Zionism and it has duties to fulfil.
It would be an enormous mistake and an abysmal
act of ignorance to disregard anyone of these
circles. For Palestine is an Islamic land where the
first Qibla and the third holiest site are located".*

And: *"Article 15: The Jihad for the liberation of
Palestine is an individual obligation. When our
enemies usurp some Islamic lands, Jihad becomes
a duty binding on all Muslims. In order to face the
usurpation of Palestine by the Jews, we have no
escape from raising the banner of Jihad".*

I am sure you are aware they are talking about Israel
here, not another state somewhere else. I ask you. In your
support of Palestinian rights are you supporting Islamic
jihad against me? There is no way of avoiding this question.
I do not expect you to be a Zionist, but if you are not a
Zionist, are you a jihadist?

The "moderate" arm of Palestinian society is headed
by the Palestinian Authority President Mahmoud Abbas,
ably supported by Prime Minister, Salim Fayyad. I heard
Fayyad speak at the annual IDC Conference in Herzlia
where he was invited as a keynote speaker. He was given a
warm reception by the Israeli audience who yearn for a
permanent peaceful solution to the painful conflict. But, let
me read you some sections of the Palestinian National
Covenant, which is their national constitution.

77

Article 2 states that: *"Any Palestinian state will be with the boundaries it had (sic!!) during the British Mandate, as an indivisible territorial unit."*

Really? I thought we were negotiating a two state solution? Where is Israel in this equation? And what is this Palestinian state they had during the British Mandate?

Palestinian supporters claim to nationhood stems from United Nations Resolution 181. It will come as a shock to their belief system to read Article 19 of the Palestinian National Covenant. The so-called legitimacy of their claim evaporates with the reading. The Palestinians quote the Resolution as their raison d'etre , yet they officially reject it and call it illegal! They reject it, they say, because it was *"contrary to the will of the Palestinian people."* According to my understanding of the law this would, therefore, make UN Resolution 181 null and void, invalid. It, therefore, invalidates any Palestinian claims to land or nationhood. This, then, surely leaves the League of Nations Palestine Resolution of 1922 on the records books? It reads:

"Article 19: The Partition of Palestine in 1947 and the establishment of the state of Israel are entirely illegal, regardless of the passage of time, because they were contrary to the will of the Palestinian people and to their natural right in their homeland, and inconsistent with the principles embodied in the charter of the United

Nations, particularly the right to self-determination".

Whichever way you look at it, the Palestinians try to deny Israel but they succeeded in denying their own existence. Isn't that called cutting off your nose to spite your face?

The Palestinian National Covenant also denies the Jews biblical, historical, political, and all cultural rights to Israel.

"Article 20: *Claims of historical or religious ties of Jews with Palestine are incompatible with the facts of history and the true conception of what constitutes statehood".*

While wanting to create an Islamic state of their own, they deny me any national rights: *"Judaism, being a religion, is not an independent nationality. Nor do Jews constitute a single nation with an identity of its own; they are citizens of the states to which they belong."*

This, also, is part of Article 20 if their constitution. Don't you find this racist? Where are *our* human rights in all of this? Am I to allow Palestinians to define who I am? Am I to allow them to deny me my history? Whatever happened to the nation of Judah, of Zion, of Jewish national aspirations throughout the centuries of Diaspora dispersion?

You probably share the Palestinian outrage when people rightly say that Palestinians never had a nation of their own and neither do they have any national rights enshrined in international law as do the Jewish people. But this is fact based on history.

From my perspective, the Palestinian narrative is based on a lie. It is based on a deconstruction of history. It is based on nonexistent rights they never had as a people.

I can go on about their calls for violence against me (calls to which you remain silent) but I want to return to our core problem. This is our problem, the problem between you and me. If you approve of the advancement of Palestinian rights alongside the Jewish State of Israel then we have what to discuss and agree on. Israel has, and will, make painful concessions for peace.

If the issue is land, it is ours to give or not to give. It is not theirs to take.

If, on the other hand, you promote Palestinian rights over my rights to exist this letter will, doubtless, be our last communication.

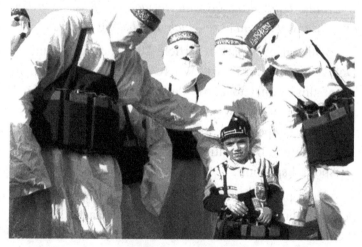

Really. Are these the people you campaign for? How about the human rights of this child? Why are you so silent?

ISRAEL'S HUMAN RIGHTS RECORD - A GUIDE FOR ISRAEL'S CRITICS

This is addressed to Israel's human rights critics. It is an aid to help them in their campaign - so do please pass it on to them. This is an assessment of Israel's human rights record.

- Israel does not execute its own citizens as is done in so many countries, including the USA.

- Israel does not kill its own citizens for the crime of public protest as countries such as Iran do by prison cell beatings or hangings.

- Israel does not publicly stone women to death as they did in Afghanistan and is routinely practiced in countries such as Saudi Arabia and Iran.

- Israel does not whiplash girls as a punishment for being raped as they do in many Muslim countries.

- Israel does not cut off the hands of young boys for stealing as they do in several Muslim countries.

- Israel does not hang anyone for being homosexual. In fact, Israeli homosexuals reach the highest ranks in our political, cultural, and academic life.

- Israel does not shut down its free press or media for criticising or challenging the country's leadership, as they do in Venezuela, Iran, Saudi Arabia, Libya, Indonesia, Burma, and many more countries.

- Israel does not teach its children racial hatred and incitement to violence as they routinely do in Palestinian state schools and Muslim madrassahs worldwide.
- Israel does not deliberately target civilians as they regularly do in Palestine, Iraq, Afghanistan, Sudan, and other violent regimes.
- Israel does not use its citizens as human shields.

The above lists the negative "does nots" of Israel's human rights record. Now let me list what Israel does do in human rights.

- Israel allows citizens of all faiths, minorities, women to vote.
- Israel allows all its citizens, including its Arab citizens to take leading positions in its schools, universities, legislature, courts, Knesset, and all factors of a free and open society.
- Israel permits people of all religions to freely practice their faith. Go ask Christians in the newly democratic Iraq how they feel about that. Go try to find a Jew or a synagogue in Saudi Arabia, Dubai, Abu Dhabi, and many other Islamic countries.
- Israel has a Supreme Court that is not only available to its own citizens, but also to any Palestinian with a grievance against Israel. Find me any Palestinian court willing to accept a claim from an Israeli terror victim against the Palestinian Authority, Hamas, individuals, or any of the numerous terror organisations under their control. Would their legal

system open themselves up to any claim for justice from suffering Israelis? I doubt it.

- Israel has numerous NGO's whose sole purpose in life is to investigate, criticise, and pursue legal remedies against the state. Does this exist in any Arab or Islamic regime? It certainly does not happen in Iran, Saudi Arabia, Syria, Gaza, etc.
- Israel is the most socially conscious nation in the region. It may have its shortfalls but it is aware of them and remains a work in progress.
- Israel, in its open society, is constantly debating human rights within its own society and its approach to its Palestinian neighbours.
- Israel has a free press in which Israeli attitudes to its own citizens and its actions towards Palestinians are freely expressed.
- Israel allows free speech. When was the last time you allowed an Israeli official to speak freely in your university? You eagerly permit Islamic radicals that advocate suicide bombings on to your campus but not members of a democratic country. Why don't you allow them the basic human right of free speech? Or is it only violent hate speech against Israel that you support and practice?

Israel cannot be more responsible for Palestinian lives than the Palestinians themselves.

According to the results of a study compiled by the international NGO, The Institute for Monitoring Peace and Cultural Tolerance in School Education, published at the

end of January 2011, Israel and, strangely, Tunisia ranked at the top of the Middle East region's rankings for teaching peace and tolerance in their school systems. The Palestinian Authority along with Egypt, Syria, and Saudi Arabia were close to the bottom of the list with Iran dead last. The report's complaint against the low ranking countries was that they failed to show support for democratic values or respect for the "other," nor did they encourage principles of democracy. Though Egyptian schoolbooks did plead for religious moderation they also contained anti-Jewish material and promoted "pro-war" narratives. Despite the fact that there is a three decades old peace agreement the Egyptian schoolbooks deny the existence of the State of Israel. Tunisia, despite their 2011 revolution, was given as a positive example to the Arab world. According to the report it has a more tolerant attitude to non Arab countries. Until the uprising, Tunisia had an almost total separation of mosque and state and that Islam was not a dominant force in their school system. Tunisia's school system was reported to be more open to the peace process and the existence of the State of Israel and this is included in their official school textbooks, something that is totally lacking in the educational system of the Palestinian Authority. Tunisian schoolbooks also make mention of the Holocaust.

IMPACT-SE NGO head, Shelley Elkayam, said that, *"the move toward moderation in Tunisia reflects a pedagogic approach geared to preparing the child for living in a global village in a culture of tolerance."*

Tunisia, like Israel, preciously protects its national heritage and values. Its liberal democratic principles, expressed in its educational system are in stark contrast to most of the Arab world, and particularly the Palestinians who should be preparing their children for a world of peace and tolerance, as Israel is doing.

So, if it is only against Israel that you demonstrate and protest, I have only one thing to say... Get yourself an education ! Until you do, your bias and, yes, your anti-Semitism is showing. For to criticize Israel solely, and with false claims, while remaining silent against the real human rights abuses in this world, leads me to the inevitable and only conclusion I can draw from your venom against us alone.

You're an anti-Semite. And that is a human rights crime!

I WAS LEFT - NOW I'M RIGHT
(AS IN CORRECT)

Who was it that said, *"If you are not a Socialist by the age of thirty you don't have a heart. If you are still a Socialist after the age of thirty you don't have a head"*. I guess I fit into that category.

There was a time, in European countries, when left wing Socialists rallied around the Jews to fight an anti-Semitism that came from the right. Those days are gone. Now it's the right that are rallying around the Jews, and Israel, to fight the anti-Semitism and anti-Zionism of the left. That is not to say that Jews were free from persecution at the hands of the left. The Soviet Communist purges killed thousands of Jews and Stalin was an infamous anti-Semite. Remnants of this Jew-hating strain can still be found in parts of post Communist eastern Europe.

In my formative years, I always voted Labour. This was not from any conscious effort on my part. It stemmed, I suppose, from being raised in a working class Jewish family in northern England, and with a father who had been a member of a trade union when he worked as a carpenter building Mosquito aircraft for the RAF in Trafford Park.

The Jews and the Socialists were the ones who put an end to the political career of Sir Oswald Mosley in Britain. Mosley wanted to import Hitler's sick rhetoric into Britain.

A historic incident occurred when the combined mob pounced on him and his fascist brown shirts as he tried to address a crowd in Manchester's Belle Vue. This was a defiance, from the left, of a cherished British democratic tradition of free speech. It was felt then that the fascist ranting of a British Nazi had no place in Britain. Freedom of speech was considered one of the highest values of an enlightened society. The individual was given credit for discerning and rejecting an odious message which reflected on the messenger rather than the listener. Today, there is an active campaign by certain left wing governments to prevent any speech that counters their perceived values, particularly as it applies to race or religion. They decide, under the law, what is allowed to be said, and what is not. It has left a divide that prevents the public from expressing their concerns about the rise and intentions of radical Islamists while giving freedom of expression to those who slander Israel. In certain European countries it is illegal to quote the Koran if you are not a Muslim but it is perfectly legitimate to call Israelis "Nazis."

Notable people are facing criminal charges for pointing to offences performed in the name of a religion while others go free for justifying suicide bombers in public speeches, funding terror, and slandering Israel. It is just one sign of a left wing multicultural society gone politically incorrect.

Israel is a fledgling developing nation created mainly by the aspirations, bravery, and struggle of Socialists. David Ben Gurion held sway over the likes of Zeev Jabotinsky and

Menachem Begin. The agricultural villages and kibbutzim that turned barren land and malarial swamps into rich orchards, arable farmland, and fish ponds were the result of tireless and backbreaking labor by men and women who were passionately anchored in a secular Socialist Zionism.

In Britain I had, for most of my working life, been an individual making my own way in the world. True, I had been employed by a couple of companies as I progressed in the fields of marketing and sales before leaving them to chance my fate to my own abilities. I pursued a middle class independent existence for myself and my family. This should have turned me into a Conservative, especially as I detested what appeared to me to be the bullying tactics of old Labour personified by trade union leader Arthur Scargill, who challenged Margaret Thatcher with regional and national strikes that affected and interfered with the lives of non union citizens.

We left Britain for several reasons. A moment of epiphany was listening to talking heads on a BBC TV news show immediately after Yom Kippur in 1973. News had filtered through to us as we prayed in the Bury Synagogue of north Manchester on the most holy day in the Jewish calendar. Israel had been attacked by three Arab armies for whom the reality of a tiny Jewish state was an anathema. We rushed home after the daylong service to switch on our TV and gather news of what was happening. The main topic of conversation was not about Israel's survival. Rather it was centered on how this war would affect the price of petrol for British drivers. In a sense it was creating in us an

identity crisis. How could we stand idly by while fellow Jews who had created the Jewish homeland were fighting for their very existence? They were fighting against superior forces, but at least they were fighting. Not like a few decades before when millions went to their deaths with little or no resistance.

And so we arrived in Israel.

We decided to try kibbutz life. By that time the backbreaking labor of moving rocks by hand was long gone. Initially, I enjoyed the tedious work in the banana fields, later the dates and the mangos. The idyll of kibbutz life faded when I questioned decision making processes that revolved around who you were rather than efficiency. Consecutive Labour Governments in Israel were baling out the kibbutzim that were accumulating increasing debts. I recalled Margaret Thatcher once famously saying that, with Socialism, you eventually run out of other people's money. We left kibbutz and made our way to the coastal town of Netanya.

This did not stop me voting Labour at each Israeli election. I shared the Shimon Peres dream of a New Middle East in which Israel would play a leading role in raising the prosperity and happiness of the peoples in the region. Even with the violent irritation of an Arafat-led Palestinian uprising, I shared the Israeli leaders resolve to work towards a solution.

My formative experiences were a strange mix. I was a prominent runner in Israel competing in distance up to and including the marathon. I was the originator of the Sea of

Galilee Marathon which has the reputation of being the lowest marathon in the world as it is located below sea level.

I took a group of Israeli runners to participate in the 1982 London Marathon. I arranged a meeting for them with the Israeli Ambassador at the Israeli Embassy in Kensington. Shlomo Argov told us how he regularly jogged around nearby Hyde Park. I knew that, after my return from London, I had a stint of army reserve duty. Every Israeli has to do army service. This includes two monthly periods of military training. Shortly after my return I was shocked to hear that Shlomo Argov had been the target of an assassination by Palestinian terrorists outside the Dorchester Hotel in London. Although he wasn't killed, a bullet had severed a nerve and this able diplomat became a vegetable.

This incident was the final straw for an Israel that had been reeling from incessant attacks by Arafat's terrorists who were then based in Lebanon.

Arafat and his forces had been chased out of Jordan when they tried to usurp the Hashemite leadership. Arafat had created a state within a state (much like Hizbollah achieved in Lebanon) and had attempted to overthrow the rule of King Hussein. In a bloody battle, what was to be known as *"Black September,"* Hussein's forces succeeded in putting down Arafat's revolt and threw out the surviving Palestinian forces. Arafat found refuge in Lebanon where he proceeded to destabilize that country by threatening the weak regime and attacking Israel. He brought Lebanon to civil war while firing rockets at civilian targets in the north

of Israel. Repeated ceasefires were imposed but Arafat's forces violated them with two hundred and seventy attacks on Israel in an eleven month period in 1981in which twenty nine Israelis were killed and more than three hundred injured. The terror attack against an Israeli diplomat in London internationalized Arafat's terror campaign and left Israel no choice but to respond.

On 6th June 1982, the IDF entered Lebanon with the sole purpose of ending the suffering of Israeli citizens living in the north of the country by driving Arafat and his terrorists out of that country and away from Israel. As the IDF entered Lebanon I went with them.

I can report that we were welcomed like a liberating army as we drove up the coast road towards Beirut and then into the Shouf Mountains. The Lebanese had had enough of Arafat's dangerous interference in the affairs of their country. This feeling dissipated as the war dragged on. Ariel Sharon had encouraged the inefficient and poorly armed forces of the newly elected president, Bashir Gemayal, to take charge of his country. His Christian militia, known as the Phalangists, took on the PLO in small battles in and around Beirut. In the final days of the war, a war named "Operation Peace of the Galilee" by the Israelis, the Phalangists received permission from the IDF to conduct mopping up operations in the Sabra and Shatila refugee camps. They exploited the opportunity to take a vicious and deadly revenge on the Palestinian Arabs by murdering hundreds of them in cold blood. The result of this outrage was that Ariel Sharon was accused of war

crimes for the slaughter of so many innocent civilians. It is worth noting that Sharon was not in uniform. He was not even the Chief of Staff. He was Israel's Defense Minister. An in depth investigation into this incident found him not guilty or, as one cynical Israeli summarized the tragic event; *"Christians slaughter Muslim Arabs and they blame it on the Jews!"*

The troublesome Arafat found a new haven in Tunis. From there he continued to command terrorist operations against Israel. In September 1985, in response to the murder of three Israelis in Cyprus by Arafat's Force 17 terrorists, Israel launched a long range air attack on one of his beachside camps. Flying 1280 miles, eight Israeli planes destroyed Arafat's compound killing sixty terrorists. Unfortunately for Israel, and maybe the world, Arafat was not in the compound at the time of the attack. In 1988, Israel's Mossad assassinated Arafat's deputy, Abu Jihad, in a daring raid in the heart of Tunis.

By this time local Palestinians were questioning Arafat's leadership. They were working with the Israeli authorities while a distant Arafat was fighting his war of liberation against the Jews. In response to his failing appeal, on 14 December 1988, Arafat announced to the United Nations that he was renouncing terrorism, promised to recognize Israel, and accepted UN Resolution 242. The Israeli Government bought this lie. They brought him out of exile and allowed him to set up shop in Ramallah. Israel felt this would encourage a new era of cooperation starting with autonomy and leading to a two state solution.

There were many Israelis who said that this was doomed to failure, that Arafat was incapable of changing his spots from terrorist to statesman. They pointed to the clear signs of his treachery in Jordan and in Lebanon as proof of his perfidious nature. I was one who chose not to believe them.

Like most Israelis I was tired of the bloodshed and incessant terrorism. I shared the Peres utopian dream of a New Middle East of beneficial sunlight in which Israel would contribute to the region and people would look to us with delight. Some dream!

While Arafat was telling the world that he was working for *"the peace of the brave"* he was giving us the peace of the grave. He would talk peace abroad and terror at home.

The reality, for me, came on the evening of 1st June, 2001, when a Palestinian suicide bomber blew up twenty one Israeli teenagers outside a beachside disco in Tel Aviv. Another one hundred and twenty were injured, many seriously. I began to question and research why Palestinians, on their way to statehood, would continue to bomb us rather than cooperate with us to achieve their national aspirations. I began to listen more carefully to what Arafat was saying, not to a starry-eyed world but to his own people.

"We plan to eliminate the State of Israel and establish a purely Palestinian state. We will make life difficult for Jews by psychological warfare and population explosions. We Palestinians will take over everything, including all of

Jerusalem. Peace for us means the destruction of Israel. We are prepared for an all-out war which will last for generations. The victory march will continue until the Palestinian flag flies in Jerusalem and in all of Palestine."

"We will not bend or fail until the blood of every last Jew from the youngest child to the oldest elder is spilled to redeem our land!"

With words like these I removed the Peres rose-tinted glasses and replaced them with lenses of clear glass.

How was it possible to believe the pronouncements of left wing Israeli politicians who said that only by gestures and concessions is it possible to achieve peace if Arafat's words remain the cornerstone of Palestinian ambition? Yes, be for peace. Yes, be for two states for two people , but only when you have a pragmatic partner on the other side. Until today, this has not happened.

When, for me, the realization of Palestinian intent dawned I had to ask how the world refuses to listen to, or accept, what lies in store for Israel if these threats and intentions are real? How could the world turn a deaf ear to Palestinian pronouncements eagerly supported by left wing groups and governments? The anti-Israel, anti-Semitic pronouncements still resonate today.

How could Israel meekly surrender its sovereign rights without first demanding, as an absolute precondition, that the Palestinians accept the existence of the Jewish State of Israel within acceptable and agreed borders? It is blindingly obvious that the Palestinian Arabs still harbor a fervent

desire and ambition to eradicate Israel and claim it is Palestine. There can be no granting them any concessions, let alone land, until the incitement stops, until they begin to educate their children for peace, and until iron-clad security arrangements are made to safeguard Israel and accepted by both the Palestinians and the international community. It must be made clear and enshrined in international law, as a further guarantee and deterrent against breach of contract, that Israel will be legally justified in reclaiming any territory granted and transferred to the Palestinians in the event that they indulge in terror or military warfare against the Jewish State.

Arafat was notorious for his scheming. He set up rival terror gangs under his patronage rewarding them for successful murderous attacks against Israelis. His patronage kept Palestinians in a state of Arafat controlled rivalry.

On 22 January, 1995, Israel experienced the first double suicide attack when two Palestinians detonated themselves at a busy bus terminal at Beit Lyd in central Israel close to Netanya. Islamic Jihad took responsibility for this attack that killed twenty one young men and women and wounded a further sixty nine.

Palestinian terror began to strike Netanya on 7th November 1999 when three pipe bombs exploded by the High Court building injuring twenty seven people. 2001 saw an intensification of terror attacks on my home town. The coastal resort town of Netanya became a convenient target for Palestinian terrorist coming out of the nearby town of Tulkarm. Only a fifteen minute car ride it was easy

for Arafat's murderers to deliver their cargo of gunmen and suicide bombers to their target – any crowded civilian target would do.

New Years Day 2001 would announce their intentions. Hamas planted a car bomb on busy central Herzl Street. Fortunately no one was killed though fifty were injured by the exploding vehicle. It happened on a dark early evening. I was in my office on Herzl Street when an orange glow temporarily lit up my window, then a large explosion, followed by a silence that seemed timeless. Suddenly, screams and the sound of people running as they fled from the scene of the carnage. I went out to see what had occurred and if I could help. The scene was something out of a Hollywood movie. Cars were burning, wreckage strewn across the street, a smoldering tire rolled past me, and I was a hundred yards away from the blast. The instant help of locals was incredible. As I ventured towards the point of explosion the injured were already being treated by shopkeepers or had been ferried to the local hospital by caring citizens. Within moments the police arrived to herd people away from the area as a precaution against a second bomb and to preserve the scene for forensic experts.

This was soon followed on 4th March 2001 when a Hamas suicide bomber blew up three civilians and injured sixty five again on Herzl Street in Netanya. Two months later, on 18 May 2001, yet another Hamas suicide bomber was delivered to kill five shoppers and maim seventy four people at the entrance to the HaSharon Shopping Mall on

Herzl Street. Islamic Jihad tried to blow up schoolchildren outside the ORT school in Netanya on 30th May 2001 when their car bomb exploded injuring eight teenagers.

2002 saw a deadly escalation of terror attacks in Netanya. It began on 9th March 2002 when Al-Aqsa gunmen opened fire on tourists at the Jeremy Hotel. They killed two people including a child and wounded fifty more.

Then, on 27 March 2002, the most deadly and significant attack took place in Netanya. Called the Passover Massacre, a Tulkarm Palestinian terrorist, who had once worked at the Park Hotel, personally delivered his explosive package to worshipers who had gathered in the banqueting hall to celebrate the Jewish festival of freedom and redemption from oppression to self determination in their own land. A member of Hamas, he succeeded in murdering twenty two people, including elderly Holocaust survivors, and injuring a further one hundred and forty people, many seriously.

I had passed the Park Hotel that horrible day on my way to my daughter's home in Kfar Yona, half way to Tulkarm, to celebrate Passover with my family. As we were preparing the table for the traditional Seder service I saw scenes of Netanya on her TV out of the corner of my eye. We were horrified with the breaking news of this attack. We raced through the ceremony of Pesach that echoes eternal prayers of thanks for our deliverance from evil and thanks for our freedom painfully aware that yet another attack had taken place on our freedoms in our homeland.

It was a significant moment for Israel and for me, personally. Together with two prominent Netanya figures, we formed an organization to help the growing number of terror victims in our town. I met many of them and was constantly moved by their plight and suffering. In this role I brought several organizations to Netanya and to the Park Hotel. For days after the awful event the banqueting hall remained in ruins. During the first week the recessed dance floor still floated in a mix of wine and blood. A dinner knife, that had flown from the table by the impact and power of the explosion, was speared in the concrete ceiling. Visitors wept. They recited prayers. They lit candles. The wanted to meet the survivors and hear their stories. I saw how damaging it became for the victims to constantly relate their experiences. As one lady, who had lost her husband, told me she had to increase her medication after each recital I decided to protect them from what was becoming, to put in brutally "terror tourism." We had to leave our people in peace, helping them with psychological counseling and group therapy ably and professionally provided by Dr. Ronny Berger and his team at NATAL, the Israeli trauma centre for terror victims. We heard that organizations, better placed and connected than us, had raised millions of dollars. I can vouch that precious little of this came to Netanya terror victims although the Park Hotel attack had been the catalyst for fund raising by them. Top American lawyers came to sign up our local terror victims to class action law suits against the Arab Bank that had been a conduit for Palestinian terror funding. To this day the Netanya terror

victims have not seen a penny. This may be due to the fact that the legal action has not yet been settled. The wheels of justice turn slowly in America. The US authorities and Federal Government are not doing enough to stem the flow of fund raising that is taking place in mosques around America for terror groups like Hamas. Neither are they sufficiently vigorous in investigating or prosecuting the obvious fund raising for Palestinian terror that is going on under their noses. The same applies to Britain. Netanya terror victims have yet to have their day in court nine years and more after the murderous crimes committed against them in our small town.

The Palestinian terror campaign against Netanya continued unabated. Two months after the Passover Massacre terror struck once more. In a combined operation carried out by Hamas and the Popular front for the Liberation of Palestine, a suicide bomber walked into the fruit and vegetable market and, in the explosion, killed three people and injured fifty nine. A guy who worked with us was permanently injured in the blast. He has subsequently died. Then we had a near miss, a miracle.

My wife left the office to go to the main shopping mall to buy gifts for our grandchildren ahead of our Shabbat visit to them. I received a phone call from our daughter that she had bought what we wanted to give them. I called my wife and told her to save her money and to come back to the office. Shopping is a magnet to her. Nothing stops her from her favorite habit. Our grandchildren may have been supplied but there was her own curiosity to be satisfied. A

rare decision to turn back may have saved her life. As she recalled, within moments of turning around she heard a terrific explosion behind her. Both she and the suicide bomber had been approaching the mall entrance from different directions at the same time. This Islamic Jihad bomber blew himself up at the same mall entrance that had been targeted four years earlier. Five local citizens were killed and seventy were wounded.

In Israel, staggering under a massive campaign of Palestinian murder, your life could rest on a split decision. Should I go shopping, or not? Should I meet my friend at the coffee shop or restaurant, or not? Should I walk, or go by bus?

Yasser Arafat incited and encouraged his people, including Palestinian children, to martyrdom at the same time as he was telling the international community what a brave peacemaker he was. Muslim clerics, like Sheikh Ibrahim Mahdi, focused their efforts on praising suicide bombers. In words repeatedly aired on Palestinian television he encouraged the sacrifice of children for the Palestinian cause as being acts of martyrdom against Israel.

"All weapons must be aimed at the Jews, at the enemies of Allah, the cursed nation in the Qur`an, whom the Qur`an describes as monkeys and pigs. We will blow them up in Hadera. We will blow them up in Tel Aviv and in Netanya."

"We bless all those who educate their children to jihad and to martyrdom."

We, in Netanya, knew that Arafat and his disciples meant what they said. Meanwhile the world community was imploring Israel to take further steps towards peace. Subsequent Israeli governments accepted their demands and made gestures and concessions. Palestinian terror continued.

Increasingly people began to be persuaded by the Palestinian argument. Despite the ongoing wave of terror they created an efficient propaganda machine. They not only attacked Israelis with their suicide bombers, terror, and rockets they defied a world with a charm offensive portraying themselves as victims. The world overlooked the dead and maimed of an Israel constantly under terror siege. Instead, they took the Palestinians to their hearts. They adopted the slogans and sound bites and set off in campaigns on their behalf.

It was staggering to me that we were suffering so much yet no one heard our screams. If these pro-Palestinian human rights activists acted to bring the Palestinians to the table and agree with us an equitable peace their actions would have been a blessing. Instead, they used their actions to hurl abuse and hate against us. One thing they are not is peace activists. Their hard core are radicals of the far left in love with violence and radical causes. It's a blood feud for them. Even when they undertake so-called peace campaigns in support of the Palestinians it is done with passionate hate and violence towards Israel.

An increasing part of their campaign has been not only to promote the Palestinian agenda but, to define their case, they demonize Israel.

With the demonization came actions against Israel, projecting it as a brutal oppressor and occupier whose actions must be criminal, whose products must be boycotted, its leaders arrested, its soldiers prosecuted as war criminals. It was the demonization of the Jew that was the prelude to the next stage of their demise in Nazi Europe, namely their elimination. This became a deliberate part of the offensive against Israel – the elimination of the Jewish state, stage by stage. It began by the adopting the Palestinian message, not to champion a desirable peace between two peoples but to eliminate one of them in favor of the other. It continued to demonization, then to boycotts, and on to delegitimization, in order to set up a weakened, isolated, Israel for the final coup de grace – the final solution of the Jewish problem in the Middle East.

This campaign was heartily promoted by Muslim students, ably backed by left wing activists and misguided liberals.

Ehud Barak, Israel's Defense Minister, stated that delegitimization is a strategic threat no less than Hamas and Hizbollah. I have mentioned elsewhere in this book who is behind BDS Movement and the flotilla activists? It is an alliance of left wing radicals that speak the language of anti-imperialism, anti-Western, anti-American, anti-Zionism, anti-establishment, linked to the Palestinian cause. Their core beliefs are that Israel is on the wrong side. Israel, for them, is an imperialist stooge while the Palestinians are weak, oppressed, and automatically just no matter what they

do. *"We are all Hizbollah now!"* as seen on a banner at an anti-Israel rally in London. They are opposed to Israel's existence. They are opposed to compromise. They are opposed to a two state solution. Their violent beliefs were reflected in a Socialist Workers journal of 2008.

"From the standpoint of Marxism and International Socialism an illiterate, conservative, superstitious, Muslim Palestinian peasant that supports Hamas is more progressive than a liberal, atheist, educated Israeli that supports Zionism, even critically."

The hand of the plotters is seen etched in the Arab uprising. It is the combined organizational force of International Socialists, Marxists, and Islamic Socialists. The pattern of entrenching their grassroots in universities among the impressionable students and reaching out into the wider world has spread from Palestinian support to regional regime change in the Middle East. This is the camp to which mainstream Europe, and increasingly America, have misguidedly attached themselves. The agenda is not regional peace but global domination.

At its core, they are not only anti-Israel they are anti-democratic. This type of thinking is inimical to democracy, be it, social democracy or liberal democracy. Their objective is to delegitimize the State of Israel, bring about its internal collapse, as they think they did in South Africa. They intend to weaken the ability of Israel to respond militarily to terror and demoralize it by putting it under sanctions and economic pressure. The way they are doing it is a civil society campaign of boycott, divestments, and

sanctions. They frame Israel as always the aggressor whose actions can never be justified, whereas Palestinian actions are automatically just because they are weak and oppressed. Their aim, to eradicate the Jewish State, will not get them far in mainstream Europe, never mind America, so their technique for advancing their agenda is to hide that agenda, to blur that agenda. Instead they speak the language of the middle ground and human rights. They say things that sound reasonable to reasonable people.

They raise issues such as road blocks, settlements, the disproportionate use of force, but they do not raise them in the format of a reasoned debate. Instead of opening up the discussion by questioning whether force was applied disproportionately or not, or if the settlements are the real problem, or not, or if road blocks are about security, they frame these words and turn them into emotive expressions such as roadblocks equal war crimes, settlements equal apartheid, disproportionate force equals ethnic cleansing . That's not debate. That's demonization. They use it to close down the debate. It does, however, appeal to the middle ground who are swayed by visions of suffering and the emotional language being used. It makes it difficult for them to feel comfortable, to remain neutral.

The attempt is to put Israel beyond the pale. In order to fight this one has to look beyond the rhetoric, to look at the facts, to examine the core beliefs of the delegitimizers and ask them are they really for peace? Are they really for a two state solution? Or do they have a more malevolent agenda?

Why should we care for the occasional Marxist and Trotskyite? There aren't that many of them. They may have limited influence but their influence is limited to influential people, opinion makers, academics, writers, commentators, editors, trade union leaders.

The radical left also make the liberal left feel guilty. Those are the ones who can be nudged into feeling sympathy to those less well off than themselves. They are made to be aware that they are well off while others are suffering from oppression, namely the Palestinians. One way that the liberal left can feel better about themselves is by giving support to the cause of the more extreme left. That doesn't mean that they agree with everything they say but they introduce the language of *"Well, I don't agree with everything they do but I support their actions to end the oppression and occupation of the Palestinians."*

In order to justify this message they begin to take onboard the claims put forward by the activists. Later these claims are fired at Israelis or Israel supporters by the liberal left, the media, church leaders, and *"reasonable"* politicians who are quick to adopt the *"politically correct"* message. This is the method to convert public opinion that is effectively applied by the sophisticated manipulators of the Palestinian narrative.

They are unaware that they have surrendered to the platform of the hateful hard left who are in cooperation with a racist Islamist Palestinian agenda. It is important to engage the liberal left and, by reasoned argument, steer them away from the extremists and hard liners. This can be

done in a number of ways. If the BDS mob were really in favor of the development and advancement of the Palestinian Arabs why don't they sponsor joint projects between Israelis and Palestinians in education and sport. Instead of finding money for provocative and violent flotillas why don't they fundraise for worthy causes such as expensive medical procedures for Palestinian Arabs in Israeli hospitals. Israel has a charity *"Save a Child's Heart"* which performs heart surgery on people from outside of Israel including Palestinian Arabs and Muslims. Raise money for this, not for confrontation. Such activities would go a long way in creating the right atmosphere for future peace and cooperation. But these radicals have zero interest in such positive activities that conflict with their political agenda which is to drive a wedge between the two peoples, and not to unite them in pragmatism and reconciliation.

To the shame of the western community of diplomats and politicians they succumb to the stubborn vocal pressure amplified by the media and the Muslim diplomatic offensive and bend to the narrative that condemns Israel. International resolutions are passed that further isolate Israel and give the enemy (for that is what they have become) greater confidence and strength.

The campaign to remove Israel is relentless. It is not a campaign to impose peace, despite the pleadings of a few individual nations.

Now we have the looming Iranian nuclear threat. The impotent diplomatic world, unable to face the reality of an

Israel under siege, is incompetent to face the reality of this clear and present danger. There is a Jewish expression, born out of a long history of persecution.

"Better to listen to the threats of your enemy rather than the promise of friends."

There is nothing right-wing in being patriotic. You are just right. There is nothing right-wing in standing for the truth. You are right, in its purest form.

The Bible is always a place for inspiration;
Ecclesiastes 10:2 (NIV):

> *"The heart of the wise inclines to the right,*
> *but the heart of the fool to the left ."*

I was left. Now I'm right.

NATIONALISM IS A GOOD THING

Nationalism is not a bad thing. You can be patriotic for your country and still respect other countries ethnicity, culture, and traditions. You can be patriotically nationalistic about your country and still be tolerant to minorities within your society, subject, that is, to them being tolerant, respectful to your national values and heritage (if you still have any), and integrating themselves into your society.

I live in Israel, support the England football team, yet also admire the soccer skills of Brazil and Spain. That, for me, is appreciative globalization. It is not throwing away my values for a common good.

Don't you cheer wildly for athletes from your own country at the Olympic Games? Don't you proudly chant your national anthem and go weepy with the success of seeing your national flag being raised in victory? That is an outward sign of patriotism. Yes, nationalism is fine. It is globalism socialism that is such a defeatist mess.

This utopia of nothingness lead heads of religion to abandon their nationalism, the original core values of their faith. Instead, they convert them into a global socialism.

Universal dreamers cut the ties that bind to drift free in a world of harmony that leaves them anchorless and rootless.

I blame Yoko for splitting up The Beatles. I loved The Beatles. I loved their music. They were an integral part of my life at one stage. I was involved in the pop scene back in Manchester. I had a group that once replaced The Beatles at a little gig when the lads from Liverpool had just begun their rise to immortality. They were never the same when John Lennon shacked up with Yoko Ono. Some people said they were about to split anyway but I thought, at the time, that she was an interfering busybody. She attended their recording sessions. After that they weren't the Fab Four any more. Pity!

John wrote fabulous songs both with Paul and also alone. He wrote one beautiful lyrical song the words of which resounded round the world. If Yoko Ono split The Beatles, the message behind his song, *"Imagine,"* split the world.

The words became a global anthem, a philosophy that has weakened us. It has made us vulnerable to those who ride this ideal to further their not so utopian aim – world domination. Lennon reflected the mood. He expressed the political move to nowhere, when he wrote *"Imagine."* Oh, if only his words became real. Instead, the message did not reflect anything achievable. His words led a naïve world down the path to self destruction.

> *"Imagine there's no heaven*
> *it's easy if you try*
> *no hell below us*
> *above us only sky*
>
> *imagine all the people*

living for today...
imagine there's no countries
it isn't hard to do

nothing to kill or die for
and no religion too
imagine all the people
living life in peace...

you may say I'm a dreamer
but I'm not the only one
I hope someday you'll join us
and the world will be as one

imagine no possessions
I wonder if you can
no need for greed or hunger
a brotherhood of man

imagine all the people
sharing all the world...
you may say I'm a dreamer
but I'm not the only one

I hope someday you'll join us
and the world will live as one."

"Imagine no possessions. I wonder if you can."

No John, I can't, and neither could you. Not with your four apartments in the Dakota, five luxury homesteads, one hundred thousand head of cattle, and a yacht. You were not exactly preaching by example there, John. Actually, you deserved them. Your talent enriched us. It certainly enriched you. You deserved the wealth.

We all strive for a better life. Wealth and possessions are part of that. But living your lifestyle and writing those

words were hypocritical. They form the basis of a hypocritical world that swirl around the lyrics and philosophy of *"Imagine."*

> *"Imagine there's no heaven and no religion too."*

So, people abandoned their faith at least in secular Europe, and what has that led to? Faithless people with no spiritual anchor.

> *"Imagine all the people living for today."*

So, people took credit, spent like there was no tomorrow, and accumulated the debt that is causing today's chaos.

> *"Imagine there's no countries. It isn't hard to do."*

Yes, it is. Countries are the bricks of a civilized world. Without them, the world falls apart. Do they really believe by relinquishing their national pride for a universal paradise it will prevent greed and hunger better than by individual nations working together?

The song was saying drop your pride in your nation's history, open your gates to the world, and let them all in, take care of them, lose your identity for the global good and, at the same time, save the world. Who is going to pay for all this? George Soros? Or you?

I refuse to. I don't want to take in the world's rejects or those who wish to exploit our nation's benefits but who refuse to conform to our national heritage and values. Does

that make me a racist, an oppressor? Am I, therefore, guilty of human rights crimes? Does it mean I have no values of love and peace? I don't think so.

I am ready to defend my country. I am ready to fight and die for my homeland, my family, my society, my values, because they are mine and nobody is going to take them away from me. Does that make me a fascist?

Lennon dreamed of a brotherhood of man, a world that will live as one. This may be the anthem of the global multi-culturalist. It is also the anthem of Jihad, except they definitely believe in one religion. So they are in conflict. The two may be united today to achieve a global village, but conflict will be the inevitable end when one side asserts its agenda on the other, and we know who that winner is going to be, don't we?

Lennon wrote *"Imagine."* Today his song should be renamed *"Paradise Lost."* True paradise comes from each nation being true to itself and being respectful of different cultures. If you want to see an example of a global village gone wrong just look at that Tower of Babel called the United Nations. Beginning life as the shining hope of a united world for the betterment of mankind, it has become a darkened chamber of prejudice and the perpetuation of suffering.

Oh, I know they make speeches about how they save the world but the results of their councils and the constitution of their members resound with hypocrisy and failure. UNWRA calcifies refugees instead of eradicating this phenomenon.

UNHRC has countries like Libya, Pakistan, and Cuba on its board, and they condemn Israel, the only liberal democratic nation in the region, more than any other regime or dictatorship. When Saudi Arabia is elected to the new UN women's committee you know your organization is in deep trouble.

An amazing but little known fact is that despite the fact that Israel receives wall to wall blanket condemnation at the United Nations it is the 31^{st} largest contributor to the United Nations budget.

There ought to be a new rule at the United Nations. Those who don't pay, don't say. There is an expression, either put up or shut up! At the UN, this should apply not only to financial contributions, but to member state's individual examples on human rights, terrorism, humanitarian aid and development.

Parts of Europe and America have woken up to the impending disaster caused by unrestricted immigration linked to national neglect. They see globalization as one of the factors that have led to the migrancy and socialism that is damaging their own culture and economy. They see the political campaign for a new world order, backed by socialists, liberal dreamers, church leaders, financed by misguided governments and malevolent characters such as George Soros. They see this as being a gift from heaven for a massively powerful Islamic Trojan Horse.

The useful idiots, as Soviet sympathizers were once described by Lenin, are paving the way for the coming global caliphate. They weaken the foundations of their own

society. They knock down all resistance to globalization, acting as eager ants and front men for the army of Islam to take over at a later stage.

The Islamic invasion infiltrates every vacant nook and cranny that opens up to them.

Their progress is constant and timeless. They have patience though some, impatient to achieve glory, resort to violence. This statement is not written out of hatred. It is an expression of the fear of many based on what is happening before their eyes.

Let me state clearly. There must be tolerance for differing cultures and faiths – up to a point. That point must be when tolerance is converted to weakness and an appeasement is employed to question and change national values. A Spaniard has no claim to challenge the national values of France if France is not imposing its national values on another nation. This mutual respect is the cornerstone of natural harmonious nationalism.

Had Muslim immigrants integrated into the society of their host nations, had they accepted the norms and standards of the countries to which they chose to belong, had they been tolerant and sympathetic to the nations that welcomed and accepted them, giving them welfare and social benefits as other ethnic minorities had done before them, there would be no phobias, fears, or alarms.

The large scale immigration of blacks from Africa and the Caribbean into Britain was initially met with a degree of trepidation and some racism but, in the main, this has faded as blacks are integrated and accepted into British society.

They are admired and respected in many fields where they have accomplished success. There has been no fear, however, that these good citizens would look on their host nation, as they arrived and took their benefits, as Dar al-Harb, a House of War, to be molded and converted to their culture. Instead, they accepted and adopted the standard norms of British society while maintaining privately their own individual culture.

The fault lies squarely at the door of ambitious representatives of Muslims who demand in strident voices changes in society and from the establishment that upsets and disturbs the population. When this is backed by threats of violence the population rise up to face down the danger to their society. There is a demand that nations and cultures change their character, drop their values, and there is rebellion in the air. Lines are being drawn in the sand but the invasion proceeds with great determination.

The shrewd ones prefer the stealth approach. They remain invisible as rules and laws are introduced to protect their interests. They impose themselves by first electing proxies to push their agenda before gradually taking over positions of power and influence. They make publicized statements about perceived ills of public, foreign, and social policies of the establishment, making it sound as if they speak for the common good when, in effect, they wish to impose their programs and laws onto society.

The world as we know it is being destroyed, deliberately, by these people. They are ably supported by nations who have abandoned their history, jettisoned their

religion, and are drifting aimlessly in a multicultural sea. Some are coming out of their self induced stupor of global stupidity and are shocked to see the way the world, and their country, is changing.

They scream in horror at what is transpiring before their eyes and are told to pipe down and not disturb the reverie. But they don't. They continue to speak out and become active to reject the invasion of alien influence into their society. they attempt to change, often amateurishly, the national course and discourse back to its original worth.

The Tea Party movement in America, Geert Wilder's Freedom Party in the Netherlands, the English Defense League in Britain are not radicals. They are seeing their country being stolen from them. They are saying *"I want my country back!"* They are being told to quiet down, to take another puff of the peace and love pipe and everything will be fine. No, it won't! These people are being called racist, fascists, and Nazis. No, they are not. They are patriots with love of country, true to core values that are being snatched from them. They are trying to wake up their countrymen. They are trying to drag their countries back to the national values they cherish, back to their original source.

They are a small minority, the boisterous ones. The mass of the population in Europe and America remain silent, but they are watchful, they are worried, they are supportive. They do not express their fears on the streets in noisy demonstrations. They do so at the ballot box. This is

why we are witnessing a swing to the right in Europe, America, and in Israel.

There are many nations that support Israel. So do the EDL, Geert Wilders Party, and the Tea Party. They see Israel as an example of a nation that is being attacked and humiliated for holding firm to original values and faith. They see Israel, and themselves, as nations under siege, resisting the plunder of heritage and land. They admire Israel for its fight for self determination and its principles.

Increasingly, the nations and politicians that admire and support Israel are based in the centre or to the right of the political spectrum. It used to be the other way round. A few may have had a fascist, or neo-fascist past. One example is Gianfranco Fini who succeeded in transforming his neo-fascist Italian party into a post-fascist National Alliance. As a foreign minister, deputy Prime Minister, and President of the Italian Assembly, he became one of Israel's and Italian Jewry's most reliable friends. While some European liberals perform intellectual fraud by embracing far left and Islamist cohorts the centrist and centre right identify with Israel's dilemma. They are not fascists or Nazis. Nazis and fascists, may I remind you, were those who hated and persecuted the Jews. They chose the Jews as their first victims for annihilation before moving on to attempt to conquer the world. Isn't this the Islamic message today?

I ask you: Who are the ones who are attacking the Jews today? Who are the Nazis who are murdering Jews today, because they are Jews? Who are the Nazis who are

inciting hatred against the Jews today? Who are the Nazis who are spewing anti-Semitic slogans and producing Goebbels-type propaganda against the Jews and Israel today? Who are the Nazis that vow to destroy the Jew among nations? It is they who are the true Nazis and racists of our time, and not the patriots who rise up in defense of their country. The battle is over nationhood.

There is another Beatles song. Remember the one that goes:

> *"All we are saying is*
> *give peace a chance"?*

Ah, if only the activists were pressuring Israel for the benefit of a mutually assured peace in the Middle East. Sadly, it is not so. Instead, the lyrics to their song is *"All we are saying is that Israel is a racist, Nazi, apartheid regime guilty of the worst war crimes and human rights abuses!"*

Israel has recognized the right of Palestinian Arabs to self determination. Why do the Palestinians still refuse to recognize Jewish self determination in Israel? Some say they already have a state in Jordan. After all, Jordan was carved out of a Palestine that should have gone to the Jews according to the San Remo Declaration of 1920 and the League of Nations resolution of 1922. In addition, the majority of Jordanians are Palestinian Arabs. So I ask the question: How come the Palestinian Arabs are not screaming *"Occupation!"* at the Jordanians? They are occupying a tract of land six time bigger than Israel, a tract of land that was Palestine. A significant number of

Palestinian Arabs have family living in Jordan. Their familial connections are there. It makes sense to me. So, why the silence? Why do they, instead, turn their attention only to the Jewish state? As if we don't know the answer. It is clear they want a second Palestinian state.

This leads me to my next and crucial question: Is this new state going to be the end of the story? Or is there going to a violent demand for a third Palestinian state, namely the end of Israel?

Millions of Arabs and others see Israel as occupying holy Muslim land. They claim to want the whole of Palestine and that includes Israel. You will read sufficient evidence of this in this book.

The Palestinians brainwash themselves that Israel doesn't exist, shouldn't exist, won't exist in the future. This is confirmed in their refusal to recognize the Jewish state of Israel. Prime Minister Salim Fayyad, a moderate Palestinian according to all descriptions, walked out of discussions rather than sign a document that declared the aim of negotiations is to establish two states for two peoples.

Their refusal to sit in direct talks with Israel over critical issues, and their new tactic of obtaining international recognition for Palestine without compromising on borders is an indication of their long term intent. There is a growing list of nations who, despite the high risk that peace talks could be stalled indefinitely by their move, announce their impending recognition of a state of Palestine. This was clearly defined in a Jerusalem Post editorial on December 9, 2010:

"The sides are supposed to be working towards a two state solution. Not merely two states but two states whose conflict is at an end; an independent Palestine not merely being established, but being established in the context of a reconciliation with Israel.

Abbas's (Palestinian President Mahmoud Abbas) ongoing attempt to seek recognition of Palestine without presiding over a substantive process of reconciliation with Israel is a type of escapism. It ignores the need for Palestinian society to undergo an internal process that includes coming to grips with the legitimacy of a Jewish state with secure borders living alongside a peaceful Palestinian state."

Earlier in this chapter I mentioned the stealth activists. Nobody embodies the stealth deceivers more than the originators of the BDS Movement. They recruit people to lobby outside, and inside, stores seemingly to highlight *"the plight of the Palestinian people"* and *"the oppression and occupation of Israel."* They place their activists to executive positions on committees, in unions, on the campus bodies, even in religious organizations. They take advantage of the rank and file members who are, generally, too complacent to take leading roles on committees and are usually too ill informed to take a judged position on matters far away from their personal needs, such as the Israeli-Palestinian issue. They are, in fact, the secular underground who covertly partner the Islamic agenda to remove the Jewish

abomination of the Zionist state by basing it on *"moral and human rights issues."* Anywhere you have conflict, human rights are put in jeopardy on both sides of the dispute. These can only be solved by ending the cause of the conflict. My question is if the cause of the conflict has been the failure to establish a Palestinian state alongside Israel, or is it the failure to establish a Palestinian state in place of Israel the cause of the conflict? The movers of the BDS clearly belong to the second camp. Their failure to prod their Palestinian leadership towards a pragmatic solution has prolonged the conflict. Therefore, they perpetuate the human rights crisis for both societies.

Earlier in this book I talked about Omar Barghouti and the BDS Movement. One may appreciate his concern for Palestinian society and encourage its development. However, nowhere in his words or actions does he pledge for a Palestinian nation alongside the Jewish state of Israel. His motivation, which he hides as do so many of the manipulative campaigners, is to encourage a Palestinian state in place of Israel.

The BDS Movement is small potatoes but what they stand for, the forces that are driving it, have major global significance. They may be focused on Israel but their enterprise is spreading across the whole of the Middle East into Europe and taking root in America. It is a potent mix of international Marxism combined with global jihadi Islam taking the route of *"social justice"* to achieve their aim. For them, Israel is one barrier to overcome before marching on

to bigger things. Nationalism and patriotism are the only roadblocks that can effectively stop them.

Nationalism is a good thing when it is based on peaceful recognition and respect of your existing neighbors. Nationalism for Palestinians can only begin when they recognize that basic fact. Which bring me back to globalization as seen through Islamic eyes. The Islamists are never happy with what they have got. They always want more. They want what isn't theirs. They want your nation, and they want mine.

Nationalism is better than globalism if your nation is important to you. If it isn't, throw it away. Give it to whoever wants to control it. I am talking about nationalism here, not imperialism. I'm talking about defending what is yours, not taking what is not. So Islamists are imperialists, as are social globalists.

Modern day imperialism is demonstrated by the arrogance of those who plan to take over the world in a form of social globalism. They may choose to call this movement progressive. It is not. It is regressive and shares the same base instincts as communism.

Jihad is a form of imperialism. They view the need to have their superiority expressed and executed in global domination. Only when their imperialistic aims have been met will they achieve the fulmination of their religious and political agenda.

Go to the Oxford English dictionary. Peruse the word *"imperialism."* It is given as *"a policy of extending power and influence through means such as establishing*

colonies or by force." Isn't that the definition of global jihad?

That is why people are rising up in certain nations to declare their nationalism. It is to fight against the imperialistic designs of Islamism, even when it creeps up in the form of liberation and national aspirations as it does with the Palestinians. You fight it by declaring loyalty to your own national core values.

Germany's Angela Merkel admitted in October 2010 that *"multiculturalism has utterly failed!"* She spoke out in fear of the fracturing of German society in which a growing minority of Turkish immigrants are challenging the German democratic model.

On Britain's growing internal ills Tony Blair *blamed, "the failure of one part of the Muslim community to create an identity that is both British and Muslim."* The failure, Mr. Blair, was the fault of governments such as yours who vested power in radical organizations, such as the Muslim Council of Great Britain, rather than speak directly to the Muslim population and tell them what is expected of them as British citizens. Instead, Britain now has a growing Muslim minority that feels disenfranchised due to the message they have received from a radical central organization, yet expects the government to continue giving them not only benefits but to cater to their political demands both internal and external.

The tail is now wagging the dog. The reason this has happened is because the British leadership no longer know

who they are and what they represent. They have totally surrendered and lost the plot.

Great Britain wanted to show the world how great it was by flinging open its doors to all and sundry. Now they see how wrong they were as they pay the price that comes with a deluge of uncontrolled immigration.

Blair then turned his attention to the European leadership, of which he was, and still is, a player.

The European establishment's refusal to address the problem of a developing Islamic supremacy in Europe, and its determination to promote a statelessness for the global good, is causing millions of Europeans to abandon entrenched political parties and turning to anti-establishment and independent parties who are willing to speak up and act against the problem.

The President of the European Union, Herman Van Rompuy, made a speech at an assembly of European leaders in which he advocated that the time of the nation-state has ended. He is wrong. Van Rompuy represent the ideals of a Belgium nation that has failed as a united nation yet hosts the European Union, but he does not represent the feelings of those residing in other countries, and proud of, their national history and core values. On January 23 2011, tens of thousands of Belgians took to the streets of the Belgian capital calling for national solidarity in a nation that has collapsed internally. The Belgian centre right party is negotiating with the socialist party to form a coalition government to keep their nation intact.

Van Rompuy's speech displayed ingratitude to the American nation-state who, together with the nation-states of Britain, Australia, Canada, and others, came to save a collapsed Europe from a regime that wished to put an end to the nation states of Europe during the Second World War. His memory, it seems, is short. Or he wants to dissolve national identities by absorbing an increasing number of countries into a regional, and eventually, a global anonymity. Behind it all is a sinister ambition for global power in which Van Rompuy sees himself as a global emperor. Nationalism is a barrier to people like Van Rompuy with global ambitions.

Perhaps the most striking aspect of the widespread street rallies and demonstrations across the Arab world in January and February 2011 was the absence of any anti-Israel protest at the start of their street demonstrations. Insults hurled at Israel and America only appeared when the extreme Islamic elements took center stage. The core issues of the people were against their leaders and their form of governance, not against Israel and not against America.

The world had been convinced by all the international talking heads and "experts" that the Israel-Palestinian issue was the main source of unrest and violence in the Middle East, and that Israel was the sole cause of this violence and danger by its oppressive policy against the Palestinians. Sparked by the hate-Israel gang, illuminated by the Walt and Mearsheimer academic libel, much quoted by the US Chairman of Joint Chiefs of Staff Administration, Mike Mullen, spread by EU foreign policy chief, Catherine Ashton,

repeated in news sheets such as The Guardian, and repeated like a mantra on BBC and CNN political talk shows, it was always the case that Israel was responsible for all the ills and foment in the Arab and Muslim world. Remove Israel from the West Bank they say, stop building additional bedrooms in Ariel, give the Palestinians everything they demand, or else the Muslim world will rise up in violent protest and Israel will be to blame for the bloodshed. Well, the Arab world did rise up in protest and bloodshed. In January 2011, the Arab street erupted. From Tunisia to Algeria, and on to Yemen, Egypt, and Jordan, millions rioted in noisy, violent, protest and, guess what, they never mentioned Israel even once. Their grievances were solely against their own corrupt and repressive leaders. The oppression they were resisting was at the hands of their own Arab Muslim leaders, not the Jewish Israelis. The human rights violations they criticized were within their own society. Pointedly, they didn't even mention the Palestinians once. Why should they? Egyptians have a 40% unemployment rate and millions of Egyptians earn less than $2 a day. That's economically worse than the average Palestinian on the West Bank.

Those who called themselves *"experts"* convinced all who would listen that Arab despair leads to radicalism, which then breeds terrorism, and that the root cause of that despair was the Palestinian issue. Remove that issue from the table and there will be less despair and less violence. Rubbish!

Not only did the so-called diplomatic experts get it all wrong, not only were they caught with their pants down by

the sudden eruption and rapid dissolution of decades old regimes, what they also did not consider was that the *"moderate"* regimes were the first to fall. Hard line regimes such as Iran, Hizbollah in Lebanon, and Hamas in Gaza, tightened their grip on power while the more "benign" rulers of Tunisia and Egypt collapsed to the will of the people.

The message is clear. The instability in the Middle East was not about Israel. During the regional riots, Israel was a beacon of stability. Perceptions changed and, when discussing democratic processes in the Middle East during this stormy period, Israel appeared as the true beacon of liberal democracy in the region.

It's not about Israel. It's about the shape and character of the Arab and Islamic regimes. What do they want for, or from, their people? What do they want for their region? Is it peace, prosperity, security, and mutual recognition and respect for their neighbors? Or is it resentment, hate, radicalism, and the desire to remove a sovereign power from within their midst? If they replace their former regimes with democratic governments that truly represent the will and needs of the people then the region is in for a better future. If, on the other hand, extreme elements, such as the Muslim Brotherhood, take advantage of the power vacuum to impose their intolerant and undemocratic rule as has happened in Palestinian society with Hamas and with Hizbollah in Lebanon, then Israel will become the focal point of real conflict in the region as the radical arc of Islamic hegemony spreads across the Middle East. The

Middle East is at a critical juncture. There is the choice of a bright democratic future, or the dark prospect of rigid theocratic rule. The problems between Israel and the Palestinian Arabs are real and require solutions. They are not, though, the cause of the upheavals that have rocked the region and shaken the world.

The basic principles of Israel and Israeli society shone through the dark winter days of early 2001 when Arabs confronted their leaders. Israel forged their democracy on values that are sorely needed in the Arab and Muslim world today.

Jews have been led to nationality through two uniquely similar historical circumstances. It was no coincidence that the two seminal moments in Jewish history shared a common bond – the Exodus and the Holocaust.

The Jewish journey from oppression and persecution occurred at the Exodus from Egypt. The Jewish people were brought from the shackles of slavery to freedom in their own land. Thus began a journey of thousands of years that has linked Jews as a people, and as a nation, to the land of Israel bequeathed to them in the laws of the Torah. This unique experience was repeated when the Jews rose from the bondage of the persecution and oppression of Nazi Germany to create the re-establishment of their nation state in Israel, a state that had been enshrined in international law repeatedly in the San Remo Declaration, the League of Nations, and the United Nations. No other nation has had such reconfirmation of its legitimacy.

The Arab street is struggling to find the freedom from oppressive leaders and free themselves from the shackles of

poverty and hard-handed governments. They can learn from the Israeli model and find a better future by allowing Israel to share its bounty with them. The Arabs have numerous nations spread across the map of the region.

There is no other place on earth that Jews can fulfill their religious and national identity, except in Israel. The desire of the pioneering socialist Zionists was that, by normalizing the Jews in a state of their own, they would be accepted by the international community as a *"goy k'chol hagoyim"* – a nation like all other nations.

The expectation was that anti-Semitism would die as a result of the creation of a state in which the Jew need no longer to be a Jew – maligned and persecuted. Well, it hasn't. Nor will it ever be. It hasn't, because nothing will ever put an end to anti-Semitism.

Since its inception Israel has been attacked, stigmatized, and isolated. It is the Jew among nations. It finds no place as a member of the international community.

In the United Nations, which gave it recognition at a unique and temporary historic moment, Israel has no place in any of the regional blocs. Geographically, Israel is in Asia, but the Asian bloc countries blocks Israel. Its Arab neighbors are responsible for that. The non-aligned nations turn their backs on Israel. The Muslim countries see to that. Since membership to the Security Council depends on regional membership Israel is permanently prevented from being elected to it. Historically, the Jews have always been alone. Even when accepted into host nations, Jews have felt

the cold shoulder of hatred. Historically, Jews have thrived and advanced even under these circumstances.

The Jewish State of Israel will always be a uniquely individual nation. Its religious and moral laws make it stand out from all others. This does not make Israel a theocracy. The majority of Israelis are secular Jews but even they maintain the religious-national linkage.

Hebrew is the language of modern Israel. Respect is given to the Jewish holy days that are celebrated nationally. They have become an integral part of the rhythm of life of the Israeli calendar. Seminal annual events such as Holocaust Day, Memorial Day, and Independence Day take on religious and national significance.

Part of the world may define Israel from a biased, hateful, even anti-Semitic, perspective. Israelis see themselves as a proud religious, cultural, skilful, entrepreneurial nation. Nationalism is the natural tendency to protect ones identity, ethnicity, and self determination.

As for me, nationalism is a good thing. I love my unique nation and intend to defend it.

THE PALESTINIAN NARRATIVE – DEFYING COMMON SENSE AND REASON

The best way to forge the future is to reinvent the past. It's incredible how they can deny what's in front of their face. Thousands of years of history are there for them to see, in stone and coins and parchment and artifacts. Yet they close their eyes and deny it exists. When this relates to Jewish identity and culture what is the difference between this and Holocaust denial?

They kill us, destroy us, take or decimate our values, our possessions, and our history, and then they have the chutzpah to say we were never there. What evil intent is at work as they rob us of our soul?

In order to create a belonging to the land with any depth Palestinians rewrite a history which defies reason and evidence. The media and the diplomatic corps always use the Palestinian narrative as their starting point when defining history and describing issues relating to the Israel-Palestinian conflict. This may be because successive Israeli governments have been so incompetent at stating our case, while the Palestinians have been so good at cooking up a good story.

It is also true that what has been inflicted on Israelis does not merit the same media coverage and amount of

verbiage as Palestinian suffering. It could also be that pro-Israeli supporters, and there are many, are not as vocal, pro-active, or as good at initiating the headline making activities and demonstrations as the anti-Israel crowd.

In the same currently popular *"politically correct"* vein, I present a potted history of Palestine. It is an unraveling of events that exclude, as much as possible, the Jewish voice.

In keeping with today's biased reporting, the observations and statements made at certain points in history will be those of Arabs and notable non-Jewish witnesses. This will reflect a more accurate history by not allowing Jewish or Israeli observations from spoiling this presentation in their favor.

The Palestinian narrative would have us believe that Jesus was a Palestinian. No, don't laugh! This is true. They have actually said that – repeatedly. In fact, the Palestinian narrative began slightly more than thirty years ago and came out of the barrel of a gun – Arafat's gun.

Here is the actual history of Palestine, warts and all.

Almost two thousand years ago the Jewish nation of Judea was captured and destroyed by the Romans. Emperor Titus ordered the destruction of the Jewish Temple in Jerusalem. This was the second time that the Temple had been destroyed. The first time had been by the Babylonians (today's Iraq).

For a short three year period the Jewish Revolt managed to wrest control over Jerusalem but the might of

Rome proved too strong and hundreds of thousands of Jews were killed, deported, or sold into slavery.

When Masada fell in 73 C.E., it was the beginning of the end of the Jewish nation of Judea. When 960 Jewish men, women, and children, chose collective suicide on that desert mountain top, rather than Roman slavery, it terminated a Jewish rule that included kings such as David, Solomon, and Saul. They were not just names in the bible. They were men who ruled a Jewish nation and left us impressive structures and archaeology as evidence of their rule.

The Roman emperor Hadrian, an early model anti-Semite, cursed the Jewish people as he drove them into exile. He wanted to wipe out all evidence of a Jewish existence and connection in Judea.

Hadrian decreed that Judea be renamed *"Syria-Palestina"* after the Philistines, an ancient enemy of Israel that had roamed and looted the Mediterranean but had disappeared from the world more than six hundred years earlier. Echoes of events taking place today.

Although the majority of the Jewish population had been murdered or driven into exile, a vestige remained in the land. Living in secret and poverty they prayed that the Jewish people would return to reclaim their land. These prayers ring down the ages and are chanted in synagogues and homes in daily prayers today.

As I promised earlier in this chapter, apart from one or two notable exceptions, I have withdrawn Jewish statements and witnesses to the Holy Land in recent centuries to avoid

the protest that this history is biased in Jewish favor. I confine the brief historical observations to non-Jews and Muslims. This should reflect a "politically correct" version of history including predominantly Arab and Palestinian voices.

In 985 the Arab writer Muqaddasi complained that *"the mosque* (there was only one mosque in Jerusalem at that time) *was entirely empty of worshippers. The Jews constitute the majority of Jerusalem's population."*

In 1377, Ibn Khaldun, one of the most credible Arab historians, wrote *"Jewish sovereignty in the land of Israel extended over 1400 years. It was the Jews who implanted the culture and customs of the permanent settlement."*

Some people dispute that the Dutch cartographer, Adriaan Reland, ever visited the Holy Land. Some claim that he simply collected reports from other scholars and explorers who had visited the region during 1695-1696. Whatever the truth, he documented visits to many locations at the end of the seventeenth century. He wrote that the names of settlements were mostly Hebrew, some Greek, and some Latin-Roman. No settlement had an original Muslim-Arab name with a historic root in its location. Most of the land was empty and desolate, and inhabitants were few in number and mostly concentrated in Jerusalem, Acco, Tzfat, Jaffa, Tiberias, and Gaza. Most of the inhabitants were Jews and the rest Christians. The few Muslims were mostly the nomadic Bedouins. The Arabs were predominantly Christians with a tiny minority of Muslims. In Jerusalem

there were approximately five thousand people mostly Jews with some Christians.

Alphonse de Lamartine was a French writer, poet, and politician. In 1835, following a visit to the Holy Land wrote; *"outside the city of Jerusalem we saw no living object, heard no living sound, a complete eternal silence reigns in the town, in the highways, in the country."*

William Thackeray in 1844, James Finn, the British Consul in Palestine, in 1857, W.M.Thompson in 1866, Mark Twain in 1867, the Reverend Samuel Manning in 1874, and B.W.Johnson in 1892, all saw and reported on the complete desolation of the country outside of the few cities in the Holy Land.

In 1913, a British report by the Palestinian Royal Commission reported on the conditions along the coastal plain along the Mediterranean sea. *"The road leading from Gaza to the north was only a summer track, suitable for transport by camels or carts. No orange groves, orchards, or vineyards were to be seen until one reached the Jewish village of Yabna."*

The utter desolation, the total lack of population, save for the Jewish majority in cities such as Jerusalem, Tzfat, Tiberias, Acco, and Jaffa, as reported by non partisan and respected observers underscore the falseness of a narrative that claims Palestinian sovereignty and occupation on the land in history.

Battles were raging in the early part of the twentieth century that led to the downfall of the Ottoman Empire, an

empire that had ruled the Middle East for centuries. Even before the fall of the Ottoman control of the Holy Land Jewish organizations and individuals were making representations to reclaim the Holy Land as the national home of the Jewish people.

Theodor Herzl, born in Budapest in 1860, had suffered from anti-Semitism while studying law at the University of Vienna. He left in protest. As a writer he became the Paris correspondence of the Vienna Free Press, a liberal paper. He was interested in issues of social reform. During this time of social consciousness he was moved by the Dreyfus trial in France that threw France into a fury of anti-Semitism. Dreyfus, a French military officer, was found guilty of trumped up charges of treason. He was publicly humiliated by the military and by the French establishment. Rioters took to the streets shouting *"Death to the Jews!"* This event opened a new chapter in Herzl's life and in the destiny of the Middle East.

Having experienced and witnessed the disgrace of anti-Semitism he devoted his life and his writings to the future security of the Jewish people. He formulated the need for a Jewish homeland which he expounded in his book *"Der Judenstaat"* (the Jewish State) which he published in 1896.

His work led to the creation of the World Zionist Organization. At the same time organizations in Eastern Europe, such as *Hovavy Zion*, were active in recruiting and preparing young Jews to settle in the land of Israel as agriculturalists and to reclaim the desolate land for a future Jewish nation.

Herzl convened the first Zionist Congress in 1897 and was declared President of the World Zionist Organization. He told people, including world leaders, that the Jewish state in Palestine had been established at that congress. *"If you will it, it is not a dream!"* This famous Herzl quote became the Zionist vision in the late eighteenth and early nineteenth centuries.

What became known as *"the First Aliyah"* took place between 1883-1903. It was small in number. Twenty five thousand Jews fled Russia and Rumania to avoid anti-Semitic persecution and two thousand five hundred Yemenite Jews arrived to fulfill their religious dream. Most settled in the towns. Only about a quarter took to farming.

They were poor but were assisted financially by Baron Edmond de Rothschild.

An important immigrant during this initial Aliyah was Eliezer Ben Yehuda who revolutionized education and culture by resurrecting the ancient Hebrew language to become the national language of the Jewish state.

The Second Aliyah, between 1904-1914, was the springboard to Jewish nationalism by people reclaiming the land. Forty thousand Jews immigrated, again mainly to escape the mounting Russian anti-Semitic pogroms. They were idealists inspired by revolutionary ideas of the modern Jew, to the creation of a Jewish state through reclaiming and nurturing the land. They created the kibbutz. The first kibbutz, Degania, was founded on the shores of the Sea of Galilee. It celebrated its 100th anniversary in 2010.

Efficient progress had been made that by 2nd November, 1917. The British Government look favorably at the reconstitution of Palestine as the Jewish national home. This was enshrined in what has become known as the Balfour Declaration when, on that date, the British Foreign Secretary, Lord Arthur James Balfour, sent a letter to Lord Rothschild, declaring that *"His Majesty's Government view with favour the establishment in Palestine of a national home for the Jewish people."* The condition was given that this would not impinge on the civil and religious rights of non Jews in Palestine.

In effect, the Balfour Declaration was the Magna Carta for the national home in Palestine for the Jewish people.

Neville Chamberlain said, in a speech he gave at the Alexandra Theatre in Birmingham on 13th October, 1918, *"As great responsibility will rest on the Zionists, who before long will be proceeding with joy in their hearts to the ancient seat of their people. Theirs will be the task to build up a new prosperity and a new vocalization in old Palestine, so long neglected and misruled. They will carry with them the hearty goodwill of the British nation and its earnest hope that in their own country they may prove worthy of their past and of the great opportunity that has been given to them."*

At the fall of the Ottoman Empire an international conference was held in San Remo, Italy, to resolve the territorial disputes, and to decide on the fate and future of the territories previously ruled by the Ottomans, including Palestine. San Remo has become a forgotten event but, as it

relates to Palestine, it is highly significant. From 19-26 April, 1920, world leaders deliberated on how to allocate former Ottoman-ruled lands of the Middle East according to League of Nations mandates. The Jewish request for Palestine was on the table. There were also Arab demands for territorial sovereignty – but not in Palestine.

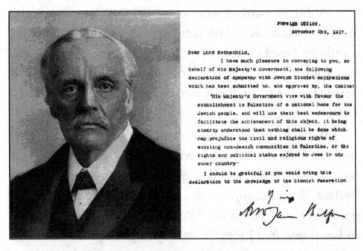

As a result, the San Remo Conference became the foundation document for the whole of the Middle East. It mandated the region into three areas;. Syria, Mesopotamia which became Iraq, and Palestine.

At San Remo, the Balfour Declaration was officially adopted as the basis for the British Mandate for governing Palestine. In effect, it created the legal existence, ownership, and sovereignty of the Jewish state in Palestine.

Sovereignty was vested in the Jewish people as a result of the San Remo Resolution which brought the Balfour Declaration into a binding act of international law.

This important fact needs repeating. The Jewish State of Israel draws its legal sovereign rights, not as a result of the United Nations Partition Resolution of the General Assembly on 29th November, 1947, but from the San Remo Resolution that was confirmed by the League of Nations on 24th July,1922.

Although borders were not decided at San Remo, the issue was discussed. The premise was that the boundaries should be based on the work done by George Adam Smith, the learned Scottish scholar and theologian, who had devoted his life to the historical geography of the Holy Land.

If, as an Israeli, you learn not only Zionism but also the internationally recognized legitimacy centered around the 1919-22 period you will be able to raise your head and declare *"I am occupying my land and proud of it."* I would go further and say to the Palestinians, as a strong majority in Israel say, that I may be willing to grant part of my land to them if they will be able to prove to me their desire to live in peace and security and recognize my rights, as described in international law, to my Jewish National Home.

Go back to our modern roots. The Palestine Mandate was a legal commission for the administration of Palestine. The draft was formally confirmed by the Council of the League of Nations on 24th July 1922 and it came into effect on 26th September 1923. It read:

"Whereas the Principal Allied Powers have also agreed that the Mandatory should be responsible for putting

into effect the declaration originally made on November 2ⁿᵈ, 1917, by Her Britannic Majesty, and adopted by the said Powers, in favor of the establishment in Palestine of a <u>National Home of the Jewish People</u>, it being clearly understood that nothing should be done which might prejudice the civil and religious rights of existing non-Jewish communities in Palestine, or the rights and political status enjoyed by Jews in any other country."

The text of the Balfour Declaration was adopted for this legal document.

Please note. The legal document gave legitimacy for the Jewish people exclusively to create their national home. Regarding non-Jewish communities, it ordains the protection of their civil and religious rights. Nowhere does it mention or include any sovereign rights for Palestinians, Arabs, Christians, or anyone else.

The document recognized the *"historic connection of the Jewish people with Palestine"* and gives this *as "the grounds for reconstituting their national home in that country."*

Note two aspects to this legal statement. First, they talk of *"reconstituting"* not *"constituting"* mind, but *"reconstituting"* meaning constituting for a second time their national home in that country, thereby acknowledging the four millennia unbroken connection of the Jews to the land. It legally empowered the Jews to legally establish their country in Palestine.

Emir Feisal, the most prominent Palestinian of his time, in agreeing to the creation of a Jewish State in

141

Palestine, said in 1919: *"The Arabs admit the moral claims of the Zionists. They regard the Jews as kinsmen whose just claims they will be glad to see satisfied."*

He added, *"No true Arab can be suspicious of Jewish nationalism and I say to the Jews - welcome back home."*

At that time there was no doubt that Article 22 of the League of Nations Covenant was linked exclusively to the Jewish national home as set down in the Balfour Declaration and confirmed at San Remo.

At that time everyone was aware of the contents and the intent, including Emir Feisal who wrote in his letter to America's Felix Frankfurter on 3rd March 1919, that he saw the development of Palestine into a Jewish commonwealth with extensive boundaries as agreed with Zionist pioneers, Chaim Weitzman and Nahum Sokolov, as *"moderate and proper."*

Despite the fact that Palestine was, justly, to be handed to the Jewish enterprise, on 16th September, 1922, less than two months after the confirmation of the admission of a mandate to establish the Jewish national home in Palestine, Winston Churchill succeeded in forcing through an amendment to divide the Mandated territory into two administrative areas namely Palestine to become the national home of the Jewish people, and what became Transjordan under the rule of the Hashemite family from Saudi Arabia. It stipulated that the Transjordan part of Palestine was to be exempt from the Mandate provisions for a Jewish National Home. He effectively carved out 77% of the original Mandated

Palestine and handed it to Emir Abdullah, thereby reducing the land for a Jewish national home down to only 0.23% of what had been the Ottoman Empire. The Arabs gained 99.37%. Many Jews and Israelis consider this a grave injustice.

This, then, is the legal basis of the Jewish rights of sovereignty over what had been Palestine, the Holy Land, and Judea and Samaria as they were known in biblical times. The Arabs were given sovereignty over Palestine/Transjordan as well as other parts of what had been the Ottoman Empire.

By this time the labors of the Jewish immigrants was attracting the attention of neighboring Arabs who came to seek employment and work. The British Hope-Simpson Commission recommended, in 1930, a *"prevention of illicit immigration to stop illegal Arab immigration from neighboring Arab countries."*

The British Governor of the Sinai (1922-1936) reported that *"this illegal immigration was not only going on from the Sinai, but also from Transjordan and Syria."*

The Governor of the Syrian district of Houran, Tewfik bey el-Hurani, admitted in 1934 that in a period of only a few months over thirty thousand Syrians from Houran had moved to Palestine.

Jews had lived peacefully under the Muslim Ottoman rule. Violence erupted with the incursion of stateless, foreign Muslim Arabs. They attacked Jews. The Hebron Massacre of local Jews in 1929 was done by foreign Arabs,

143

not by the established local families who had lived there alongside Jews for years.

Between 23rd and 24th January 1929, Arab rioters murdered sixty seven Jews and destroyed Jewish houses and synagogues in Hebron. The rioters were recent immigrants from foreign Arab lands. Nineteen indigenous Arab families, at great risk to themselves rescued four hundred and thirty five Jews by hiding them in their homes under order was restored.

Despite the removal from their grasp of vast tracts of land that had been designated as the Jewish national home in Palestine, Zionist and Jewish organizations continued to work on the creation of the Jewish state. They developed the infrastructure of governance though restricted by the British whose mandate obligated them to advance the Jewish cause.

The League of Nations was replaced by the United Nations. Instead of declaring the acceptance of the Jewish state, as obligated on them under international law and previously approved resolutions, the United Nations introduced to the General Assembly on 29th November, 1947 a partition plan to divide the already rump territory into two states, one for the Jews and another for the Arabs. This came about mainly due to the growing disinterest of the British Government in holding on to their failed mandate. The British had economic problems at home and an increasingly violent situation in Palestine. In the spirit of *"good riddance"* they worked through the United Nations to wash their hands of the mess they had created.

On 24 November 1947, at the Political Committee of the UN General Assembly five days before the vote, Egypt's delegate Heykal Pasha gave a clear warning: *"The United Nations should not lose sight of the fact that the proposed solution might endanger a million Jews living in the Muslim countries. If the United Nations decides to partition Palestine, it might be responsible for very grave disorders and for the massacre of a large number of Jews. If a Jewish state were established, nobody could prevent disorders. Riots would spread through all the Arab states and might lead to a war between the two races."*

The Partition Plan was approved by a majority of 33 votes to 13 against with ten abstentions. The Zionist leadership accepted the Partition Plan despite the injustice of being left with a pittance of what had been legally theirs. The Arabs though, through the Arab League, rejected the Partition Plan. They wanted all the land, including that given to the Jews. This is significant because their rejection and refusal kept in force the previous League of Nations Resolution that Palestine be the Jewish national home as the standing international ruling and law.

The first modern day jihad against the Jews was declared on 3rd December, 1947, when the imams at Cairo's Al-Azhar University called on the Muslim world to proclaim a holy war against the Jews. One student moved by this call was Yasser Arafat. Jews were attacked and killed in the rising violence against them. The US State Department did not want to provide the Jews with the means to defend themselves. So, on 5th December 1947, the

United States imposed an arms embargo on the region. This deprived the fledgling nation of the weapons they needed to repel the Arab invasion. The British, meanwhile, were providing weapon shipments and training to the Arabs. Jordan's Arab Legion was led by a British officer, John Glubb. British RAF planes flew with Egyptian squadrons over the Israel-Egypt border. On 7th January 1940 Israeli planes shot down four British aircraft.

On 9th January, 1948, a thousand Arabs attacked Jewish communities in the north of the country. Jews tried to repel violent Arab attacks. The United Nations blamed the Arabs for the increasing violence. This was admitted by Jamil Husseini when he addressed the Security Council on April 16, 1948; *"The representative of the Jewish Agency told us yesterday that they were not the attackers, that the Arabs had begun the fighting. We did not deny this. We told the whole world that we were going to fight."*

The Jews fought back. During the period between the declaration of the United Nations Partition Plan and the end of the British Mandate over one thousand six hundred Jews and Arabs had been killed.

On 14th May,1948, the British Mandate in Palestine officially ended. On that day the Jewish Peoples Council gathered in the Tel Aviv Museum and David Ben Gurion declared the establishment of the State of Israel. The next day British forces left Palestine.

In mid May 1948, five regular Arab armies invaded Israel in a coordinated assault. The young Zionist state

begged, borrowed, and bought whatever arms they could obtain.

On 28th May, 1948, the disparate fighting forces were merged into the Israel Defense Forces. The United Nations Security Council issued several calls for a cease fire. The Arabs ignored them.

The war raged until 7th January 1949 and the War of Independence was formally terminated on 20th July 1949.

Throughout the latter phases of the war, Israel gained strength, fought successfully and not only ejected the invading Arab forces but also captured and held some 5,000 sq. km. over and above the areas allocated to it by the United Nations in the original Partition Plan, with a considerable improvement in defensible borders.

The Six Day War of 1967 in which Israel was threatened by both Egypt and Jordan left Israel in control of much of the land that had been bequeathed to them in international law in 1922. The surprising thing was that when Israel was able to announce its legal rights and apply its sovereignty over all of the country west of the Jordan River after its victory in the war it did not do so, except in the case of Jerusalem. The Israeli Knesset did, though, pass an amendment to the Law and Administration Ordinance of 1948 by adding Section 11b stating that Israel possessed sovereignty.

It was only after the 1967 war between Egypt, Jordan, and Israel that saw the emergence of Yasser Arafat and the PLO. Suddenly these wars were promoted to have been

between Israel and the Palestinians, if we are to believe the developing Palestinian narrative.

Mohammed Abdel-Raouf Arafat was born Qudwa al-Husseini on 24 August 1929 in Cairo. Arafat's Fatah terrorist group dominated a growing resistance to Israel that had been nurtured by the Arab League. By its well publicized campaign of violence and murder, Arafat became the chairman of the PLO Executive Committee in 1969.

The narrative grew of a displaced Palestinian people that demanded the land that had been usurped by the Jews. They make the case that Palestine belongs to them due to their long history and culture. It is interesting to note that there is no Arab word for Palestine. Even the so called Palestinians do not have an original word except *"Filastin,"* a derivative of the English word. Most Arabs cannot even pronounce *"Palestinians"* in Arabic. It is not their natural language. They can't really be blamed because the Palestinian people never existed. There were Palestinian Jews, Palestinian Arabs, Palestinian Christians during the Mandate period, but no Palestinian state. The only state granted legal rights and sovereignty over Palestine were the Jews, as explained in this history.

There is no Palestinian language and no unique Palestinian culture. Here are just a few statements by Arabs regarding Palestine that prove my point:

1937 - The Arab leader, Auni Bey Abdul Hadi, told the UN Peel Commission, *"There is no such country as Palestine. Palestine is a term the Zionists invented.*

Palestine is alien to us. Our land was for hundreds of years a part of Syria."

1946 - Philip Hitti, Princeton's Arab professor of Middle East history, told the Anglo-American committee of inquiry, *"It's common knowledge there is no such thing as Palestine in history."* In his testimony before the same committee, Professor Juhan Hazam said, *"Before 1917, when Balfour made his declaration, there had never been a Palestinian question, and there was no Palestine as a political or geographical unit."*

1977. Zahir Muhsein, executive member of the PLO, said in an interview with the Dutch newspaper Trouw, *"The Palestinian people do not exist. The creation of a Palestinian state is only a means for continuing our struggle against the State of Israel."*

It is this message that continues to resonate with Israel in all its dealings with Arab and Palestinian representatives to this day. Nothing has been said or done to reassure them that the ultimate goal of the Arabs is not the destruction of the Jewish state. On the contrary, everything that has happened confirms this fear.

Joseph Farah, an Arab-American journalist, wrote, *"The truth is that Palestine is no more real than never-never land. Palestine has never existed as an autonomous entity."*

Walid Shoebat was a former PLO terrorist. He acknowledged the lie he had been fighting for when he said, *"Why is it that on June 4, 1967 I was a Jordanian and overnight I became a Palestinian? We considered ourselves*

Jordanian until the Jews returned to Jerusalem. Then, all of a sudden, we were Palestinians."

Syrian leader, Hafez Assad said, *"There is no such thing as a Palestinian people. There is no Palestinian entity."*

The founder of the PLO himself, Ahmed Shukari declared at the podium of the United Nations in 1956 that *"such a creature as Palestine does not exist at all."*

Azmi Bishara, the Israeli Arab leader accused by Israel of treason, said in a TV interview *"There is no Palestinian nation. It's a colonial invention. When were there any Palestinians?"*

Even Yasser Arafat admitted in 1970 in an interview with Italian journalist, Arianna Palazzi, *"The question of borders doesn't interest us. Palestine in nothing but a drop in an enormous ocean. Our nation is the Arabic nation. The PLO is fighting Israel in the name of Pan-Arabism. What you call Jordan is nothing more than Palestine."*

The 1970 admission by Arafat that Jordan is Palestine is factually true. It was established by the British on 77% of the land promised to the Jewish people by the League of Nations in 1922. The Palestinian people is an anthropological fabrication. It was devised as a *"Trojan Horse,"* as admitted by Feisal Husseni after the Oslo Accords, for conquering the land of Israel. The object of this propaganda is to blot out and forget the name and identity of the ancient biblical Eretz Israel, and to transform it into the land of *"the Palestinian people"* fabricated by Arab propaganda.

Israel is the victim of the most unprecedented fraud in history. The question needs to be asked. Why is the world courting this bluff? Why is the world hypnotized by this lie? Why are we they using it to lead Israel to nowhere except into a thicket of deception, rather than advancing a peaceful solution honestly, based on historical fact, giving credit and credence to whoever deserves it, while respectfully searching for a pragmatic path to peace?

It is true that the Palestinian case in made up almost entirely of lies and false perceptions of national deprivation. It is equally true that successive Israeli governments have seriously failed to make their case based on historic and legal rights. It is this twin failure that has led them, and the world, into decades of utter frustration and inability in solving the pace process.

No progress can be made until these core issues are faced and acknowledged by all parties attempting to unravel the Gordian knot that is the Israel-Palestinian conflict.

IT'S NOT THE JEWISH STATE OF ISRAEL THEY ARE DENYING – IT IS ISRAEL ITSELF!

There is a popular discussion that says Israel is not entitled to call itself the Jewish state. The grounds given are that to do so is racist and is yet another Israeli obstacle to progress in the peace talks. The Palestinian leadership has rejected any consideration of accepting the Jewish State of Israel. In fact, it is not the Jewish ethnicity of the state that they are denying, but the state itself.

Israel, as an internationally recognized and legitimate sovereign state, appears on the map, except maps used under the control of the Palestinian authority. Israel, geographically, does not exist – not on their maps, not in their schoolbooks, not On their official TV channels, or in their media. I repeat. I am not discussing the Jewish nature of Israel. I am talking about Israel itself.

In his excellent book, *"Saving Israel,"* author Daniel Gordis asks the key unanswered Question that haunts all Israelis. Is Palestinian nationalism a civil rights movement with a terrorist element, or is it, as it has repeatedly proved itself, a terror-based movement dressed in civil rights garb?

There is a cynical joke in Israel. Someone asks a Hamas representative if the military and civil wings of Hamas were the same, or separate entities. *"Of course they*

are separate," the terrorist insisted. *"The military wing is in the basement and the civil branch is on the first floor."*

To Israelis, the competing civil and terrorist wing of the Palestinians are no joke. They have proved themselves to be rejectionists. From an Israeli perspective, the latter is odds on to win. Leading players, including Hamas, Islamic Jihad, as well as the Fatah affiliated security men by day and terrorist by night operatives make a compelling case for Israelis to totally mistrust Palestinian intentions.

Even without the physical violence that radical elements add to the distrust, the Palestinian Arab delegitimacy of Israel extends through its myriad educational, religious, and cultural programs. It eliminates Israel completely from its school books.

All official flags, emblems, and maps show the geographic outline of Israel as Palestine. The *"moderate"* Palestinian Authority glorifies terrorists as a central theme in all their public, cultural, and sporting commemorations and events.

I refer to Palestine Media Watch for some of the Palestinian pronouncements on this subject. I have limited the contents of this subject to some of the most outstanding examples recorded during in the limited timeframe of Ramadan 2010.

The Palestinian Authority official daily newspaper frequently call terrorist murderers *"heroic"* on its front page.

It featured an obituary notice by the Fatah movement, Yatta branch, announcing the death of *"the fighter"*

Mahmoud Abu-Araam. *"Mahmoud Abu Araam, father of "the heroic prisoners **Khalil and Muhammad Abu Araam.**"*

<div align="right">Al-Hayat Al-Jadida, August. 24, 2010</div>

Khalil Abu Araam is serving seven life sentences, having been part of the unit responsible for the murder of five Israelis in shooting attacks. Muhammad, his brother, was sentenced to 11 years' imprisonment.

The PLO dedicated a meeting to the murderer of four Israelis in a terror attack. *"The PLO Revolutionary Council emphasized, in an announcement that was published at the conclusion of the fourth sitting – the sitting named after the commander shahids (martyrs) Hazem Gamsiyyeh, Muhammad Odeh, and **Ramadan al-Battah.**"*

<div align="right">Al-Hayat Al-Jadida, July 24, 2010</div>

Ramadan al-Battah was given four life-sentences for murder of Israelis in a terror attack. Palestinian Authority official paper glorified the planner of the Munich Olympic Games Massacre, Abu Daoud: *"His name shone brightly in the German city of Munich in 1972. In its* [Black September terror group's] *ranks were many distinguished men and women, headed by the panther of Palestine, Salah Khalaf, "Abu Iyad."* **Abu Daoud** *was one of his prominent assistants. His* [Abu Daoud's] *name shone brightly in the German city of Munich in 1972, where the Olympics took place. Oh, how these events evolved into a violent drama of the most tragic kind. May Allah have mercy on this great Fatah fighter and patriot,* **Abu Daoud.**"

<div align="right">Al-Hayat Al-Jadida, July 6, 2010</div>

154

Palestinian Authority praise for terrorist planner of Munich Olympics massacre Al-Hindi: Terrorist planner of the Munich Olympics massacre, Amin Al-Hindi, in which PLO terrorists murdered eleven Israeli athletes, was referred to in the PA daily: " *Everyone knows that Amin Al-Hindi was one of the stars who sparkled at one of the stormiest points on the international level - the operation that was carried out at the* [Olympics] *sports stadium in Munich, Germany, in 1972. That was just one of many shining stations.* "

Al-Hayat Al-Jadida, August 20, 2010

Amin Al-Hindi was one of the senior planners of the murders of 11 Israeli athletes in the Munich Olympics in 1972. PA leaders honor terrorist with *"official military funeral."*

President Abbas, Prime Minister Dr. Salam Fayyad, Secretary General of the Presidential Office, Al-Tayeb Abd Al-Rahim, members of the PLO Executive Council and of the Fatah Central Committee, several ministers, commanders of security forces, senior civic and military personnel, as well as relatives of the deceased, attended the official military funeral of Amin Al-Hindi, perpetrator of the Munich Olympic massacre.

PA Ministry of Prisoners' Affairs honors a suicide terrorist with a home visit to his family.

"PA Minister of Prisoners' Affairs, Issa Karake, visited the home of the Palestinian Shahida (Martyr) *Ayyat Muhammad Lutfi Al-Akhras, who died a Martyrs' death on March 29th, 2004, in the Dehaishe refugee camp."*

Al-Hayat Al-Jadida, August 30, 2010

155

Ayyat Al-Akhras carried out a suicide terror attack in a Jerusalem supermarket, killing two Israelis. The correct date was March 29, 2002 and not as written in the report.

PA Ministry of Welfare inaugurated a summer camp named after terrorist, Dalal Mughrabi:

"The Ministry of Welfare in Ramallah yesterday inaugurated the fourth integrative camp for special needs participants, and in Bethlehem the second camp named after Shahida (Martyr) ***Dalal Mughrabi*** *at the headquarters of the "Light of the Generations" Youth Association in Bethlehem. The second summer camp named after Shahida* ***Dalal Mughrabi*** *commenced with the support of the National Committee of Summer Camps General Coordinator of the committee is the Deputy Minister of Youth and Sports."*

Al-Hayat Al-Jadida, July 29, 2010

Dalal Mughrabi led the worst terror attack in Israel's history in 1978, when she and other terrorists hijacked a bus and killed 37 civilians, twelve of them children.

Boxing tournament named after terrorist Hassan Ali Salameh. PA TV sports news: *"Tomorrow, Friday, the Palestinian Boxing Association will be holding the Shahid* (Martyr) ***Hassan Ali Salameh*** *Youth and Men's Tournament at the Shari'a school in Hebron."*

PA TV (Fatah), August 5, 2010

Days later, this report appeared in the official Palestinian Authority newspaper; *"In the presence of* [Jibril] *Rajoub* [Fatah Central Committee member] *successful conclusion to the Second Palestine Boxing*

156

*Tournament for youth and men in Hebron. The tournament [was] held at the Shari'a School for Boys in Hebron, and was named by the Palestinian Boxing Association after Shahid **Ali Hassan Salameh,** the "Red Prince."*

Al-Hayat Al-Jadida, August 9, 2010

Hassan Ali Salameh was Commander of Operations for the *"Black September"* terror group. He planned the murders of 11 Israeli athletes in the Munich Olympics in 1972. The Palestinian Youth and Sports Ministry sponsors a youth camp named after terrorist Abu Jihad:

"Opening of Shahid (Martyr) ***Abu Jihad*** *camp in Aqaba."* (Village near Tubas, in Jenin District).

"Salam Daraghmeh, spokeswoman for the Youth and Sports Administration in Tubas, conveyed to us that the Shahid (Martyr) ***Abu Jihad*** *camp has opened in Aqaba, under the auspices of the Youth and Sports Ministry. Present at the opening ceremony were the head of the Youth and Sports Administration in the Tubas region, Arafat Al-Masri; General Director of Youth Affairs in the Youth and Sports Ministry, Walid Atatreh, and principal of the Aqaba Boys' High School, Marwan Salameh."*

Al-Hayat Al-Jadida, August 8, 2010

Abu Jihad headed PLO's military wing, and was responsible for the deaths of dozens of Israeli civilians. Among other attacks, he directed the most lethal terror attack in Israel's history, in which 37 were killed in the 1978 bus hijacking.

Palestinian Authority Summer camp named after a terrorist involved in Munich Olympic Games massacre;

Newspaper Headline: *"Folktales at **Mahmoud Al-Hamshari** [summer] camp"*

*"The Ministry of Culture organized a folktales event at the summer camp at the **Mahmoud Al-Hamshari** School in the Tulkarem district, which was attended by the Director of the Ministry of Culture, Abd Al-Fatah Alkam."*

<div align="right">Al-Hayat Al-Jadida, July 20, 2010</div>

Mahmoud Al-Hamshari was involved in the murders of the Israeli athletes at the Munich Olympics.

Continuing their pattern of naming Palestinian children's and teenager's summer camps after murderous terrorists. Yet another camp was named after Abu Ali Mustafa, this time by the Palestinians Women's Committee; *"The Palestinian Women's Committee in the town of Arabeh, in the Jenin district, in cooperation with the Popular Front for the Liberation of Palestine, yesterday concluded the activity of the 9th [summer] camp named after Shahid* (Martyr) ***Abu Ali Mustafa***, *with a mass gathering at which the camp's participants were honored."*

<div align="right">Al-Hayat Al-Jadida, July 19, 2010</div>

Abu Ali Mustafa – General Secretary of the terror organization *"Popular Front for the Liberation of Palestine"* (PLFP), planned numerous terror attacks against Israeli civilians during the Palestinian terror war (the "Intifada").

The official Palestinian Authority TV channel broadcast pictures of a town square being named in honor of a terrorist:

<div align="center">158</div>

The town square in the West Bank town of Madama features a monument honoring *"the heroic Martyrdom-Seeker,"* **Omar Muhammad Ziyada** and his *"heroic Herzliya operation"*. (A suicide bombing on June 11, 2002, which killed a 15-year old girl and injured 16 others in Herzliya).

The monument shows pictures of the suicide terrorist, and of former PA Chairman, Yasser Arafat. The text above the terrorist's picture is a verse from the Koran:

> *"Fight them, and Allah will punish them by your hands, lay them low and give you victory over them, and heal the hearts of a believing people."*
>
> Koran, 9, 15

Below the picture of the terrorist are the words: *"The heroic Shahada–Seeker* (Martyrdom-Seeker, PA term of honor for suicide terrorists) **Omar Muhammad Ziyada** *(Abu Samed) who carried out the heroic Herzliya operation on June 11, 2002."*

> PA TV (Fatah), August 15, 2010

The Palestinian Authority also honored Saddam Hussein by naming a town square after the Iraqi dictator; The monument in the square of Beit Rima shows pictures of Arafat and Saddam Hussein. Over the picture of Saddam Hussein is an inscription which reads, *"Long live the nation, long live Palestine."* Under the photograph: *"The Shahid (Martyr) leader,* **Saddam Hussein.**"

> PA TV (Fatah), August 26, 2010

Secretary of State Hillary Clinton said on April 23, 2009, in the House Appropriations Subcommittee on State, Foreign Operations and Related Programs: *"We will only work with a Palestinian Authority government that unambiguously and explicitly accepts the Quartet's principles: A commitment to non-violence, recognition of Israel, and acceptance of previous agreements and obligations, including the Road Map."*

Phase I of Road Map clearly states that *"All official Palestinian institutions end incitement against Israel."*

Palestinian Authority leaders' statements, its education of youth, its official events and commemorations, its media coverage of these events and statements, clearly show that not only does it not comply with its commitments but that it perpetuates a glorification of violence and martyrdom against Israelis. Instead of working against incitement it deliberately works *for* incitement.

It continues to *"unambiguously and explicitly"* deny Israel's existence. It incites to hatred, and glorifies terror and violence.

Here are a number of shocking official Palestinian pronouncements on Israeli cities. During Ramadan 2010, the official Palestinian TV channel ran a week long quiz show based on *Palestinian history and geography*. Contestants were offered cash prizes for correct answers.

Host: *"Palestine is completely occupied, and we want it liberated. Say the names after me: **Jerusalem**, Gaza, Ramallah, **Haifa, Jaffa**, Bethlehem."*

Note: Jerusalem, Haifa, and Jaffa are cities in Israel. The woman was handed $100 for "correct" answers.

PA TV (Fatah), August 11, 2010

Host: *"Haifa is a Palestinian city; can you name other Palestinian cities?"*

Man: *"Haifa, Jaffa, Acre, Nazareth, Gaza, Ramle, Hebron, Bethlehem."*

PA TV (Fatah), August 12, 2010

Note: Haifa, Jaffa, Ramle, Acre are cities in Israel. Other residents gave similar answers and received $100 for "correct" answers.

Host: *"I want you to name five Palestinian cities."*

Woman: *"Ramallah, Jerusalem, Haifa, Acre, Gaza."*

Host: *"I want you to name five Palestinian cities that you've visited?"*

Woman: *"Nahariya, Acre, Jenin, Gaza."*

PA TV (Fatah), August 13, 2010

Note: Jerusalem, Nahariya, Haifa and Acre are cities in Israel. Other residents gave similar answers and received $100 for "correct" answers.

Host: *"Can you tell me which countries share a border with Palestine?"*

Man: *"In the north, Lebanon and Syria. In the east, Jordan. In the west, the Mediterranean. In the south, Egypt and the Sinai."*

Note: Israel was not cited as a bordering country, yet it was the "correct" answer and he was awarded $100.

Host: *"Can you name four Palestinian cities?"*

161

Woman: *"Acre, Haifa, Jaffa, Nablus, Ramallah."*

PA TV (Fatah), August. 16, 2010

Note: Acre, Haifa and Jaffa are cities in Israel. The woman received $100 for a "correct" answer.

Host: *"Which countries share borders with Palestine?"*

Man: *"Lebanon, Jordan, Egypt."*

PA TV (Fatah), August 18, 2010

Note: Israel was not cited as a bordering country yet the host rewarded him with $100.

Host: *"Name three Palestinian cities?"*

Woman 1: ***"Haifa, Jaffa, Acre."***(!).

Host: *"Which countries surround Palestine?"*

Woman 2: *"Syria, Lebanon, Jordan, Egypt."*

PA TV (Fatah), August 19, 2010

Note: Israel was not cited as a bordering country. Both received $100 for "correct" answers.

Host: *"Which countries share borders with Palestine?"*

Man: *"Lebanon, Jordan, Egypt, Syria."*

PA TV (Fatah), August 22, 2010

Note: Israel was not cited as a bordering country yet the host gave him $100.

On August 20, six different people were asked to name five cities in Palestine. Their answers were: Contestant 1:**Acre, Jaffa, Haifa**, Gaza, Ramallah. Contestant 2: Gaza. Jericho, **Haifa, Jaffa, Acre**. Contestant 3: **Acre, Haifa, Jerusalem,** Ramallah, Jenin. Contestant 4: **Acre, Haifa, Jaffa,** El-Bireh, Nablus.

Contestant 5 said **Jaffa, Haifa, Acre, Jerusalem,** Bethlehem, and contestant 6 said **Acre, Haifa, Lod, Nazareth,** Ramallah.

PA TV (Fatah), August 20, 2010

Note: The respondents received $100 each for portraying Israeli cities Haifa, Jaffa, Lod, Nazareth, Jerusalem and Acre as Palestinian cities.

Host: *"Can you name five Palestinian cities?"*

Woman: *"Haifa, Jaffa, Acre."*

PA TV (Fatah), August 23, 2010

Note: Haifa, Jaffa and Acre are cities in Israel. The respondent received a $100 prize.

Host: *"Do you know which countries share borders with Palestine?"*

Woman: *"Jordan, Syria, Lebanon, Egypt, and the Mediterranean."*

Note: Israel was not cited as a bordering country yet the host gave her $100.

Host: *"Can you name three cities on the Palestinian coast?"*

Woman: *"Acre, Haifa, Jaffa."*

PA TV (Fatah), August 30, 2010

Note: All are Israeli cities on **Israel's** coast.

The repetition of the message illustrates the incessant brainwashing via their official media. It is noteworthy that the aim of the constant and intensive broadcasting, with the added incentive of cash money, was to inculcate the

identification of towns and cities within Israel as integral parts of *"Palestine."*

Here are further claims of Israel being an irrevocable part of *"Palestine."* An outspoken Palestinian Minister clearly defining Palestinian goals as an *"end to Israel."*

"PA Minister of Tourism, Khuloud Daibes, said: "This day [Festival for Tourism and Cultural Heritage] is meant to bring joy to people's hearts and to preserve the Palestinian heritage. Moreover, it is part of the popular resistance whose goal is to bring about an end to Israel."

Al-Hayat Al-Jadida, August 1, 2010

The Palestinian Authority official daily newspaper never refers to Israel by name.

Here it refers to the Galilee region of Israel as *"the Palestinian Galilee,"* In an article about a Palestinian music CD: *"From Nazareth, Ma'alia and Tarshiha **in the Palestinian Galilee** to Rahat in the south, the Centre has succeeded in gathering different musical creations."*

Al-Hayat Al-Jadida, July 9, 2010

The Palestinian Authority TV channel often broadcast songs denying Israel's right to exist. In their children's programs they inevitably rename Israel as *"Palestine,"* and present it as a lyrical long lost paradise.

In part of a children's program showing children visiting Bethlehem, PA TV chose to play in the background a song referring to *"My homeland Palestine"* with the words *"Do you know what happened in '48?* [Year of Israel's creation] *They took everything."*

164

The music video of the song is the longest running video for children broadcast on PA TV. It ran repeatedly for more than 10 years during 1998 to 2009. During 2010 the song has been used in a children's program. *"My homeland, my land is very pretty. It has forests, stone houses and a sea. My homeland, my land is very pretty. It has hills, lemon and olive trees. I live in my village. My village in my homeland. My homeland is so pretty. The smell of a fig tree. The aroma of jasmine. Do you know what happened in '48?* [Year of Israel's creation] *They took everything. They burned the room. The houses they broke. The forests they destroyed. The village they erased. The names they changed. They changed the names. My homeland, her name is Palestine."*

> PA TV (Fatah), music video broadcast repeatedly 1998-2009,
> and August 8, 2010

According to the official Palestinian daily newspaper, Israeli Arabs are *"Palestinians of the Interior."* Their banner headline of July 6, 2010 read. ***"Palestinians of the Interior participate in protest strike!"***

The story began, *"The Supreme Supervisory Committee of the Arab public in the **Palestinian Interior** [i.e. Israel] yesterday published an announcement..."*

> Al-Hayat Al-Jadida, July 6, 2010

This was repeated in the same paper on July 9th, 2010:

*"A military order was extended prohibiting the Chairman of the Islamic Movement in the **Palestinian Interior** [i.e. Israel], Sheikh Raed Salah, from entering any part of the city of Jerusalem until Sept. 29, 2010...*

*In response, the spokesman for the Islamic Movement in the **Palestinian Interior**, Adv. Zahi Nujidat, publicized an announcement on behalf of the movement...*"

Al-Hayat Al-Jadida, July 9, 2010

Continuing this theme, the paper later the same month again referred to the Palestinian Interior; calling them *"the 1948 territories," "The Islamic Movement **in the** [Palestinian] Interior [i.e. Israel]: The Al-Aqsa Mosque Is currently in the sights of the Israeli sniper... The Islamic Movement **in the 1948 territories** [i.e. Israel] published an announcement yesterday concerning the violation of the Al-Aqsa Mosque.*"

Al-Hayat Al-Jadida, July 23, 2010

Israel is also *"occupied Palestine"* meaning that Israel itself is occupied land.

The sports section reported on an Israeli Arab football team in Israel's national league as follows, *"The* [Israeli-Arab city] *Sakhnin United team returned Monday evening to **occupied Palestine** [i.e. Israel], following the conclusion of its training camp in Brasov, Romania.*

On a different note, the directorate of the team signed an agreement with the Arab Bank [Note: the correct name is: "The Arab Israel Bank"] *in **occupied Palestine** [i.e. Israel], to sponsor the club's football team during the 2010-2011 season.*"

Al-Hayat Al-Jadida, July 30, 3010

The Israeli town of Nazareth in the Galilee is *"the 1948 occupied Palestinian Interior."* This occurs when

166

Israel is extending the hand of mutual cultural exchanges between Israeli and Palestinian Arabs. In a TV news broadcast they reported, *"The city of Nazareth, in **the 1948 occupied Palestinian Interior** [i.e. Israel], welcomed some 40 businessmen and business women from the Nablus district."*

<div align="right">PA TV (Fatah), July 18, 2010</div>

In Israel there is a problem of local Arabs participating in terror attacks. When caught, sentenced, and jailed, the Palestinian media refer to them as *"1948 prisoners."* This does not mean they have been prisoners since 1948. It refers to them as Palestinians living within their 1948 borders. *"**The 1948 prisoners** [euphemism for Israeli Arabs in Israeli prisons for terror offenses] called to the Hamas negotiators not to give up on them and to demand they be included in any future [prisoner exchange] deal."*

<div align="right">Al-Hayat Al-Jadida, July 20, 2010</div>

Reflecting the theme of their Ramadan quiz show, a TV discussion program referred to Haifa as being *"on the Palestinian coast"* and *"under occupation."* PA TV host referring to an artistic initiative involving water from all over the world .

*"This idea occurred to you based on the fact that Palestine has no sea – or, we have a sea, but we can't get to it, as a result of **the occupation**."*

A visual of the Israeli city Haifa is shown. PA TV reporter: ***"This [Haifa] is the Palestinian coast**, overlooking the Mediterranean Sea. We are still prevented from reaching it and vacationing in its waves."*

<div align="right">PA TV (Fatah), July 18, 2010</div>

<div align="center">167</div>

It is informative listening to how the official Palestinian media refer to Arab Members of Israel's Knesset.

"Chairman of the Arab Democratic Party, Member of Knesset Taleb A-Sanaa, Conveyed to [Hamas] *Member of Parliament Abu Tir* [imprisoned by Israel] *the good wishes of our Arab population in* **the '48 territories** [i.e. Israel], *and their identification with him. Member of Knesset A-Sanaa and* [Hamas] *Member of* [Palestinian] *Parliament Abu Tir discussed the deportation* [order against Abu Tir] *and Israel's attempt to empty Jerusalem of its original inhabitants, to Judaize it and to seize control of the Al-Aqsa Mosque."*

<div align="right">Al-Hayat Al-Jadida, Aug. 31, 2010</div>

The Palestinian references in this section of the book were randomly taken during the short timeframe of Ramadan 2010. It gives a clear indication of the intensity of their indoctrination and ambitions beyond the initial establishment of a Palestinian state.

President Obama called Palestinian maps that make no reference to Israel a security threat to Israel. *"I will never compromise when it comes to Israel's security... Not when there are maps across the Middle East that don't even acknowledge Israel's existence."*

<div align="right">June 4, 2008, AIPAC Conference</div>

Yet the entire official Palestinian maps in offices, websites, schoolbooks, and those appearing on official PA

TV since the start of the proximity talks continue the PA policy of defining all of Israel as *"Palestine."*

It is crystal clear that the Palestinian will persist in their agenda to replace Israel with *"Palestine."*

PALESTINIAN REFUGEES –
WHOSE RESPONSIBILITY?

Palestinian refugees are *"Super-Refugees."* They are treated to a status not afforded to any other refugee group in the world.

Here is a strange and unique UNWRA definition of what is a refugee.

You may be surprised to learn that their definition reads that a refugee is a person *"whose normal place of residence was Palestine between June 1946 .and May 1948 or June 1967"*[1]. It also considers all descendants of the 1948 refugees as "refugees."

This definition does not apply to any other group, which comprise of tens of millions of people worldwide, who became refugees since World War Two[2].

Between seven and ten million Balkan refugees were driven out of their homes.

Between twelve to sixteen million Germans were expelled out of Sudetenland, Romania, Hungary, and Poland.

Fourteen million refugees were exchanged between India and Pakistan.

[1]. Ben-Dror Yemini, Mideast Truth Forum, January 15, 2009.
[2]. Ditto.

In 1994, 900,000 refugees were exchanged in the territories between Armenia and Azerbaijan.

From 1980 non-Muslim blacks were expelled from Mauritania and exiled to Senegal and Mali while 75,000 Arabs fled to Mauritania.

Ethnic conflicts in Sudan caused between three to four million people to flee Arab-dominated Khartoum.

Cyprus has been divided with the Turkish invasion of that island that left 250,000 displaced people.

More than 800,000 Jewish refugees were forced to leave their homes and possessions in Arab countries at the time of Israel's declaration of statehood.

The United Nations acting mediator in October 1948 estimated that 472,000 Arabs fled Palestine leaving 360,000 needing aid. Today UNWRA say they are aiding 4,600,000 Palestinian Arabs.

The US Committee for Refugees and Immigrants estimated in 2006 that there was a world total of sixty two million refugees, of which 34,000,000 were displaced by war[3].

The question needs to be asked why it is that only the Palestinians out of a total of 62,000,000 refugees worldwide merit special treatment?

Examining the Cypriot appeal against the Turkish invasion of 1974 it is striking that the United Nations, in its attempt to wash its hands of the many claims by the Greek Cypriots including humanitarian and refugee damages, stated that too much time has elapsed to impose refugee

[3.] Ben-Dror Yemini, Mideast Truth Forum, January 15, 2009.

status on the displaced Cypriots. If this is the UN stance in Cyprus why is it perpetuating Palestinian refugee status into its fourth generation as an exclusive right, thereby excluding the vast bulk of our world's deprived and displaced humanity?

This is a question of huge international consequence, yet has anybody heard of this issue being raised in any international forum?

The accepted practice for the Cypriots must become acceptable for Palestinian Arabs, and vice versa. The Arab refugees can hold out hope of an alternative future in a Palestinian state. What about the Cypriots? This alternative hope does not seem to apply to Cypriots who have been driven out of their homes by the invading Turks.

Israel has been accused of causing the Palestinian refugee crisis. It is yet another stigma wrongly attached to the Jewish state for decades. Who are the guilty ones?

It is true that the displacement of Arabs out of the fledgling State of Israel was a result of war, but this war was not of Israel's choosing. Rather, it was imposed on the new nation by vengeful Arab armies. Charges have been made against Israel of forcing out the Arabs, but the overwhelming evidence clearly highlights the guilt of Arab leaders. Here are some of the evidentiary statements made at the time:

*"The fact that there are these refugees is the direct consequence of the act of the **Arab states** in opposing partition and the Jewish state. The Arab states agreed upon this policy unanimously and they must share in the solution*

of the problem." Emile Ghoury, Secretary of the Palestinian Arab Higher Committee, in an interview with the Beirut Telegraph, September 6, 1948. (same appeared in the London Telegraph, August 1948).

"The most potent factor [in the flight of Palestinians] *was the announcements made over the air by the **Arab-Palestinian Higher Executive,** urging all Haifa Arabs to quit. It was clearly intimated that Arabs who remained in Haifa and accepted Jewish protection would be regarded as renegades."*
London Economist. October 2, 1948

*"It must not be forgotten that the **Arab Higher Committee** encouraged the refugees' flight from their homes in Jaffa, Haifa, and Jerusalem."*
Near East Arabic broadcasting station, Cyprus, April 3, 1949

"Every effort is being made by the Jews to persuade the Arab populace to stay and carry on with their normal lives, to get their shops and businesses open and to be assured that their lives and interests will be safe."
Haifa District HQ of the British Police, April 26, 1948

*"The mass evacuation, prompted partly by fear, partly **by order of Arab leaders,** left the Arab Quarter of Haifa a ghost city. By withdrawing Arab workers their leaders hoped to paralyze Haifa."*
Time Magazine, May 3, 1948, page 25

"The Arab civilians panicked and fled ignominiously. Villages were frequently abandoned before they were threatened by the progress of war."

General John Glubb "Pasha," London Daily Mail, August 12, 1948

"The Arabs of Haifa fled in spite of the fact that the Jewish authorities guaranteed their safety and rights as citizens of Israel."

Monsignor George Hakim, Greek Catholic Bishop
of Galilee, New York Herald Tribune, June 30, 1949

Sir John Troutbeck, British Middle East Office in Cairo, noted in cables to superiors (1948-49) that the refugees (in Gaza) have no bitterness against Jews, but harbor intense hatred toward Egyptians: *"They say 'we know who our enemies are* (referring to the Egyptians), *declaring that their* **Arab brethren** *persuaded them unnecessarily to leave their homes. I even heard it said that many of the refugees would give a welcome to the Israelis if they were to come in and take the district over."*

"The **Arab states** *which had encouraged the Palestine Arabs to leave their homes temporarily in order to be out of the way of the Arab invasion armies, have failed to keep their promise to help these refugees."*

The Jordanian daily newspaper Falastin, February 19, 1949

"The 15th May, 1948, arrived. On that day **the Mufti of Jerusalem** *appealed to the Arabs of Palestine to leave the country, because the Arab armies were about to enter and fight in their stead."*

The Cairo daily Akhbar el Yom, October 12, 1963

"Arabs still living in Israel recall being urged to evacuate Haifa by **Arab military commanders** *who wanted to bomb the city."*

174

Newsweek, January 20, 1963

*"Who brought the Palestinians to Lebanon as refugees, suffering now from the malign attitude of newspapers and communal leaders, who have neither honor nor conscience? Who brought them over in dire straits and penniless, after they lost their honor? **The Arab states**, and **Lebanon** amongst them, did it."*

The Beirut Muslim weekly Kul-Shay, August 19, 1951

*"The Arab exodus was not caused by the actual battle, but by the exaggerated description spread by the **Arab leaders** to incite them to fight the Jews. For the flight and fall of the other villages it is our leaders who are responsible because of their dissemination of rumors exaggerating Jewish crimes and describing them as atrocities in order to inflame the Arabs. By spreading rumors of Jewish atrocities, killings of women and children etc., they instilled fear and terror in the hearts of the Arabs in Palestine, until they fled leaving their homes and properties to the enemy."*

The Jordanian daily newspaper Al Urdun, April 9, 1953

*"The **Arab governments** told us: 'get out so that we can get in.' So we got out, but they did not get in."*

A refugee quoted in Al Difaa (Jordan) September 6, 1954

In listing the reasons for the Arab failure in 1948, Khaled al-Azam (**Syrian Prime Minister**) notes that *"since 1948, it is we who have demanded the return of the refugees, while it is we who made them leave. We brought disaster upon a million Arab refugees by inviting them and*

175

bringing pressure on them to leave. We have accustomed them to begging. We have participated in lowering their morale and social level. Then we exploited them in executing crimes of murder, arson and throwing stones upon men, women and children all this in the service of political purposes."

Khaled el-Azam, Syrian Prime Minister after the 1948 war, in his 1972 memoirs, published in 1973

***"The Arab states** succeeded in scattering the Palestinian people and in destroying their unity. They did not recognize them as a unified people until the states of the world did so, and this is regrettable."*

Abu Mazen (Mahmoud Abbas), from the official journal of the PLO, Falastin el-Thawra ("What we have learned and what we should do"), Beirut, March 1976

*"Abu Mazen charges that the **Arab states** are the cause of the Palestinian refugee problem."*

Wall Street Journal, June 5, 2003.

Mahmoud Abbas (Abu Mazen) wrote an article in March 1976 in Falastin al-Thawra, the official journal of the PLO in Beirut, *"The **Arab armies** entered Palestine to protect the Palestinians from the Zionist tyranny, but instead they abandoned them, forced them to emigrate and to leave their homeland, imposed upon them a political and ideological blockade and threw them into prisons similar to the ghettos in which the Jews used to live in eastern Europe."[4]*

4. Big Lies: Demolishing the myths of the propaganda war against Israel, by David Meir-Levi.

Mahmud al-Habbash, a regular writer in the official Palestinian Authority paper, Al-Hayat al-Jadida, indicates in his column *"The Pulse of Life"* (December 13, 2006) that the Arabs left Israel in 1948 only after political Arab leaders persuaded them to do so by promising the Arabs a speedy return to their homes in Palestine, *"**The leaders and the elites** promised us at the beginning of the "Nakba" (the establishment of Israel and the creation of refugee problem in 1948), that the duration of the exile will not be long, and that it will not last more than a few days or months, and afterwards the refugees will return to their homes, which most of them did not leave only until they put their trust in those "Arkuvian" promises made by the leaders and the political elites.*

Afterwards, days passed, months, years and decades, and the promises were lost with the strain of the succession of events." The term "Arkuvian" is after Arkuv, a figure from Arab tradition who was known for breaking his promises and for his lies.

"We heard sounds of explosions and of gunfire at the beginning of the summer in the year of the 'Nakba'. They told us, 'The Jews attacked our region and it is better to evacuate the village and return, after the battle is over.' And indeed there were among us (who fled Israel) *those who left a fire burning under the pot, those who left their flock* (of sheep), *and those who left their money and gold behind, based on the assumption that we would return after a few hours."*

<div align="right">Asma Jabir Balasimah um Hasan, woman who fled Israel, Al-Ayyam, May 16, 2006</div>

An Arab viewer called Palestinian Authority TV (PA TV April 30, 1999) and quoted his father and grandfather, complaining that in 1948 the Arab district officer ordered all Arabs to leave Palestine or be labeled traitors.

In response, Arab MK Ibrahim Sarsur, then head of the Islamic movement in Israel, cursed the leaders who ordered Arabs to leave, thus, acknowledging Israel's assertion.

Statement of son and grandson of man who fled:

*"Mr. Ibrahim Sarsur. I address you as a Muslim. My father and grandfather told me that during the 'Nakba' our **district officer** issued an order that whoever stays in Palestine and in Majdel* (near Ashkelon – southern Israel) *is a traitor, he is a traitor."*

Response from Ibrahim Sarsur, head of the Islamic movement in Israel:

"The one who gave the order forbidding them to stay there bears guilt for this, in this life and the afterlife throughout history until resurrection day."

Fuad Abu Higla, then a regular columnist in the official PA daily, Al Hayat al Jadida, wrote an article before an Arab summit, (March 19, 2001), which criticised the Arab leaders for a series of failures. One of the failures he cited, in the name of a prisoner, was that an earlier generation of Arab leaders forced them to leave Israel in 1948, again placing the blame for the flight on the **Arab leaders:**

"I have received a letter from a prisoner in Acre prison, to the Arab summit: to the (Arab and Muslim) kings and presidents, poverty is killing us, the symptoms are exhausting us and the souls are leaving our body, yet you are still searching for the way to provide aid, like one who is looking for a needle in a haystack or like the armies of your predecessors in the year of 1948, who forced us to leave (Israel), on the pretext of clearing the battlefields of civilians. So what will your summit do now?"[5]

The overwhelming summary of narrative evidence more than exonerates Israel for being the main cause of the refugee problem. The blame clearly lies at the Arab door.

Israel consistently sought to solve the refugee problem after the 1948 War of Independence.

On August 1st, 1948, David Ben Gurion said:

"When the Arab states are ready to conclude a peace treaty with Israel this question will come up for constructive solution as part of the general settlement, and with due regard to our counter-claims in respect of the destruction of Jewish life and property, the long-term interest of the Jewish and Arab populations, the stability of the state of Israel and the durability of the basis of peace between it and its neighbors, the actual position

5. PA daily: Arab leaders caused the refugee problem, by Itamar Marcus and Barbara Crook- Dec. 17, 2006 (pmw.org.il)

and fate of the Jewish communities in the Arab countries, the responsibilities of the Arab governments for their war of aggression and their liability for reparation, will all be relevant in the question whether, to what extent, and under what conditions, the former Arab residents of the territory of Israel should be allowed to return."

Despite the inherent danger of large scale repatriation into Israel it did not prevent them from taking in a large number of refugees as a condition for signing a peace treaty. In 1949, Israel offered to allow families that had been separated during the war to return, agreed to release refugee accounts frozen in Israeli banks (eventually released in 1953), offered to pay compensation for abandoned lands, and agreed to repatriate 100,000 refugees. The Arabs rejected all the Israeli compromises. They were unwilling to take any action that might be construed as recognition of Israel. Despite this position taken by the Arab states, Israel did release the Arab refugees' blocked bank accounts, which totaled more than ten million dollars. In addition, through 1975, the Israeli Government paid to more than eleven thousand claimants more than twenty three million Israeli pounds in cash and granted more than 20,000 acres as alternative holdings. Payments were made by land value between 1948 and 1953, plus six percent for every year following the claim submission. Arab rejectionism continued.

In 1948 the Arab position was expressed by Emile Ghoury, the Secretary of the Arab Higher Committee: *"It is*

inconceivable that the refugees should be sent back to their homes while they are occupied by the Jews, as the latter would hold them as hostages and maltreat them. The very proposal is an evasion of responsibility by those responsible. It will serve as a first step towards Arab recognition of the State of Israel."

Egyptian Foreign Minister Muhammad Salah al-Din: *"It is well-known and understood that the Arabs, in demanding the return of the refugees to Palestine, mean their return as masters of the homeland and not as slaves. With a greater clarity, they mean the liquidation of the State of Israel."*

<div align="right">Al-Misri, October 11, 1949</div>

In 1957, the refugee conference at Homs, Syria, passed a resolution stating: *"Any discussion aimed at a solution of the Palestine problem which will not be based on ensuring the refugees' right to annihilate Israel will be regarded as a desecration of the Arab people and an act of treason."*

<div align="right">Beirut Al Massa, July 15, 1957</div>

The treatment of the refugees in the decade following their displacement was best summed up by a former UNWRA official, Sir Alexander Galloway, in April 1952: *"The Arab states do not want to solve the refugee problem. They want to keep it as an open sore, as an affront to the United Nations and as a weapon against Israel. Arab leaders don't give a damn whether the refugees live or die."*

The oppression of the Palestinian Arabs continued to be exacerbated by the condition in which the defeated Arab

nations treated their Arab kin. Saudi Arabia refused to employ Palestinian Arab refugees during their labor shortage in the 70s and 80s choosing instead to recruit thousands of South Koreans and other Asians.

Kuwait, who had denied Palestinian Arabs citizenship, expelled 300,000 of them following the Gulf War, in which the Palestinians cheered wildly for Saddam Hussein. The Kuwaiti Ambassador to the United States, Saud Nasir al-Sabah, made a statement that is significant to the Israeli security situation today and the refugee question: *"If people pose a security threat, as a sovereign country we have the right to exclude anyone we don't want."*

Jerusalem Report, June 27, 1991[6]

Surely that applies to Israel today?

Netty Gross, of the Jerusalem Report (July 6, 1998), visited Gaza and asked an official why the camps there hadn't been dismantled. She was told the Palestinian Authority had made a *"political decision"* not to do anything for the nearly half a million Palestinians living in the camps until the final-status talks with Israel took place.

The only people responsible for their continued suffering over more than sixty years are the Arab leaders who pretend to support them.

Complicit in this crime is the United Nations who, through UNWRA, perpetuate the criminal status of Palestinian refugeeship, rather than treating them like all other refugees and ensuring that they are absorbed into the

6 The Palestinian Refugees. *Mitchell Bard.*

nations in which they find themselves. Not only do they perpetuate careers and huge budgets over an issue that exclusively and deliberately has not been solved but, when criticized, they advance a Stockholm-Syndrome type of response that is more Palestinian propaganda than fact.

The Irish Times in November 2010 reported the words of John Ging, the senior UN official to Gaza as saying, *"There has been no material change in Gaza,"* referring to Israeli supplies to the Strip. He also said that the easing of the Israeli blockade as being *"nothing more than a political easing of the pressure on Israel and Egypt."*

I fail to see how the flow of four thousand six hundred trucks can be described as *"a political easing."*

That was the number of trucks that carried 93,000 tons of food, fuel, and other goods into Gaza that month. The previous months had also seen thousands of trucks pass from Israel into Gaza. One hundred and eighty thousand Palestinian Arabs received medical treatment in Israeli hospitals in 2010.

As Ging's views, expressed by this senior United Nations official, is it any wonder that Israel perceives that organization, and its various bodies, including Ging's UNWRA, as being so entrenched with the Palestinians as to be biased against Israel even as we work tirelessly to provide far more than humanitarian aid to those in Gaza?

Palestinian refugees by definition are people who were born in what was once Palestine. This ceased to exist in 1948. The vast majority of those born outside of Israel (post 1948) have never set foot in Israel.

Why then should Israel be under the burden to care or compensate for the iniquities of the Arab nations who brought war and suffering on Israel, causing the refugee problem. and then left their fellow Arabs stateless for decades?

It is bad enough that more than eight hundred thousand Jewish refugees were forced to flee their homes in Arab lands under fear of death in 1948-50. This was truly ethnic cleansing. Driven out at a moment's notice, most left valuable possessions, properties, businesses. monies, behind as they departed in panic, scared for their lives, as Arab mobs threatened to slaughter them. Many Jews were killed in the anti-Semitic riots in these Arab countries.

Israel has not made a case, yet, for compensation against the Arab countries that expelled their Jews and stole their properties. Neither did the fledgling Jewish state apply to the United Nations to keep these immigrants in constant refugee status. Instead, they welcomed them, absorbed them, and integrated them into Israeli society.

UNWRA's funding for Palestinians for the year 2010-11 was to the tune of one and a quarter billion dollars. Since it is mainly run by Palestinians, it serves to maintain and reproduce hatred against Israel and the West. This satisfies the Palestinian and Arab leadership. It detracts from their own shortcomings. For them, the refugees have always been a club with which to beat Israel, rather than a problem to be solved in the same manner as all other refugees problems worldwide, by legal absorption into the society in which they find themselves.

James Lindsay, a retired general counsel of UNWRA, criticized his organization for employing known terrorists in its camps and for continuing the politicization of the refugee issue. That means stirring up hate and violence against Israel.

The finger of blame that points at UNWRA goes back decades. Strangely, some of its most prominent critics are senior figures in the organization.

In 1953 Lt.-General Sir Alexander Galloway, who was then the UNWRA Director in Jordan, famously said: *"It is perfectly clear that the Arab nations do not want to solve the Arab refugee problem. They want to keep it as an open sore, and as a weapon against Israel."*

He had a solution to this particular refugee problem. *"Give each of the Arab nations where the refugees are to be found an agreed upon sum of money for their care and resettlement and then let them handle it. If the United Nations had done this immediately after the conflict the problem may have been solved a long time ago."* It would have been solved. It would not have festered into a major cause of bloodshed and world unrest. It would have saved billions of dollars. Galloway also described the futility of the situation: *"Staff begets staff. Plan follows plan. Typewriters click. Brochures and statistics pour out. The refugees remain, complain, and breed, while the political game goes on. The hard unpalatable fact is that the refugees will not go back to their homes in Palestine. This acceptance should be a matter of politics. It is beyond the function of UNWRA."* This is more

relevant today than it was in 1953. For his honesty, Galloway was fired.

Every other refugee crisis has been solved, mainly through the process of a time limit to refugee status. An exceptionalism has been allowed to congeal on Palestinian Arab refugees who have formed a dependency on UNWRA.

Why is it that European nations have taken in millions of Middle Eastern immigrants yet the Arab nations refuse to accept them? May I suggest the Arab nations do the same as Europe, America, and Israel, the very nations they freely condemn for their perceived Muslim hatred, and renounce their shameful perpetuation of refugee status for their fellow Arabs. It is a stain on their soil and on their soul.

PALESTINIAN FUNDING, OBSCENE, INSANE, IMMORAL!

If the Palestinians in Gaza and the West Bank really had a humanitarian crisis Israel would be the first nation to increase the flow of goods into the territories. The truth is that Israel has not received any demand from the Palestinian Authority beyond what is already flowing into the territories. They have reached the limit of what they need.

Much of the population in the Palestinian-controlled areas have reached a reasonable living standard. Growth is in double figures. Palestinian employment prospects would be brighter if Israelis were less concerned about their justifiable fear of Palestinian terrorism.

Hamas announced the construction of a new neighborhood in the Gaza Strip. They celebrated the international cuisine to be enjoyed at the Roots Club and at Greens. Recently, in June 2011, a second shopping mall opened in Gaza City. The sliding escalator in Israeli-made.

Netanya does not have a municipal Olympic size pool. Neither does Ashkelon, or Sderot. Gaza does.

Gaza City is part of the Palestinian territory operated by the Islamic terror regime, Hamas.

Netanya has been hit by repeated Palestinian suicide attacks, car bombings, and terrorist gunmen that have left

over fifty of its citizens dead and more than three hundred injured. The people of Sderot, Ashkelon, Ashdod, and other southern towns and villages in Israel, have been under rocket bombardment from the Gaza Strip. Palestinians receive record amounts of international funding. The victims of Palestinian terror get nothing. This is obscene! Over recent years, the Palestinian has received not millions, but billions, of dollars in funding from the international community. It was rumored that Yasser Arafat died with a personal fortune of more than one hundred and twenty million dollars. It is undoubtedly true that many of the current Palestinian leadership, and those close to them, have millions stashed in overseas accounts from kickbacks and contracts. Palestinian President Abbas has two sons living in luxury outside of the Palestinian territories. They own the cellular phone contracts in the territories as well as other lucrative businesses. Other Palestinians live a wealthy lifestyle.

The western media clearly services the Palestinian propaganda machine with their one-sided reporting. They would have us believe that the Palestinians are suffering the worst humanitarian crisis in human history, desperate for basic needs, and even deprived of building materials by a cruel Israeli blockade. As such, they formulate public opinion with their biased and emotional reporting and journalism. One example of the effect on public opinion was the ruling in a British court in which the judge instructed the jury to take into consideration that Gaza is *"a hell on earth"* and that people there are starving. It is easy

to search Google Earth and visit YouTube to see that Gazans enjoy a middle class lifestyle. Nobody is starving in Gaza. Most enjoy good staple diet, and even cordon bleu dining. In other words the judge was either lying, or had been misinformed by the media.

Recent disturbances in Egypt highlighted that the average Egyptian earns less than the average Palestinian.

Statistics show that Gazans have a longer lifespan (73.68 years) than their supporters in Turkey (72.23 years). Iranians only get to spend an average of 71.43 years in this world. In comparison, Sudanese only live an average of 52 years, while the poor Somalis only survive for an average of fifty years.

Infant mortality in Gaza is superior to most Arab and South American countries and considerably better than Africa.

Editors and journalists can easily sweep aside this veil of deceit with a couple of clicks of their computer mouse, if they chose to do so. Had they the courage to resist Hamas threats and done what they are supposed to do, namely investigative, accurate, professional, fair and balanced reporting instead of falsely throwing guilt at Israel, they could expose the truth that is Gaza. It is quite sinister that they choose not to. Honest reporting would reveal a middle class lifestyle that puts a lie to the news that they have been propagating. They can easily do this, but prefer not to. Is this due to laziness, or political bias? Does the emotive message of Palestinian victimhood sell more newspapers than the truth?

To really tell the truth about Gaza they would have to inform their viewers or readers of the international standard sports facilities, the dredging and enlarging of the Gaza harbor to receive international shipping, the construction and equipping of new governmental and municipal buildings, the construction of luxury apartment blocks, houses, and grand mansions, and other first class facilities, both public and commercial.

How has all this been achieved without building materials? Or without construction equipment? Office equipment? Furniture? Appliances? Computers and software? Foodstuff? Medical aid and equipment? I thought that nothing was getting through due to the Israeli blockade? That life in Gaza was hell on earth, and people were starving? The truth was that shops were stocked with clothing, food, provisions, toys, cakes, candies, trimmings, everything you needed for an enjoyable life. Go to the beach at Gaza and you would see the wind-surfers. Enjoy a day at the water park. Dine out at luxury restaurants and clubs serving the best cuisine in sophisticated surroundings. This was the miracle of life in the Palestinian territories, achieved with no access to building materials or basic humanitarian supplies, according to your national media. This is insane! This is false. You have been lied to!

But the worst of it is this. While middle class Palestinians plead poverty and receive excessive amounts of funding, there are other parts of our world where millions of people, including children, are dying of malnutrition and disease. Their cries go unheard by the governments, aid agencies, and so-called human rights organizations and

activists who are too busy screaming abuse at Israel. They die, ignored by the politicians, the NGOs, and the individuals that have an anti-Israel agenda that keeps Hamas in power. They profess to be humanitarians. They are hypocrites.

The African child, dying today, is a victim of the phony *"political correctness"* that promotes the Palestinian cause as flavor of the year while ignoring genuine grief.

These children could be saved if they received just a small portion of the obscene funds that flow into Palestinian territories including Gaza, funds that strengthen Hamas.

This is immoral!

It is time to divert the bulk of this Palestinian funding to those who are dying and truly living in misery, truly desperate for our help. People have been deceived by the money and media machine that promulgates a totally false political image of Palestinian sufferance.

This is not to say that there are no problems that must be solved. It is, however, radically removed from the truth. It is truly disproportionate.

The donors to the Palestinian cause would better serve the interests of the Palestinians, and the international community, if they would condition their funding on forcing the Palestinian leadership to conclude a binding solution to the Middle East conflict. Instead, they have allowed their money to be pumped into the Palestinian society with no political accountability or responsibility in accepting the two-state solution that has been on the table for decades. The Palestinian leadership should have their feet held to the fire and made to

conclude a permanent agreement with the Israelis. They should be threatened with the cessation of funding if they do not accept a pragmatic solution to end the conflict. They do not do so because their propaganda is accepted so readily. They are under little pressure for accountability, both financially and politically. This is why they constantly reject any solution. This is why they have the chutzpah to refuse even to talk directly to the Israelis.

They prefer to go through the motions of empty negotiations while holding out their hand for the increasing amounts of money they know they will receive for their phony sob stories. Hundreds, if not thousands, of diplomats from the United Nations and the European Union, as well as NGOs, and human rights groups, receive massive funding and enjoy permanent careers promoting the Palestinian narrative. They choose not to bite the hand that feeds them.

They would rather not end the problem by forcing the Palestinian leadership to resolve the conflict. Instead, they sponsor and support a Palestinian society that holds on to their hopeless ambition to eliminate Israel.

Why do they do this? Because they have their own careers to consider. And so the spiral continues.

Palestinians are enjoying a comfortable lifestyle with no pressure on them to advance the peace process. Why should they when they have hit the jackpot with their stories of victimhood and sufferance. The Palestinians in the West Bank and Gaza have become the world's wealthiest beggars. Palestinian funding has become obscene, insane, and immoral.

THE BATTLE FOR JERUSALEM

Agree with me on this. You'd have to say that anyone who told you that the ancient Jewish temple, built by King Solomon in the city of David in Jerusalem, visited even by Jesus was in Nablus, that person is an idiot, right?

Yasser Arafat was an idiot!

At Camp David, in 2000, at the negotiations with Israel in which he said "No!" to everything, he shocked President Clinton, Dennis Ross, Ehud Barak, and all the negotiators when he told them that there was no records of any Jewish history in Jerusalem, and the Jewish temple was in Nablus. Of course, he couldn't produce any evidence to show it had been there. It was just another case of Palestinian fantasy.

This idiocy leapt off the front page of my morning newspaper as I sat down to breakfast one morning in November 2010. The Jerusalem Post headline read, in truth-denying boldness, *"Jews have no right to Western Wall, Palestinian Authority study says."* I nearly choked on my cornflakes.

The Western Wall, otherwise known as the Wailing Wall, is the iconic wall to the west of where the ancient Jewish Temple once stood. According to the report printed in my copy of the newspaper, the Western Wall belongs to the Muslims as an integral part of the Al Aqsa mosque and

the Haram al Sharif, which is the Islamic term for the Temple Mount, according to a recent Palestinian Authority official paper.

This paper was the result of a study done by Al-Mutawakel Taha, a senior official with the ministry, to "refute" Jewish claims to the Western Wall.

The study claims there isn't one stone in the wall that belongs to the era of King Solomon. *"The Zionist occupation falsely and unjustly claims that it owns this wall, which it calls the Western Wall or Kotel,"* Taha, who is a renowned Palestinian poet and writer, wrote in his project.

Al-Mutawakel Taha is also an idiot.

Taha conveniently fails to mention that evidence as to the authenticity of the Western Wall and the Jewish Temple were recorded centuries before *"the Zionist occupation."*

He also fails to acknowledge that the temple wall stood before the Al-Aqsa Mosque was built.

The author, who is affiliated with PA President Mahmoud Abbas's Fatah faction, emphasizes that over the past few decades, Jews have failed to prove that the wall has any connection to their religion. *"Many studies published by Jewish experts have affirmed that there is no archaeological evidence that the Temple Mount was built during the period of King Solomon."*

The paper added: *"One can only conclude that Al-Buraq Wall is a Muslim wall and an integral part of the Al Aqsa Mosque and Haram al-Sharif. No one has the right to claim ownership over it or change its features or original character. Also, no one has the right to agree with the*

194

occupation state's racist and oppressive measures against history and holy sites."

Not wanting to upset the Obama Administration, this official Palestinian Authority report was removed from their Ministry of Information website under heavy condemnation from the American State Department. A month later, in December 2010, it resurfaced on the official Palestinian Authority news agency website, Wafa[1].

Mr. Taha needs reminding that in 1930, the Supreme Muslim Council (not exactly a pro-Zionist organization) published an English-language tourist guide to the Temple Mount entitled *"A brief guide to Al-Haram al-Sharif,"* which stated: *"The site is one of the oldest in the world. Its sanctity dates from the earliest times. Its identity with the site of Solomon's Temple is beyond dispute. This, too, is the spot, according to universal belief, on which David built there an altar unto the lord, and offered burnt offerings and peace offerings."*

Since when were King Solomon and King David Palestinians?

Jews do not have much sympathy for the Supreme Muslim Council of 1930, headed by the notorious Nazi-supporting anti-Semite, Amin el Husseini, but here at least they acknowledged, as they said, a universal belief.

Muslim acknowledgement of a Jewish historic bond to this holy site changed following Israel's victory in the 1967 war, when Jerusalem came under Israel's control.

1. 'Study denying Jews rights to Western Wall resurfaces on official PA website' – Khaled Abu Toameh (Jerusalem Post 5.12.10.)

Palestinian and Muslim leaders began to alter their line. While the stories they recount differ from one to another, they are consistent in their attempt to erase the Jewish connection to the Temple Mount, Jerusalem, and indeed all of Israel.

Below are examples of statements by Palestinian political and religious leaders and academics, as well as other Arab and Muslim leaders, denying the Jewish connection to Jerusalem and the Temple Mount, especially during negotiations over Jerusalem and its holy sites.

Yasser Arafat feared acknowledging the existence of a Jewish connection. As he told President Clinton: *"I am a religious man, and I will not allow it to be written of me in history that I have confirmed the existence of the so-called Temple underneath the mountain."*

Al-Hayat al-Jadida, August 12, 2000

Palestinian President Mahmoud Abbas, bolstered by the west as a moderate, similarly denies that a Jewish Temple existed on the Temple Mount. He was quoted as saying: *"They* (the Israelis) *claim that 2000 years ago they had a temple. I challenge the assertion that this is so, that there has ever been a Jewish Temple. But even if it is so, we do not accept it, because it is not logical for someone who wants a practical peace."*

Kul al-Arab (Israel), August 25, 2000

Try figuring out that brain defying piece of logic. The Holocaust-denying, Jewish history-denying, Mahmoud Abbas is an idiot.

Why do we have to negotiate away our crown jewels with these dangerous idiots? It does not stop at the top. The erasing of any Jewish connection to Jerusalem seeps down the Palestinian hierarchy.

Nabil Sha'ath of the Palestinian Legislative Council and senior advisor to President Mahmoud Abbas, who previously was chief negotiator in Israeli-Palestinian talks, labels the Jewish Temple as *"fictitious."* He said: *"The Israelis are insisting on sovereignty over the Al-Aqsa Mosque on the pretext that an Israeli temple is buried beneath it and that, through their continued sovereignty, they can one day unearth it. Their claim was not substantiated by the excavations they carried out around and under the mosque."*

Voice of Palestine radio station, July 26, 2000

He also said, *"Israel demands control of the Temple Mount based on its claim that its fictitious temple stood there."*

Al-Ayyam, July 27, 2000.

Walid Awad, foreign press spokesman for the Fatah Central Media Commission and formerly director of foreign publications for the PLO's Ministry of Information, stated an interview with IMRA on December 25, 1996: *"There is no tangible evidence of Jewish existence from the so-called 'Temple Mount era.' The location of the Temple Mount is in question. It might be in Jericho or somewhere else."*

Awad accused Israel of falsifying history and archeology after 1967 in order to *"create"* a Jewish

197

connection to Jerusalem: *"Immediately after Israeli soldiers occupied Arab East Jerusalem back in 1967, the Hebrew University, the Israeli Ministry of Religious Affairs, and the Department of Antiquities collectively and individually began a massive excavation campaign in Arab East Jerusalem in a bid to find allocate traces of Jewish existence from the so called 'Temple Mount era.' The fact of the matter is that almost thirty years of excavations did not reveal anything Jewish, no tangible evidence of theirs was unearthed. Much to their chagrin, what surfaced from their underground excavations turned out to be more Muslim palaces, courts and mosques. Other excavations revealed archaeological ruins belonging to the Romans, Greeks and Canaanites. To give credibility to these claims, and to translate the ingenious falsified historical accounts of the city in order for them to obtain worldwide authenticity, the Israeli archaeologists and authorities decided to manipulate and connect the history of Jerusalem as they want it to be seen by the world, and to present it in a way acceptable to contemporary thinking of everyday people. Jerusalem is not a Jewish city, despite the biblical myth implanted in some minds. Nothing tangible has been found to give credibility to these claims."*

That's quite a detailed investigation. The only problem is it's not true. In fact, when Israel conquered the Old City of Jerusalem in the Six Day War of 1967, Israel immediately, as a gesture of peace and reconciliation, gave custodianship of the Muslim holy sites in Jerusalem to the Islamic Wakf. This privilege is now being abused.

During Jordan's nineteen-year occupation of eastern Jerusalem (1948- 1967), Jewish holy places were desecrated, vandalized and destroyed. Jews were denied access to their holy sites (including the Western Wall and the Temple Mount area) in violation of Article 8 of the 1949 Israeli-Jordanian armistice agreement.

Christian churches were prohibited from buying property in Jerusalem and Christian religious organizations were restricted from owning property near holy places.

When Israel recaptured East Jerusalem in 1967, containing Judaism's holiest sites, Israeli Minister of Defense, Moshe Dayan, immediately ordered soldiers to remove an Israeli flag that had been raised over the Temple Mount. He declared, *"To our Arab neighbors we extend the hand of peace. To members of the other religions, Christians and Muslims, I hereby promise faithfully that their full freedom and all their religious rights will be preserved. We did not come to Jerusalem to conquer the holy places of others."*[2]

Since then the issue was hijacked by Arafat, and more recently by the Palestinian Authority, to deny Jewish rights and history and impose a Palestinian fraud.

Arafat often used Jerusalem, and the Muslim holy sites, as a rallying cry to violence. It is not by accident that he called one of his terror groups the Al-Aqsa Martyrs Brigade.

[2] Meron Benvenisti, 'Jerusalem: the torn city', Isratypeset, Jerusalem, 1976).

As mentioned earlier, during the July 2000 negotiations at Camp David, Yasser Arafat refused to acknowledge Jewish ties to the Temple Mount, claiming the Jewish temple never existed there.

When talks resumed in Taba later that year, the Israelis agreed to full Palestinian sovereignty on the Temple Mount, but requested that the Palestinians acknowledge the sacredness of the Temple Mount to Judaism. They refused.

The then-Foreign Minister, Shlomo Ben-Ami, a left wing Israeli politician and an academic sympathetic to creating Palestinian self determination, told Ari Shavit in a Haaretz interview on 25th November, 2001: *"What particularly outraged me on that occasion wasn't only the fact that they refused, but the way in which they refused: out of a kind of total contempt, an attitude of dismissiveness and arrogance. At that moment I grasped they are really not Sadat. They were not willing to move toward our position even at the emotional and symbolic level. At the deepest level, they are not ready to recognise that we have any kind of title here."*

Throughout history, Jerusalem's stature as a Muslim holy city typically diminished during periods when it was securely under Muslim control.

As Dr. Daniel Pipes chronicled in an overview of the topic: *"The stature of the city, and the emotions surrounding it, inevitably rise for Muslims when Jerusalem has political significance. Conversely, when the utility of Jerusalem expires, so does its status and the passions about it."*

"The Middle East Quarterly", September 2001

Professor Jacques Gauthier devoted twenty five years of his life to the study of who has the legal claims to Jerusalem. His deeply researched conclusion was that the Jews have exclusive sovereign rights, both historically and legally, to rule over Jerusalem. His dissertation, running to one thousand three hundred pages, comes down solidly, based on facts and international law, on the side of Israel.

Since 1967, there has been a growing attempt by Palestinians to whip up religious fervor in the Arab and Muslim world in order to wrest Jerusalem from Israeli control.

Historian Dr. Yitzhak Reiter wrote in a 2005 study that was entitled *"From Jerusalem to Mecca and back: The Islamic consolidation of Jerusalem."*

"Their campaign involves denying the Jewish connection to Jerusalem and the Temple Mount while advancing Jerusalem and particularly the Al-Aqsa compound's sacredness in contemporary Islam.

It also involves reinventing history to create an Arab connection to Jerusalem predating the Jewish one. Even now, there are mounting accusations that the Muslim Waqf is deliberately destroying ancient Jewish artefacts and structures from the First Temple period under the guise of renovations on the Temple Mount in order to erase any archaeological evidence of Jewish existence there."

It is clear that Jerusalem isn't the most holy Muslim site, as it is to the Jews. It is for them in third place after

Mecca and Medina. When Muslims pray, even on the Temple Mount in Jerusalem, they do so facing Mecca.

How is it, I wonder, that Christianity has no problem with Israeli sovereignty of Jerusalem?

Jerusalem, for Christians, is more important in their religious history than it is for Muslims. The Muslim religious claim is based on a dream that Mohammad once had of some distant place. Christian reverence for Jerusalem is synonymous with Jesus. It is based on events that took place there, at the Mount of Olives, to the Garden of Gethsemane, to the Jewish Temple on the Temple Mount. By denying a Jewish history and a Jewish Temple, the Palestinians are also denying Christianity its heritage. For, without a Jewish Temple, the events of Jesus could not have taken place.

This, more than anything else, should drive Christianity to the defense of Israel over a false Palestinian narrative. Sadly, with notable exceptions, it does not seem to have done so. Leaders of Methodist, Anglican, Presbyterian, and some Baptist churches fall in line with the Palestinian argument against Israel. I outline the root cause of this in my chapter on Replacement Theology.

The Palestinians are backed in their falsehood by the United Nations. The United Nations have not only perpetuated the narrative of Palestinian dispossession by maintaining them as refugees in far off Arab lands for decades. They also champion their religious narrative today by dispossessing the Jews of their heritage.

UNESCO has called Rachel's Tomb, another indisputable Jewish holy site, a Palestinian heritage site. They have accepted the Muslim renaming of this ancient Jewish shrine. To them it is now Bilal bin Rabah Mosque, a name that did not find itself until its invention in 1996.

Jewish biblical references that go back as far as Genesis have no significance to a United Nations Cultural and Educational Organization. Instead they claim that this Palestinian cultural site is endangered as a result of Israeli occupation.

In the Jewish Torah, and in the Bible, it is written:

> *"And Rachel died, and was buried on the way to Ephrath, which is Bethlehem. And Jacob set a pillar upon her grave: that is the pillar of Rachel's grave unto this day."* Genesis 35:19-20

Throughout history, this event has remained undisputed by Jew, Christian, or Muslim until 1996, until a rewriting of history and culture by UNESCO.

The Palestinians were ably aided by Turkish Prime Minister, Recep Erdogan, who said that the Tomb of the Patriarchs in Hebron and Rachel's Tomb between Jerusalem and Bethlehem *"were not and never will be Jewish sites, but Islamic sites."* Erdogan joins the Palestinian plan to wipe out thousands of years of Jewish heritage. It is an essential part of his Islamic cause.

But the Bible goes on to state, *"A cry is heard in Ramah, Rachel weeping for her children. She refuses to be comforted."* Thus said the Lord: *"Restrain your voice from weeping, your eyes from shedding tears, for there is reward*

for your labor. Your children shall return to their borders. "

Jeremiah 31:15-17

Claiming our Jewish forefathers tomb, Rachel's grave, and Jewish Jerusalem as Islamic possession will not remove our national redemption. Our heritage has sustained the Jewish people throughout history and no retelling of a false Palestinian and Islamic narrative will erase it. Neither is the cause of peace served by this falsehood. You cannot bury the truth with lies. Mutual recognition and respect is a precondition of peace.

If Palestinians have any claim on Jerusalem it is a tenuous Islamic one based on nothing more than a dream.

Mohammed once had a dream of a night journey to a distant shrine. His dream, according to Islamic sources, did not identify this far off place, but various later interpretations, beginning in the Eighth Century, declared this place to be Jerusalem.

It was done to give a religious significance to the Muslim conquests at that time. Mohammed was in Mecca when he had this dream and Mecca remains the holiest Islamic location. It is admitted that, physically, Mohammed never visited Jerusalem.

This hardly justifies giving Palestinians sovereignty over the city. Guardianship over the Islamic holy places should be a religious task. The connection is between Mohammed and Islam, not between Mohammed and Palestinians. A minority of Palestinians are Christians who know that Jesus was a Jew, and not a Palestinian.

The Waqf, who was given his authority to control the Islamic holy places in Jerusalem by the Israeli Government, has repeatedly and criminally used their tenure on the Temple Mount to excavate and destroy Jewish heritage.

At the end of 1999 they began excavating and removing tons of rubble to create a new Marawani underground mosque, the third mosque on the Temple Mount. It is located at the only existing construction from the time of Herod. Known as King Solomon's Stable it lies under the Al-Aqsa mosque which was built later.

The Waqf presented a request to the Barak Government who gave permission for two entrances to be built and only to be used as emergency exits. They began work on a Thursday afternoon and worked solidly twenty four hours a day through Friday and Saturday, which are the Jewish Sabbath days. It was only on later Sunday morning that members of the Antiquities Department and archaeologists came to inspect the maintenance work.

They found that tons of archeologically rich rubble had been removed. Observers counted seventy tractors and diggers leaving the Temple Mount. It was estimated that three hundred trucks of valuable and irreplaceable rubble was removed from the site and dumped into the Kidron Valley.

Since 2004, Professor Gabi Barkai has been sifting through the debris in a vain attempt to identify and remove valuable artifacts and salvageable ancient relics, evidence of past sovereignty and history. Israeli archeology involves painstakingly and cautiously sifting to avoid causing

accidental damage to unique and precious items. Palestinian excavations included mechanized digging that caused deliberate and extensive destruction.

This is illegal according to the laws and regulations governing archaeological sites. These are the high standards set by Israel to protect the heritage sites of the Holy Land.

Then, in 2007, the Palestinian Muslim Waqf requested from the Olmert Government to carry out some light maintenance work on the plaza of the Temple Mount between the Al-Aqsa mosque and the Dome of the Rock.

They began digging a four hundred meter trench that ripped up ancient artifacts and remnants of the original wall of the Temple itself. As Zvi Raviv explained to me, *"They abused our stupidity!"* As Gabi Barkai put it, *"These are criminal acts that have no place in a cultured country."*

Dr. Eilat Mazar saw the wanton destruction and demanded that the Israeli Government and the Antiquities Authority stop this unsupervised digging and That the tractors be removed.

"The archaeological damage is many times worse in light of the fact that the ground level is only slightly above the original Temple Mount platform. In fact, the bedrock has been uncovered in some places meaning that earth that has been in place for many centuries, even possibly since the First Temple, has been removed. No other country in the world would allow such grave damage to its most precious archaeological treasures."

Indeed it is akin to the Acropolis in Athens or the Coliseum in Rome being destroyed to create yet another

206

mosque. This criminal activity of stealing and destroying personifies the Palestinian narrative. In its action, the Islamic crusade of destruction removed all vestige of Jewish heritage and identity and replaced it with Muslim facts on the ground.

If this had been Israel destroying a major Islamic site a global Islamic jihad would have erupted.

Muslim rights to worship at their holy sites must be, and have been, respected by Israel, except when worshippers have become a violent mob.

Muslim holy sites are, religiously, Islamic. They are not, religiously, Palestinian.

The Palestinians can shout until they are blue in the face but Jewish sites, built under Jewish sovereignty by Jewish kings, belong to the Jews. It's really that simple. You have to be an idiot to deny it. This Pallywood version of history cannot stand the scrutiny of archaeological proof. They, therefore, must destroy the Jewish evidence.

For Palestinians, the true narrative is clear. The Palestinians have built their administrative and legislative centers in Ramallah. This is where their national hero, Arafat, is buried. In any future peace agreement with the Palestinians, Ramallah is where their capital deserves to be – not Jerusalem.

RAGE

Pieces written at moments of contemplation, anger, and despair.

TOUGH LUCK! WE'RE HERE TO STAY!

Abuse. Destruction. Exile. Persecution. Massacres. Concentration camps. Genocide. Wars. Terror. Demonization. Delegitimization. Anti-Semitism. For thousands of years.

Now you claim that you don't like the way I talk. Don't like the way I write. I'm not polite. Rude.

Tough luck!

You want to get abusive again? Let me tell you. You don't push us around anymore. We are no longer the meek, weak, Jew, walking submissively into the gas chamber. Don't like that? Tough luck!

You say we act like bullies? Then, get out of my face.

You hate it when we hit back hard. Try living in my neighborhood and let's see how you behave.

You think you can get the world to gang up on us. Try it. We'll circle our wagons and hang on to what we've got. It's fortress Israel time.

Let me give you a warning. You spit on me. I'll slap your face. You hit me. I'll break your arms. Just want to let you know. We don't take your crap any more.

I don't buy your bluff. I don't trust a word you say. Don't ask me to play nice in return for your promises. I don't believe you. You want me to put my fate in your hands? Who are you kidding? I do believe my enemies. I have learned one thing down the years. When my enemies tell me that they intend to kill me, they mean what they say. So don't tell me to be soft. Soft doesn't sell in my neighborhood.

To my enemies, let me say one thing. Your wars didn't work. Your terror scarred my soul, but didn't break me. You can't talk me out of my existence. Your rockets failed to dent me. You want to try nuclear? Don't even think about it!

Don't like my attitude? Think I'm pushy? Shouldn't be around? Tough luck! We're here to stay. Live with it!

<p style="text-align:center">* * *</p>

WHO ARE THE RACISTS IN THE MIDDLE EAST?

Palestinian Arabs and their supporters constantly call us racists. It's a part of their demonization campaign against Israelis. Let's see who the Middle East racists really are..

- You attacked us on all fronts on Yom Kippur, the holiest day in the Jewish calendar.

- You send your suicide bomber to massacre worshipers at Netanya's Park Hotel on Passover, the festival that celebrates freedom from slavery in a foreign land and redemption in the Jewish land of Israel.

- You destroy Jewish holy sites in Jerusalem and Joseph's Tomb.
- You steal the Jewish heritage of the Tomb of the Patriarchs in Hebron and Rachel's Tomb near Bethlehem in the name of Islam.
- You desecrate the Church of the Nativity in Bethlehem.
- You drive out the Christians from that holy town.
- When we call our nation the Jewish State of Israel you have the chutzpah to tell us that this is racist and discriminatory.
- You, the people who are led by a man whose university thesis was Holocaust denial and by a terror group that quotes Anti-Semitic slogans in its charter.
- Who are the racist discriminators when the Palestinian Authority imposes the death penalty on any Arab who sells his land to a Jew?
- Who are the Nazi racists when the Palestinian Authority insist that any territory we give the Palestinian Arabs for a future state must be Judenrein – free of Jews?

So tell me, who are the racists in the Middle East?

* * *

WHOSE LAND IS IT ANYWAY?

You have failed to check whose land it is anyway.

You have accepted without question their narrative that the land is theirs to control and administer.

In your ignorance you may even believe that they once had a state of Palestine that was taken away from them by force. That they only want it back.

Again, wrong!

What if I told you that the only authority holding legal rights to Palestine, recognized under international law, is Israel? This is true. Look it up.

This powerful and irrevocable argument. is enshrined in international declarations and law. I do not even need to quote the famous Balfour Declaration. It is sufficient for me to start with the San Remo Declaration of 1920 that mandated the whole of Palestine as the national home of the Jewish people. This was cemented into international law, at the League of Nations in 1922. It was reconfirmed later when the United Nations replaced the League of Nations. It is indisputable that the land was mandated to Israel as guardians of the nation home of the Jewish people.

There was never any history of Palestinian rule over any of the land. Acceptance of this fact by the Palestinians would go a long way to creating the necessary and basic foundations of trust so lacking today and portrayed in decades of rejectionism and refusal on their part. In short, it is up to Israel to transfer legal rights to the land to the Palestinians, or not. It is amazing to me that this argument has not been pounded repeatedly by any Israeli government

for years, in diplomatic circles as well as in the court of public opinion. It is irrefutable.

* * *

THE PAINFUL PROGRESS OF ISRAEL WHILE THE HATE GOES ON.

Tell me of a nation that has been shot at, vilified, and persecuted, as much as Israel.

Tell me of a nation that has risen so brightly and brilliantly above the hatred, the scorn, and the vindictiveness as Israel.

You will talk to me of occupation. I will tell you how a fledgling sliver of fragile earth was trampled on by invading Arab armies and hordes of fanatical Islamic terrorists and murderers.

You will talk to me of oppression. I will tell you how Israel rose above the heavy and bloody weight of murderous intent to develop one of the most modern and democratic nations on earth.

There are those who claim the Oslo Accords opened the door to a future peace. Others will see this as opening the gates of the Jewish state to allow the Trojan Horse of an Arafat-led Jihad into the region.

There are those who say the uprooting of Jewish settlers from parts of the Promised Land is a defiance of a religious and historic legacy. Others will claim that the few who acted on a dream of a Greater Israel delayed the

potential for a peaceful resolution of the crisis in our region.

Tell me of a nation that was attacked in its weakness by surrounding nations, determined on its eradication, yet one that still offers up a slender piece of its territory on the altar of compromise.

You may repeatedly condemn and insult this tiny nation. Yet, she will continue to be a beacon for the future.

The dangers that Israel faced yesterday are your new threats today. The solution that Israel is taking today you will adopt tomorrow. For you have been slow to realize that what threatens Israel today will devour you tomorrow.

Thus has history been, repeatedly.

But today, Israel has the strength, the intelligence, and the will, to suppress the external dangers while offering the olive branch of peace.

Today, Israel is in the painful spasms of resurrecting an ancient historic heritage and dream. Those who have developed the land are being uprooted, like fledgling olive trees. Yet these same Israelis will continue their important pioneering spirit. They will yet contribute to the splendor and heritage of the Jewish state.

Olive trees grow in rugged and infertile soil, yet flourish into character and beauty. So it is with Israel.

A DIFFERENT FORM OF LOGIC

Here, in the Levantine Middle East, a different form of logic is required to properly grasp reality. One needs to wipe away the fog of rhetoric and strident voices of hate to see the truth. So let me give you a different form of logic for discussing war, terror, land and peace. This logic is derived from the prism of the Levantine world we live in. Simply try to follow the thread in these two examples;

Israel is giving up land to achieve peace. This is happening because Israel has known wars and terror for decades, since its re-establishment. It does so because it yearns for peace.

The motto was *"land for peace."* In other words, Israel gives land for Palestinian and Arab peace. Yet, when we do, the new demand from an increasingly confident Palestinian leadership, after receiving territory, becomes *"give us even more land or you* don't get peace!" In other words, *"give us more land or we'll continue to kill you!"* This is bloody blackmail!

And when we give up land for peace, and there is a regime change, we end up with no land and no peace.

Now let me apply a different form of logic in the second example. Israel is attacked, reviled, and isolated, therefore downtrodden and oppressed, a victim of war, terror, and delegitimization. Palestinians are the proxy fighter set up by the Arabs and Iran to fight their battles by attacking us. The prize is Palestine - all of it. The order is *"Go kill the Jews and enjoy the booty."* The Palestinians are, therefore, the Arab and Iranian weapon while the patrons sit back and cheer or

214

jeer from the sidelines. If the Palestinians get bashed by Israel it's part of the fight promoted by those who are holding the tab for the Palestinians.

When Israel responds they complain, just as football spectators boo an opposing foul. So, who is to blame for the violence? Israel fighting a defensive battle on our own soil, or the aggressive Arabs who want to take what does not belong to them?

See the logic? They try to sell it to a twisted world that sees the issues through the logic of a warped mirror.

* * *

I BROOD A LOT ABOUT OUR FATE

We are a maligned people. Always have been. Look at us down the ages. We are intelligent, successful, wealthy, always contributing to society, always, rejected, demonized, and persecuted. Always weak. Our weakness has been our undoing. Nothing has changed today, except we are strong and they hate us for that too. This strength has helped us survive when others would have fallen. Our strength is derived to, finally, being home. Our dispersion added to our weakness. Our strength is knowing that we are, at last, home. Yet this is insufficient.

Since our deliverance at the UN in 1947 and our declaration of self determination in 1948, we have been attacked and pilloried ever since. The very organization that granted us our freedom cannot find a place for us in its numerous chambers. Israel does not have a permanent representation in any of the global groupings. Neither does

it belong to the non-aligned nations. Politically we are truly alone, supported through the years only by the United States.

Even this does not spare Israel, the Jew among nations, the slights and insults as we are charged with having undue, and therefore unseemly, influence over America's foreign policy.

The powerful Arab lobby, with the weapon of oil, is overlooked and relegated to the sidelines. It is the Jewish state that is the butt of vilification.

This is enhanced, in the telling, with the accusation that Israel and the Jews control the media and the banks. Undeniably, there is bad intent at play against us.

When we fight to defend ourselves we are called war criminals.

When we claim our rights to our land we are called thieves.

We have, indeed, become the modern day Shylock locked in our own ghetto, reviled by the spiteful world. As a Shylock, dare I ask *"when you prick us, do we not bleed?"*

If you give us no other option, if you hate us so much that we only have our survival to fall back on, then we are justified to shout, as Shylock once did *"The villainy you teach me, I will execute, and it shall go hard, but I will better the instruction!"*

* * *

THE LIES THAT BIND – MEDIA AS A TOOL OF PALESTINIAN PROPAGANDA

When does the media becomes a propaganda machine? When it serves the purpose of a political bias and suspends the truth in favor of forming popular opinion. When it creates, by its false reporting, an alternative reality. That is what has happened with most of the Western media when it comes to Gaza. For years, the media has been sharing a bed with lying radicals. They have been the voice of an Islamic terror regime, patronizing them by closing a blind eye to their crimes and supporting them by echoing their unfounded statements in their broadsheets. In the fight for the minds of men, news and truth are not the same. The public is lazy, apathetic, when they read their newspapers, or watch the news on their television sets. They prefer to believe what is put in front of them than take the time, and make the effort to research the facts.

It's easier to accept the narrative, especially if it colorful and emotive, as factual, even if the element of truth is tenuous. When repeated often enough, the fraud becomes fact in the mind of the apathetic reader or viewer who find themselves quoting the reiterated mantra. This is precisely what has happened with the Palestinian narrative of victimization and sufferance. The truth got lost, years ago, in the fog of emotional perceptions. There are victims, there are oppressors, in the Middle East conflict.

Which is which in your mind? With which side do you sympathize? Who do you hate? Is your opinion formulated by what you have read, or opinions heard on your TV?

When you are told that the living conditions in Gaza are horrendous, and Israel is to blame, are you convinced that your opinion is based on truth, or media lies? Will you accept that contrary evidence may cause you to reassess your opinion? Or are you hardened into a biased frame of mind, and nothing will convince you that you have been deceived? I, also, was a lazy news sponge, until something hit my desk that made me question what I was being fed by the major news and media outlets. I searched the web. It was then that I began to find a completely different scenario, one that screamed *"lies!!"* at every report and statement emanating from the pro-Palestinian camp, their supporters, but worst of all from the so-called "neutral" media. I discovered facts and evidence that were in direct conflict with their reports wrapped in emotive language. The use of language paints the political landscape. It forms public opinion around which politicians can craft their agenda.

Let me begin to set the record straight by highlighting the language used by the Gaza flotilla.

Firstly, it was not an aid convoy. It was a massive political propaganda machine. Second, the Israeli blockade on Gaza is legal. Third, aid, goods, money still flow into Gaza via properly supervised control points coordinated with the Palestinian Authority, designed to stop items that can be used for terror purposes from reaching Hamas terrorists. The activists on board the six ships wanted one of two things to happen:

1. To have the world see the Israeli navy prevent them reaching Gaza and, thereby, make propaganda capital out of it.

2. If not challenged by the navy, to be seen hugging the Hamas leadership in solidarity.

Either outcome would give them some sort of victory against the Zionist enemy. That is why they are financed. This is their sole aim, not supporting the Palestinian people as aid, goods, and luxury items are getting through to them.

There is only one agenda at work here. Hate Israel! None of the people on board the ships had any conviction to engage Israel except in confrontation, or to find a mutual solution, or to persuade the Palestinians to accept the generous peace terms offered to them by Israel for decades, or to act positively for the benefits of peace.

Hamas remains a designated Islamic terror organization. Hamas remains dedicated to eliminate Israel, by force if necessary. Yet this did not stop hundreds of international radicals from boarding ships and sailing for Gaza in a fanfare of publicity. They did so with one motive. Hate Israel!

Those that promote the Palestinian cause over other, more deserving causes, do so out of one driving motivation. Hate Israel! They abuse language by using baseless, emotive, phrases that exaggerate the Palestinian position in an attempt to shock the world into supporting them, and hating Israel.

They have succeeded, with the cooperation and participation of the media. They do so with images and statements that are, quite frankly, lies.

They commit fraud by deliberately framing a narrative that is untrue, and they do so with the connivance of the media. To corroborate this point, the media should be forced to print the facts, the photos, to explain the videos, that show a middle class lifestyle in Gaza that is in complete contrast to the false imagery that has been spoon fed to the public for years. The editors will tell you that they only print what they are told, such as the lie that no building materials were being allowed into Gaza for reconstruction. Yet they fail to report the massive construction of luxury apartment blocks, superb mansions, mosques, public and governmental facilities, Olympic-size swimming pool in Gaza City, extending the Gaza harbor, all and more built, miraculously, without materials or equipment. The editors will tell you that they only repeated the claims that Israel was blocking basic needs from getting into Gaza, Yet they refuse to investigate the shops bulging with clothes, food supplies, toys, cakes, candies, and imported items. The editors report that the children are suffering, but they don't print the news of 200,000 laptops that were delivered to the kids in Gaza via Israel.

If a free press is proud to print fair and balanced news why haven't they done so? If major newspapers and TV channels are serious about investigative reporting why haven't they exposed the truth that there is no humanitarian crisis in Gaza, and why are these lies perpetrated. Instead,

they are the perpetrators. If human rights activists are indeed what they claim to be, why have they not insisted that Palestinians are doing fine and that it is time to divert some of the record amounts of international funding to more worthy and needy causes, such as thousands of children dying in Africa, not due to lack of laptops, but due to lack of attention, malnutrition, and disease. And maybe the media should champion this cause and distance themselves from the corruption and lies that are an integral part of the Palestinian narrative.

* * *

WESTERN SUCKERS

Well, here we go again! Yet again, American and European leaders pledge obscene amounts of money to the world's biggest cry babies. Sorry, that should read the world's richest refugees. Who do I mean? What, you can't guess? Why, the Palestinians, of course.

Despite having Swiss bank accounts bulging with cash, they plead victimhood and poverty - and the world laps it up. Despite receiving huge amounts of foodstuffs, materials, fuel, equipment, and other aid, the West accepts the lie that the Palestinians are deprived prisoners. Palestinians in Gaza receive thousands of trucks carrying hundreds of thousands of tons of aid, and millions of liters of fuel that entered the Gaza Strip from Israel at the Kerem Shalom, Erez, and Nahal Oz official crossing points. One hundred and eight thousand Palestinians entered Israel for

medical treatment at Israeli hospitals during 2010. Some blockade!

So, Palestinians, stop crying crocodile tears! Truth be told, there were crossing points that are closed to the Palestinians. They were the ones controlled by the Egyptians - not Israel. Hey! Why should that simple fact get in the way of portraying Israel as the bad guys, and the poor Palestinians as victims of the Jewish Zionists? By the way, the Egyptians had their own reasons to clamp down on the Palestinians of Gaza. They were scared of Palestinian bad intentions. So, leaders of eighty countries pledged to shovel a further 3 billion dollars in to Hamas-controlled Gaza.

Hillary Clinton pledged one billion dollars on behalf of the suffering American tax payer in October 2010. That's on top of everything else they have received up to now, and will receive in the future, including from Israel.

The Taxpayers Alliance in Britain monitors the abuse of British taxpayers money that funds incitement in Palestinian children's education. They do sterling work but their voice is muted.

The various United Nations organizations, that are self-perpetuated on the false premise that people living in the Gaza Strip are refugees, can now budget their salaries and expense accounts for the next decade. UNWRA is a huge organization. A huge proportion of its efforts go into the Gaza Strip which is headed by Hamas, a terror organization plotting to take over the Palestinian Authority. And don't tell me that the billions will not find its way to Hamas and Islamic Jihad. If this funding does not end up in

222

the pockets of Hamas then I'm a ballerina! The authoritarian control of Gaza by Hamas makes the fact that Hamas is the ultimate recipient of funding so blindingly obvious to everyone except the naïve diplomatic corps. Who works for UNWRA and receive wages during the day and plays terrorist by night? Why Hamas and Islamic Jihad members, of course. Want to know who finances the activities of UNWRA in Gaza? 50% is financed by taxpayers in the European Union countries. 31% is financed by American tax payers. Only 7% is financed by Muslim countries. And you thought that the Arabs would be first in line to help their fellow Muslims? Wrong again! In the current world economic crisis, why do Western governments continue to pour taxpayers money into an area that is ruled by a tyrannical Islamic terror regime, dogmatic in its ambition to eradicate Israel? Don't they get it? Why is a ruthless, lawless, corrupt Gaza deserving of massive Western aid when other, better deserving sources of poverty, famine, and disease, go ignored? And they are getting it while they continue to fire rockets indiscriminately into Israel. You would have thought that the donors would have made their contributions conditional on Hamas stopping their terror activities, not only against Israel, but also against their fellow Palestinians who may prefer secular Fatah to the radical Islamic organization. By the way, Hamas kills Palestinians. Look it up.

Hamas has killed more Palestinians than Israelis. That's a fact. It was not for want of trying. It just happens that pro-Fatah Palestinians are easier prey than the well-

trained Israeli soldiers, and well-protected Israeli civilians under rocket bombardment. And you wonder why Israelis vote for a tougher, no nonsense, government. We are living in a tough, ruthless, and corrupt neighborhood where our enemies are being revitalized by well-meaning (read "stupid") Western leaders who give away your money freely with no strings attached. The Arabs know better.

* * *

CRITICAL JEWS

The intellectual violence perpetrated against us is usually followed by the intellectually arrogant.

These are the people who preach to us about our lack of social justice. Trailing closely behind is the intellectual claptrap with their noisy slogans of *"massacre,"* *"apartheid,"* *"war crimes,"* and *"racist,"* slogans that apply, more aptly, against my enemy.

Regrettably, some of the more high profile intellectually arrogant are Jews. They pontificate that their Judaism is one of social justice. A virtue, they claim, that is lacking in Israel. For them, this takes preference to any Jewish nationalism or historic heritage.

They willingly abandon their ancient values and Jewish self determination and replace it with Jewish justice for all. They would surrender Israel on the altar of humanity but will they be around, I wonder, when Israel is lost and our heritage plundered? Will their lack of concrete Jewish heritage bring them to erase "Next year in Jerusalem" from their Passover Seder prayers, a ceremony that will have zero

significance to them, or the breaking of the glass as the significant highlight of every Jewish wedding ceremony. This unusual symbolic act recalls, at the groom's happiest moment, the destruction of the Jewish Temple in Jerusalem.

When they unjustly employ a social justice weapon against Israel, they join the lethal crusaders against the Jews of Israel. To Israel's enemies, there can be no social justice for an Israel under constant attack. When Israel falls, as it must if an Islamic victory prevails, they will be silent, as silent as were the American Jews who refused to campaign for the Jewish passengers on board the ill fated St. Louis in 1939.

The desperate passengers who had escaped Nazi-controlled Europe pleaded to be let into America. No social justice for them. The St. Louis returned to deliver its Jewish cargo into the hands of the Nazis. American Jewish social justice is warped and cruel. They claim a higher Jewish virtue but they use it wrongly and in a dangerous fashion.

Like all good Jews, I stand for social justice but my social justice begins at home. I will apply social justice to my neighbor when my neighbor proves to me that he is not my enemy and that he recognizes my social justice.

Let me say it clearly. There is no Judaism without Jews. There is no true Judaism without Israel.

ENOUGH OF PALESTINIAN LIES. IT'S TIME TO FIGHT BACK WITH THE TRUTH

Enough of Palestinian lies. It's time to start fighting back with the truth. A fiction has been allowed to take hold. This fiction is known as the Palestinian narrative. It is the creation of a myth that has been told repeatedly so many times that it has been accepted as fact.

The falsehoods have been regurgitated endlessly in the media as to become the standard mantra. The message has become the rallying cry around which support groups are formed. Immense budgets are given to forward part of the agenda that is contained in the narrative. Activists take to the podium, the media, the universities, and to the streets. Any voice that challenges the veracity of the campaign is muted, ignored, suppressed, and even impeded with violence.

The accepted narrative is used to criticize, condemn, delegitimize, and even question the validity of the other side.

I represent the other side. I now say: "Enough!" Enough of the lies! It is time to fight back! It is time to expose the lies. It is time to expose the truth. Let's rip their narrative to pieces. Bit by bit.

This is a master class to be used against those to profess to be pro-Palestinian and anti-Israel. It exposes some of the slogans and arguments used by them to delegitimize Israel. Occupation? Yes. We are occupying our own land. How do you like those apples?

Israel withdrew every living person, and even the dead, from the Gaza Strip. Yet Palestinians and their supporters still call the Gaza Strip *"occupied."* How nonsensical is this?

The only Jew occupying Gaza doesn't want to be there. His name is Gilad Shalit, suffering five years of total isolation in inhuman conditions. If they really hate the occupation why doesn't Hamas evict him? Instead, they enjoy playing him as a bargaining chip.

I heard the argument that all they want is the creation of Palestine with Jerusalem as their capital? I guess that sounds reasonable. You assume that they only want what belongs to them, namely the West Bank, the Gaza Strip, and East Jerusalem, alongside Israel. Right?

Wrong! Why don't you listen to what they are telling their own people? Why don't you check the infamous Charters of both the Islamic terror regime of Hamas and the more "moderate" Fatah? There you will find the truth.

From their perspective, all of Israel belongs to them. Occupation does not apply only to Gaza and the West Bank. It applies to Tel Aviv, Haifa, Afula, Beer Sheva, Netanya. You name it, it's theirs.

The truth is that, for them, occupation will remain a rallying cry until all of Israel falls under Islamic Palestinian control, with Jerusalem as its capital.

Ask any Palestinian about the *"Nakba."* This new expression has become part of the glue of the Palestinian narrative. The Nakba, or disaster, is how the Arab world refers to the establishment of the Jewish State of Israel on 15th May, 1948. It only found expression in recent years as a rewriting of a false Palestinian history. For them, it is a historic mistake that must be rectified. They would have you believe that they controlled the land before 1948 and deserve to have it back. Untrue!

At a recent Nakba rally within Israel, the Islamic movement leader (yes, there is such an organization in democratic Israel), Raed Salah, called Israel *"a cancer that will be removed."*

That's how we allow free speech in our country. He called on Fatah and Hamas to unite not to reach a peace agreement with Israel but to *"unite against the occupation until the state of Palestine is established with Jerusalem as its capital."*

Sound familiar? Maybe a nation united with Jerusalem as its capital is Israel?

* * *

BRAND NAME 'PALESTINE' SIMPLY WON'T WASH

Being "For Palestine" is really being "Against Israel." Being for Palestine is a trendy way of proving yourself whiter than white. Something like a modern day Palestinian Persil. Immerse yourself in this fabulous Palestine Persil,

call your Israeli competitor a Nazi, and you emerge smelling like roses. Just like the old tired advert promoted by the Mad men, it's full of imagery and very little substance. For when they emerge from their dowsing in brand name *'Palestine'* they need to be reminded that the stains of Hamas, Islamic Jihad, human rights abuses, corruption, violence, lack of democratic process are still there for all to see, unlike the Israeli brand which is shiny white by comparison.

The branders are uncomfortable with their reject product. Issues like gay rights, women's equality, children's hate education, minority discrimination, and violence, leave the image they are trying to project in shreds. Try, as they may, to blame these defects on the Israel brand simply won't wash.

MY MEETING WITH SHAKEEL IN NETANYA

I met Shakeel outside the Park Hotel in Netanya. Shakeel was the South East Asia correspondent of the BBC. We began our interview in the banqueting hall that was the scene of the Passover Massacre. The Palestinian terror attack killed over thirty, and injured hundreds, some of whom are still trying to rehabilitate back into a normal life style.

On our way to Netanya's main shopping mall we passed several locations that had suffered other Palestinian terror attacks – shootings, car bombs, suicide attacks.

Including the two separate suicide attacks outside the shopping mall, Netanya has experienced thirteen Palestinian terrorist incidents that have killed over fifty and injured over 500 of our citizens, out of a total population of only 180,000 people.

I treated Shakeel to a fifteen minute car drive. Shakeel told me that he lived in the Gants Hill area of London. I asked him to do me a favor when he returned home. I asked him to get into his car and drive for just fifteen minutes, then stop and think of our ride together.

We drove due east out of Netanya, stopping at several traffic lights, before hitting the open country and green fields that divide Netanya from the Palestinian territories.

Just less than fifteen minutes after leaving the busy shopping mall in the heart of Netanya we stopped under the dull gray shadow of the concrete wall that borders the Arab town of Tulkarm.

We got out and I asked Shakeel to record where we were. I asked him to explain to his listeners the standard BBC explanation of this barrier. Then I gave him an Israeli interpretation. It stood on its head everything that the media, such as the BBC, would have their listeners and viewers believe about this wall. I showed Shakeel how, before the wall was constructed, Palestinian gunmen fired at the passing vehicles travelling below on the main north-south trans-Israel highway.

I explained to Shakeel that most of the Netanya suicide bombings were executed by terrorists trained, armed, and

sent out on their missions from this Palestinian-held town of Tulkarm, which was on the other side of the wall from where we were standing. I told Shakeel that, since the construction of this section of wall, Netanya had not suffered even one further terror attack originating from Tulkarm, or elsewhere. Not one person has died in Netanya since the erection of this wall.

"All other explanation are superfluous," I told Shakeel's listeners. *"Furthermore, it is standard BBC policy to explain the anti-terror barrier as being an apartheid wall that isolates the Palestinians. This is totally false,"* I told Shakeel. *"Look at where we are. Please explain to your listeners where you are standing. There is nothing to the west of this wall except for green fields, small villages such as Kfar Yona where my grandchildren live, Netanya, and then the sea. If anyone is isolated by the construction of this wall, it is Israel, and we Israelis."*

To add emphasis to my explanation I said: *"For the first time in Jewish history, we Jews have deliberately decided to enclose ourselves in a self imposed ghetto. We have decided, for our own protection and security, to cut ourselves off from our neighbors."*

"Beyond the wall," I said, *"are the Palestinian territories, mostly unoccupied, despite their claims to the contrary. Yet, they still cry victimhood. Beyond the wall, are over twenty large, and mainly wealthy, Arab and Muslim states that claim to support the Palestinian cause. Let them. Palestinians have received more financial assistance from the European Union, the United States, and the United*

Nations than most of the African nations, who are really starving and suffering. So where is their isolation?" I asked. *"On the contrary, to the west of this wall we are alone, a singular Jewish state surrounded by billions of Islamists who are still baying for our blood. It is clearly us who are the ones who are cut off."*

Before the Arafat inspired intifada terror campaign, Tulkarm was, I told Shakeel's listeners, a popular place for Israelis to shop and to dine. Their local economy benefited greatly from its proximity to major Israeli cities. Netanya gave massive employment to thousands of Palestinian Arabs in our hotels, restaurants, car repair shops, and our building industry. Security demanded of us to close the opportunity of employment to them and to bring in foreign workers with whom we have no fear of terror or murder.

"The Palestinians," I explained, *"may have bombed us, but they have also shot themselves in the foot."*

We returned to Netanya, and I took Shakeel to our local and colorful fruit and vegetable market. This market had experienced yet another Palestinian suicide bombing that killed and injured innocent Israelis who were doing nothing more sinister than shopping for their groceries.

He interviewed several people as we strolled in the sunshine. Most had experienced Palestinian terror close up and personal. Without exception, each of the local interviewees repeatedly stated that Israel does not have a peace partner. One said that we never did. Most admitted that when the Palestinian side would truly choose peace, there would be an Israeli government with the willingness,

233

ability, and the mandate to negotiate with them. It is blindingly obvious that no Israeli feels that there will be a pragmatic Palestinian partner for peace for years to come. It was clear, both from my own comments and those of the people in the market, that our prime demand from our Government was to take all necessary steps to maintain the security and protection of the people of Israel.

Shakeel found a resolute and realistic Netanya that is, today, enjoying a booming economy, flourishing tourism, and a fast developing property boom, despite the challenges imposed on us from our neighbors who have failed in their efforts to terrorize us and cower us into defeat.

I wonder if Shakeel ever took that fifteen minute car ride...

CAMERON'S INCREDIBLY STUPID SPEECH IN TURKEY

Britain's Prime Minister, David Cameron, made an incredibly stupid speech in Turkey on July 27, 2010. It displayed his ignorance of international affairs at that time. Calling Gaza a *"prison camp,"* his comments pointed to Israel as being totally responsible for the restraints and conditions there. No faulting Hamas from Cameron. Hamas and other Islamic terror groups, that prosper and operate in the Gaza Strip, were airbrushed out of his speech. For Cameron, they did not exist.

Hamas, the true prison guards of Cameron's prison camp, are not, for him, part of the problem. Cameron knows that the current accepted legal method of moving goods into Gaza is via the Israeli land route. This is accepted by all rational countries to protect Israel's security after decades of Hamas terror against Israeli civilians.

Yet, he failed to mention this important fact.

Cameron knows that hundreds of tons of aid flow into Gaza on a daily basis. Yet none of this was mentioned in his speech. Cameron failed to address the obsessive hatred of Israel that is rampant in the Middle East, including the Turkish leadership he so carefully flattered and promoted.

It has spread, via a biased propaganda campaign, to public opinion that is rooted in his own country of Britain.

Cameron stated that Turkey is a friend of Israel. Not any more it isn't. Israel trusted Turkey. Israel developed an intimate relationship with that country. It conducted close military exercises with Turkey. Israel supplied Turkey with a lot of advanced military equipment and intelligence information.

Turkey then turned round and stabbed Israel in the back. It is no secret in Israel that our military finds itself compromised militarily for being so forthcoming with Turkey during the good old days, and now finds itself facing a potential enemy it supplied with excellent military equipment and strategic knowledge. More recently, Turkey joined the "Kick Israel" mob with the IHH terror group on board the Mavi Marmara flotilla ship which added to Prime Minister Erdogan's insulting and undiplomatic behavior towards President Shimon Peres at Davos in 2009.

Under Erdogan, Turkey has shown it's extremist Islamic face. It has hardened its stance on Cypriot occupied land. It has refused to accept its responsibility for the murder of one million Armenians. It is currently occupying Kurdish territory and killing Kurds. *"Der Spiegel"* reported some were killed by Turkish use of chemical weapons

Yet Cameron promised to speed up the Turkish bully's admission into the EU. Is this what Europe really wants? Not according to the views of countries like France, Germany, and Italy, who reject Turkey's entry into Europe under suspicion of the true nature of that country. They are right to be concerned.

236

Turkey promised Europe that it would maintain a secular government. It lied. As mentioned earlier, Turkey promised Israel close and constant friendship. It lied. Turkey defied world consensus against Iran by closing up to Tehran. Erdogan embarrassed the United States, and those nations trying to build sanctions against Iran's nuclear ambition, by forging a nonsensical, non-applicable, agreement between Iran, Turkey, and Brazil.

Under the shadow of Turkey's growing Islamization, it developed friendships with Iran, Syria, Hamas, and even Hizbollah in Lebanon. After it's hateful actions and statements against Israel, and it's violent history in the region, how could Cameron possibly claim that *"Turkey can become a great European power."*?

What sort of power does Cameron want Turkey to play in Europe? Isn't Europe Islamic enough already?

Does Cameron really want an Islamic Turkey, partnered with Iran, and other radical Islamic terror regimes, entrenched in the heart of Europe? Is that the sort of Europe that Cameron visualizes as he blames Israel for all the ills of the region centered on Gaza? David Cameron needs to go back to first grade in international affairs, but not at the British Foreign Office, which is brimming with anti-Semitic Arabists, and get himself an education. Then, maybe, he will be able to give a fair and balanced speech that puts things in proportion, that speaks up for an ally in the region, if Israel is still considered an ally by Britain. The jury is still out of that question.

It would also enable him to criticize his Turkish host, in diplomatic language of course, for the dangerous foreign policies, based on an extremist religious belief, that is preventing his country from being accepted as a European nation.

The British have a military bases in Akrotiri and in Dhekalia in Cyprus. The British Prime Minister needs reminding that in 1974 Greek Cypriots fled from their homes in the north of the Mediterranean island out of fear of the invading Turks. The Turkish army chased them to the edge of the Dhekalia base. The fleeing Cypriots begged for refuge in the British base and the Turkish advance stopped there to avoid direct conflict with UK forces. They maintain their illegal occupation of Cyprus to this day.

On 12 August 2010, the German paper *"Der Spiegel"* reported an incident from September 2009 in which the Turkish army used chemical weapons on Kurdish Members of the PKK killing eight people, including women. Turkish soldiers chopped up the bodies to try and remove the evidence, but the newspaper is in possession of more than thirty photographs of the incident. This is an international war crime in anyone's language.

Yet Cameron chose to overlook this crime and concentrate on exaggerated accusations against Israel instead.

It is appalling that Britain's Prime Minister should laud a regime that has a long history of abuse and violence against neighboring countries. Britain's Prime Minister showed his lack of knowledge and lack of statesmanship.

Or maybe he was well aware of Turkey's crimes and deliberately chose to overlook them for the expediency of improving Britain's business ties with Turkey?

There's no better way to win friends and influence people than putting in the boot to Israel.

Whoever wrote his speech should be sacked, but Cameron himself could have, should have, regulated his words in a sensitive region where important leaders words resonate. His speech isolated Israel even further. His speech encouraged the dangerous players in the region to dig in their heels even further. They interpret his words as encouraging them in their anti-Israel agenda.

Turkey can continue its provocative and violent foreign policy as it has a champion in Britain's Prime Minister. Hamas can continue its suppression of Gaza. It already receives huge amount of funding from Britain. In Turkey, Britain's Prime Minister gave Hamas a free pass, and kicked out against Israel.

Yes, Cameron made an incredibly stupid and dangerous speech in Turkey.

A PALESTINE QUIZ

Here is a fun quiz for so-called Palestinians and their advocates. Try answering these questions on the subject of your long history and culture that we hear so much about. Ready? Then, here goes,

1. When was the country of "Palestine" founded, and by whom?
2. Where were its borders?
3. Where was its capital, and major cities?
4. Name at least one "Palestinian" leader before Arafat.
5. What was the unique language of the "country of Palestine"?
6. What was the prevalent religion of the "ancient country of Palestine"?
7. What was the name of its currency?
8. Choose any date from history, and tell me what was the name of the currency of Palestine.
9. What form of government did it have?
10. Since there is no country of "Palestine" today, what caused its demise, and when did it occur?
11. Why did the "Palestinians" never try to become a state until after the devastating defeat of the invading Jordanians and Egyptians in the 1967 "Six Day War" by Israel?
12. What was the original Arabic name of Palestine?

Admit it. There's no such thing as Palestine.

REPLACEMENT THEOLOGY IS BEHIND THE HATE ISRAEL CAMPAIGN

Secular liberals may be appalled that I devote a chapter to the religious aspect of anti-Israelism. They did, after all, surrender this added value years ago. To appeal to them, and to the *"Hate Israel"* religionists, I make one rather cynical comment. If they want to play the *"religion"* card against Israel, we can trump them hands down every time. It would be wrong to discuss replacement theology without including a Jewish perspective which, basically, is a theologian answer to those who practice replacement theology against the Jews.

What is replacement theology? In simple terms it dates back to the year 70 when the Jewish Temple in Jerusalem was destroyed for the second time. This became a crucial principle to the early Christians of that period who interpreted this as a sign that the Jews had been forsaken by their god, that God had turned his back on his chosen people, and that they were the new chosen race. The Christian nation was perceived to have replaced the Jewish nation.

An essential part of this Suppressionist theology is the replacement of the Torah and the Old Testament with the New Testament. They did not carry both the Old and

the New Testament as joint pillars of the new faith. They rejected everything that bound the Jews to their faith. They turn away from the Torah, Kabbalah, and other significant teachings and documents that anchored the Jewish people in their unique belief system. In their mind. the Jewish nation has been replaced by the Christian nation. Due to their rejection, there is no theology on which to base Christian theology except the New Testament. Canon law is based on this alone. Christian charity replaced Jewish *"chesed"* (charity). The Jews were the first to adopt charity to others. In ancient times, charity was unknown to the heathens. While Jews sent money from around the world for centuries to a destroyed temple in Jerusalem, the concept of charity was unknown to pagans and early Christians. Charity, or taxes, is what you gave to the church to enable it to grow in power and influence. The rest they took in conquest.

When the Crusaders rode off to claim the Holy Land for the Roman Catholic church it was a clear declaration of Replacement Theology. They may have been defeated by the Islamic army of Saladin who ruled the Holy Land, but Jews were an important secondary target of the invading European Crusaders. They went to conquer the land of Christ. It was to be a sign that Christianity had replaced both the Jewish nation and the Muslims in the Holy Land.

The dogma of replacement theology led to the claim that the Jews killed Christ. At that time this message was simple. You are either with us, or you are on the side of the

242

Christ-killer. Absolute dogma is a must for their faith system.

Throughout Europe, a repressive church persecuted the Jew. Jews who were not converted were killed or, as in the case of Clifford's Tower in York in North East England in 1190, committed mass suicide rather than renounce their faith. The Spanish Inquisition tortured and burnt Jews to death who refused to convert and be baptized.

Today, in Poland, ceremonies are still held that maintain the blood libel that Jews kill children for their blood to make bread for Passover. In several European countries, anti-Semitic religious ceremonies are held annually in front of large crowds that portray Jesus, played by an actor, being delivered for money by the Jews before being crucified by the Romans. Is it any wonder that anti-Semitism remains rooted in European Christianity?

A light-hearted story is told of a Spanish rabbi who was forced to convert to Catholicism under pain of death. One Friday night, the cardinal was riding by the home of this rabbi when he smelled the rich aroma of a Jewish Shabbat meal coming from the house.

"What is this!," he erupted at the Jew as he burst into the house. *"You maintain your Judaism which is punishable by death. You know it is forbidden to eat meat on Friday according to our laws. You must die for your disloyalty!"*

"No, your holiness," the Jew pleaded. *"This is not meat, it is fish."*

"Do you take me for a fool," shouted the cardinal. He pointed to one of his guards. *"Taste this man's food and tell me if it is meat or fish,"* he ordered.

The guard tasted the meal and announced that it was indeed meat.

"Take this man away and kill him!," ordered the cardinal.

"No, wait!" shouted the rabbi. *"Don't you remember how you sprinkled holy water over me and told me that I was no longer a Jew, but a Catholic? Is that not so?"*

The cardinal agreed.

"Then that is exactly what I did with my meal. I sprinkled some holy water on my plate and declared that it was not meat, that it was fish! If your water works for you, then, as a catholic, it works for me, too."

There are two trains of thought within Judaism regarding Israel as *"Am Segula,"* the Chosen People. The Babylonian Talmud is replete with discourse between sages.

Rabbi Ramchal taught that God created the world with the Torah. There were no Chosen People at that time. God waited to see which nation would choose his laws and stand up to the test that he would put to that nation. It was the Jews that were tested through Abraham, and later Moses. According to Ramchal, the nation of Israel were not the *Chosen* People. They were the *Choosing* nation. They chose the laws of the one God, rather than idol worship or paganism. God sealed this covenant, this Brit between God and His people.

On the other hand, Mahalal said that in the beginning God created the heaven and the earth and that the world was created for the Jewish nation. In his interpretation, Bereshit (the Beginning) refers to the Jewish people. God gave the Torah to the Jewish nation. He chose us. We are His Chosen People.

Whichever of these theories is selected, the one fact remains. That the Jewish people are His Chosen People and no one can break this bond.

This bond had been a burden.

Jews have been tested, and are being tested today.

A cynical Jewish joke has one Jew moaning, *"I know we are the Chosen People, but couldn't He choose someone else for a change?"* Yet Jews stubbornly clung to their faith.

Throughout the ages, the Jew has been perceived as a threat to those who preach replacement theology, whether they be Catholic, Christian, or Muslim.

If anything is more of a threat to their dogma than the Jew, it is Israel. How is it possible that despite centuries of rejection, persecution, conversion, genocide, and finally, the Holocaust, not only does the Jew continue to exist, but he rises from the ashes in the miracle of the Jewish state of Israel?

For those who cling to replacement theology, Israel is a slap in the face. It defies all their teachings, all their belief systems.

They watched as Arab armies came to destroy the fledgling nation of refugees. They expected the fight for

Israel to be the final death throe of the remnants of the Holocaust. This would have put the final victorious nail in the coffin of any Jewish ability to claim to be the Chosen People. Christianity stood aside as Muslim armies tried, several times, to destroy the Jewish nation in the name of Islamic replacement theology. For these dogmatic Christian spectators, the Arab armies were the modern day crusaders.

But the impossible happened. The Jews not only defended their tiny and tender nation, they won, and won again. Not only did they win, they emerged stronger than ever. The nation of Israel grew, it developed, it attracted an influx of persecuted Jews from the four corners of the globe. Hebrew, again, became the national language of the Jewish state. Jerusalem was recaptured to become, again, the eternal capital of the Jewish people.

The replacement theologists, including those of the British Anglican church, Presbyterians, Methodists, and others, regrouped. They began to intone pious feelings for the oppressed and the suffering, personified by the Palestinians. They condemned Israel for all the ills of the world.

The murder of Jews and decades of terrorism against innocent Israelis were excused as the justified reaction of an oppressed people. Murdered Jews and Israelis, horrendous and inhumane acts of terrorism in the name of Allah, do not give these people pause.

On a day when the Archbishop of Canterbury was on his way to visit Yasser Arafat, he received a message to say

that one of Arafat's terrorists had killed Israelis in yet another suicide attack in Israel. Instead of turning round and visiting the families of the dead victims in an act of condolence and sympathy, Rowen Williams continued to pay his respects and have tea and biscuits with the executioner, Yasser Arafat.

On Arafat's death, this pontiff confirmed the *"abiding strength of the Anglican commitment to the Palestinian people."* No such commitment has been given to the Jewish people of Israel, staunchly trying to defend themselves from Islamic terror.

Earlier in this book I referred to the decision of the Methodist Church in Britain to back the boycott of Israeli products. They refuse to acknowledge that the roots of Christianity are Jewish roots, not Islamic. They do not accept Jewish spiritual, national, and emotional aspirations, and the historic and biblical ties that bring the people of Zion back to their ancient land. Zionism cannot be dismissed as illegitimate and criminal, but the way their boycott decision was steamrolled through at the Methodist conference was cruel and wrong. Their decision was insensitive and unjust to Judaism. The Jewish Chronicle called the decision *"Methodist shame."* It described the conference document as *"a history of Zionism and Israel so deformed that it could almost have been written by the Hamas leadership."* The Jewish Chronicle was close to the truth. The document was prepared and guided by people close to the Hamas leadership and with whom they share an

agenda. The Methodist document did not donate one word of criticism to Hamas, Hizbollah, or any terror group. Nor did it criticize or sanction any other nation. It saved its denigration solely for Israel. This, in itself, is discriminatory. It leads one to ask what is at the core of this drive to condemn Israel exclusively.

I did ask that question. I asked it of a group of Christian Zionists who belong to the Methodist Church. At the end of a fascinating, friendly, and respectful meeting with them I picked up the courage to ask them the question that had been eating away inside me. Was anti-Semitism the motivating force behind their leaders actions against Israel? I was taken aback by the immediate and strong response. *"But of course!"* they replied in unison.

The Methodist leadership has joined the enemies of peace. The Christian embrace of Marxists and Islamists is madness. What have Marxists and radical Islam ever done for Christianity except exterminate and subjugate it? What have Jews ever done for Christianity except respect them and give them the moral ethics of Judaism, and a better life? Can someone bring these misguided Christian souls back to their senses, back to their Judeo-Christian roots and values?

Israel is a shining light of humanity in a desert of darkness and oppression. Christians everywhere should pick up that torch and shine it in all the dark corners of affliction. The Christian Zionists within the Methodist Church have a battle on their hands to bring their leaders back to their

senses, or replace them. It requires much more activism from their rank and file. They need major support from fellow Christians who are faithful to the Judeo-Christian ethos.

During this important meeting with a group of British Methodists, including a couple of ministers, at an Israeli kibbutz in the late summer of 2010, the conversation swung to the dilemma of these brave people. They consider themselves Christian Zionists by their faithful interpretation of their Bible as it applies to the gathering of the Jews into the Promised Land.

Their faith in their God brings them to identify closely with the Jewish people. Strangely, they are in conflict with the leaders of their church who, in 2010, passed a resolution at their annual convention to apply a boycott and divestment campaign against Israel. They intend to fight this based on their support and conviction in the rightness and justice of Israel. I said they were brave because, as abhorrent as it sounds, any Methodist minister in Britain faces the real threat of being evicted from their congregation for defying their leadership. This meant unemployment at a time when the British economy was in dire straits. Not only would a Methodist, and I dare say Presbyterian, minister be thrown out of work by holding true to his conviction, he would also be homeless, as the church manse belongs to the church and not to the minister.

It takes a brave soul to stand with Israel at such a critical time and I salute these men and women of

conviction. I gave them a moment of thought about a dogma that says God had removed His promise to His Chosen People and placed it elsewhere. I told them that the Jewish God is one whose word is His bond, that He doesn't change His mind at a whim.

"How can your leaders have faith in a God that removes His promise from anyone?"

Our God is a God who gives His word and keeps it. Surely they cannot believe in a God who changes His mind at will. If they do then, assuming they think that He has chosen them, He will surely take it away from them in the future? This cannot be. I am sure they do not believe that Christ has ever deserted them? Surely God is as sure of His bond as they are in Christ? We Jews believe in God with certain faith. That is the way of our faith.

Replacement theology lies at the deep heart of Islam. Their problem is they not only want to replace the Jew, or destroy him, they also want to replace everything, including Christianity. The creed of the Islamists is not allowing infidels to exist, except as a subjugated dhimmi to Islamic will and domination. They even kill each other, Shiite and Sunni, in their competitive rage to be top of the tree. There may not be overt anti-Semitism in the New Testament but it is rampant in the Koran. The Jew is the expressed enemy of Islam. The Koran calls for the killing of the Jew as a holy command.

What is the placement of the Al-Aqsa mosque, directly on top of the ruins of the two ancient Jewish

Temples in Jerusalem, if not a statement of replacement theology? It says to the Jews that we, the Muslims, have come to replace you. This is echoed in present day anti-Semitic Palestinian pronouncements.

Bosom buddies!

HAVE FAITH - SUPPORT ISRAEL

Although the heads of the major Christian churches have been persuaded to abandon Israel and rally against the Jewish State, millions of their religionists retain a fundamental belief in Jewish justice in the Holy Land.

Despite the fact that they hear only the Palestinian narrative, they know that the legitimate rights to Jewish sovereignty of the land far outweighs any other claims.

This deep belief stems from their knowledge of history and faith that rests securely in the Bible. Their religious upbringing, which includes regular recital of biblical passages, the retelling of events and festivals, reconfirm the justification of the Jewish homecoming.

Their Bible departs from the Old Testament, which is steeped in Jewish connection to the land, yet their faith includes the destiny to support and encourage the Jewish resurrection in the Holy Land, known today as Israel.

The Israeli-Palestinian dispute is hardening into a religious war, as well as a nationalistic one. The Palestinian political claims to the land are linked to the recent rise of Islam. Islamic expressions are increasingly employed to strengthen their holy imperative to conquer the land. Yet Judeo-Christian history exceeds any potential Muslim claim, which is tenuous at best and fiction at worst.

The richness of Jewish claims to the land derive from the wealth of belonging, sovereignty, development, and the outpouring of spiritual and humanitarian thought and philosophy from a time that dispossession could not erase.

In periods of history, when the Holy Land was conquered by the Muslims, it became a backwater, desolate and uninhabited. When Jews returned, as part of the First and Second Aliyah, they bought malarial swamps from Arabs who lived away from the area. These sheikhs thought the Jews mad for paying good money for worthless tracts of land. The industrious Jews, however, turned the infested ground into orchards, fields, fishponds, and kibbutzim. Although most lacked religious zeal, all were driven by the passion to reclaim the ancient land that had been a Jewish commonwealth in biblical times. All were familiar with the Jewish biblical figures, the stories and locations of their lives. For them, the Bible was a guidebook to the creation of the State of Israel.

Though Christian leaders, tied to the dogma of replacement theology, are affronted by the success of the Zionist venture, other Bible-believing Christian supporters applaud, support, and pray, for the Jewish revival in the Holy Land. They stand with Israel, not because of a United Nations resolution taken in 1947, but because of what God promised Abraham over three thousand years ago. For them, Genesis is a greater legal deed than the League of Nations Resolution of 1922, or the Balfour Declaration.

The strength of the Christian support for Israel is not to be under estimated. Throughout the world, grassroot

organizations gather to reconfirm their conviction to stand with the Jewish state. In America, they hold significant influence on their political decision makers. Many say that the Jewish Lobby holds sway in the Washington corridors of power, but the Christian majority far outnumber the Jewish vote.

Christian Zionists worldwide view the unfolding of events in the Middle East. They see the Islamic threat against the Jewish state. They also see their co-religionists being slaughtered in Iraq, Egypt, the Sudan, and in the Palestinian territories. They see them being driven out of Muslim countries and oppressed by the mainly Muslim Palestinians. They see Sharia courts making it illegal for them to practice their faith in many of the Arab countries. And they see the freedom of worship that shines like a beacon in Israel, where the Bahai faith has built its beautiful headquarters in Haifa, and where the International Christian Embassy is free to operate in Jerusalem.

Leaders, such as Pastor John Hagee of Christians United for Israel, have built huge outreach programs in the United States. The Christian Broadcasting Network reach millions of viewers worldwide. Christians for Israel International has a newspaper *"Israel and Christians Today"* that has hundreds of thousands of subscribers. *"Eagles Wings,"* led by Reverend Robert Steams, hold regional conferences, programs, and an annual *Day of Prayer for the Peace of Jerusalem.*

An organization called the International Fellowship of Christians and Jews was founded twenty eight years

ago by Rabbi Yechiel Eckstein. It has already raised over one hundred million dollars to the poor in Israel, and has been instrumental in assisting in the aliyah and resettlement of hundreds of thousands of Jews into the Jewish state. These organizations, and many others, including personalities, such as singer Pat Boone and politician, now TV talk show host, Mike Huckabee, and Glenn Beck, bring thousands of their supporters on faith missions to Israel to reunite with the Jewish people and show solidarity with their cause.

They employ the moral and theological arguments that underpin the legitimacy of the Jewish presence in Israel. They do as powerfully as their Jewish neighbors. They are firmly grounded in their faith and are not detracted by calls for social justice, and any other atheistic, Marxist, Islamic rhetoric. They are the counterweight to the misguided, appeasing, Christian voice, mainly heard in Europe, that, through multiculturalism, or the perceived need for tolerance, advance the agenda of those who would do them harm.

This support is nothing new. As far back as 1891, a Reverend William E. Blackstone presented US President Benjamin Harrison with a petition for the reinstatement of Jews to Israel. Among the signatories were John D.Rockefeller, J.P.Morgan, and Cardinal Gibbons.

Conservative Christians have a firm belief in the imperative of the Jewish return to Zion. In 1909, C.I..Schofield, a conservative Protestant, edited the King James Version of the Bible by adding extensive footnotes

which, among other things, emphasized the present and future role of Israel in world history.

One writer, who was strongly anti-Israel, Grace Halsell, still managed to write, *"Schofield said that Christ cannot return to earth until certain events occur. The Jews must return to Palestine, gain control of Jerusalem, and rebuild a temple, and engage in the final great battle called Armageddon."*

Between ten and forty million Christians believe in this religious interpretation. Although many believe that there is an anti-Semitic under pinning to this dogma, other Christian Zionists protest that there are no malevolent intentions against the Jews. Their desire to see the Jewish reclamation of the land is a significant factor in heralding the Coming of the Messiah. Many Jews reason that they share this desire. An opinion, now widely expressed in beleaguered Israel, is that only by His reappearance, can the truth of which is the one true faith be established, so let's work together to establish that Day of Judgment.

European Christian solidarity with Israel, that takes the form of Christian Zionism, dates back nearly two centuries. Christian support for the creation of a Jewish state became a significant movement in the British Victorian period. In 1840, the British foreign secretary, Lord Palmerston, *"strongly"* recommended that the Ottoman government then ruling Palestine *"hold out every just encouragement to the Jews of Europe to return to Palestine."* Lord Shaftesbury in 1853 coined the phrase *"A land without a people for a people without a land."*

Sir George Adam Smith wrote in his authoritative Historical Geography of the Holy Land that the Ottomans had to be pushed out of Palestine and replaced by the Jews, *"who have given to Palestine everything it has ever had of value to the world."*

The Balfour Declaration of November 1917, whereby the British government announced that it favored *"the establishment in Palestine of a national home for the Jewish people,"* was perhaps the single most important act premised in Christian Zionism.[1]

Christian roots in America derive from persecution at the hands of fellow Christians in Europe. Their interpretation of doctrine was not well received by the leaders of their faith, and they had to flee out of fear for their lives and safety. It was only in America that they could express their faith freely. A part of their belief system was their interpretation of the Bible, which has become living history with the creation of the State of Israel.

They are not fooled by the new religion of social justice and multiculturism that seek to remove fundamental beliefs in divine providence. Certain in what they are seeing, with the unfolding of political events relating to the re-establishment of the Jewish State of Israel, invigorates both Jewish and Christian expectancy in the Holy Land. The core beliefs of both faiths excite them as they see the development of an advanced nation is so short a period of time.

[1] The Clout of Christian Zionism. Daniel Pipes.

Today, evangelical Christians are the leading pro-Israelis within the United States. They can, and have, mustered forty million emails in campaigns calling on the President to support Israel. When President Bush ordered Israeli Prime Minister Ariel Sharon to remove Israelis tanks from Jenin as part of Operation Defensive Shield, the forty million emails came from a concerted campaign led by the evangelistic Christian force in America.

Jewish rank and file support for Israel often appears tepid and sporadic compared with the passionate and firm commitment expressed by the American Christian majority.

Jews and Christians today share a common enemy. That enemy is radical Islam. Islam has a rabid hatred of Jews, but also an open contempt for Christianity. Neither Christians or Jews hold any motivation to conquer or control Muslim lands. Jews have no proselyting intent. There is no desire or creed to convert others into the Jewish faith. It's hard enough for fringe members of the faith to prove their identity. Yet both faiths are treated with scorn and indignity by Muslims, persecuted and banned in most Muslim countries, accused of vile characteristics by Islamic leaders. Together, Christians and Jews are, or should be, natural allies and Israel should remain the bastion of their faith and support.

INSPIRING SPEECHES

In my prosecution against Israel's enemies and defamers, I call to the stand a procession of distinguished witnesses. They will confirm the true character of the Jewish state. They will also produce evidence and reason to the case against those who harm Israel. Some will highlight the charge that those who act against Israel are also acting against freedom and democracy.

Here then is the evidence of just a few notable and eloquent people who wish to shine the light of truth and justice in the name of Israel, freedom, and tolerance.

RUPERT MURDOCH'S SPEECH TO THE ADL. 2010

Rupert Murdoch is founder, chairman, and chief executive officer of News Corporation, whose numerous worldwide holdings include the New York Post, Dow Jones & Company, The Times (London), Fox News Channel, HarperCollins Publishers and 20th Century Fox. This is an extract from his speech when he was presented with the Anti-Defamation League's International Leadership Award in New York on Oct. 13, 2010:

We live in a world where there is an ongoing war against the Jews. For the first decades after Israel's founding, this war was conventional in nature. The goal was

straightforward: to use military force to overrun Israel. Well before the Berlin Wall came down, that approach had clearly failed. Then came phase two: terrorism.

Terrorists targeted Israelis both home and abroad - from the massacre of Israeli athletes at Munich to the second intifada. The terrorists continue to target Jews across the world. But they have not succeeded in bringing down the Israeli government - and they have not weakened Israeli resolve. Now the war has entered a new phase.

This is the soft war that seeks to isolate Israel by delegitimizing it. The battleground is everywhere: the media, multinational organizations, NGOs. In this war, the aim is to make Israel a pariah.

The result is the curious situation we have today: Israel becomes increasingly ostracized, while Iran - a nation that has made no secret of wishing Israel's destruction - pursues nuclear weapons loudly, proudly, and without apparent fear of rebuke.

For me, this ongoing war is a fairly obvious fact of life. Every day, the citizens of the Jewish homeland defend themselves against armies of terrorists whose maps spell out the goal they have in mind: a Middle East without Israel.

In Europe, Jewish populations increasingly find themselves targeted by people who share that goal. And in the United States, I fear that our foreign policy only emboldens these extremists. When Americans think of anti-Semitism, we tend to think of the vulgar caricatures and attacks of the first part of the 20th century. Now it seems that the most virulent strains come from the Left.

Often this new anti-Semitism dresses itself up as legitimate disagreement with Israel. Far from being dismissed out of hand, anti-Semitism today enjoys support at both the highest and lowest reaches of European society - from its most elite politicians to its largely Muslim ghettoes. European Jews find themselves caught in this pincer. We saw a recent outbreak when a European Commission trade minister declared that peace in the Middle East is impossible because of the Jewish lobby in America. Here's how he put it:

"There is indeed a belief - it's difficult to describe it otherwise - among most Jews that they are right. And it's not so much whether these are religious Jews or not. Lay Jews also share the same belief that they are right. So it is not easy to have, even with moderate Jews, a rational discussion about what is actually happening in the Middle East."

This minister did not suggest the problem was any specific Israeli policy. The problem, as he defined it, is the nature of the Jews. Adding to the absurdity, this man then responded to his critics this way: Anti-Semitism, he asserted, *"has no place in today's world and is fundamentally against our European values."* Of course, he has kept his job. Unfortunately, we see examples like this one all across Europe. Sweden, for example, has long been a synonym for liberal tolerance. Yet in one of Sweden's largest cities, Jews report increasing examples of harassment. When an Israeli tennis team visited for a competition, it was greeted with riots.

So how did the mayor respond? By equating Zionism with anti-Semitism - and suggesting that Swedish Jews would be safer in his town if they distanced themselves from Israeli actions in Gaza. You don't have to look far for other danger signs: The Norwegian government forbids a Norwegian-based, German shipbuilder from using its waters to test a submarine being built for the Israeli navy. Britain and Spain are boycotting an OECD tourism meeting in Jerusalem. In the Netherlands, police report a 50 percent increase in the number of anti-Semitic incidents.

Maybe we shouldn't be surprised by these things. According to one infamous European poll a few years back, Europeans listed Israel ahead of Iran and North Korea as the greatest threat to world peace.

In Europe today, many of the most egregious attacks on Jewish people, Jewish symbols, and Jewish houses of worship have come from the Muslim population. Unfortunately, far from making clear that such behavior will not be tolerated, too often the official response is what we've seen from the Swedish mayor - who suggested Jews and Israel were partly to blame themselves.

When Europe's political leaders do not stand up to the thugs, they lend credence to the idea that Israel is the source of all the world's problems - and they guarantee more ugliness. If that is not anti-Semitism, I don't know what is.

That brings me to my second point: the importance of good relations between Israel and the United States. Some believe that if America wants to gain credibility in the Muslim world and advance the cause of peace, Washington

needs to put some distance between itself and Israel. My view is the opposite. Far from making peace more possible, we are making hostilities more certain. Far from making things better for the Palestinian people, sour relations between the United States and Israel guarantees that ordinary Palestinians will continue to suffer. The peace we all want will come when Israel feels secure - not when Washington feels distant. Right now we have war. There are many people waging this war. Some blow up cafes. Some fire rockets into civilian areas. Some are pursuing nuclear arms. Some are fighting the soft war, through international boycotts and resolutions condemning Israel. All these people are watching the U.S.-Israeli relationship closely. In this regard, I was pleased to hear the State Department's spokesman clarify America's position.

He said that the United States recognizes *"the special nature of the Israeli state. It is a state for the Jewish people."*

This is an important message to send to the Middle East. When people see, for example, a Jewish prime minister treated badly by an American president, they see a more isolated Jewish state. That only encourages those who favor the gun over those who favor negotiation.

Back in 1937, a man named Vladimir Jabotinsky urged Britain to open up an escape route for Jews fleeing Europe. Only a Jewish homeland, he said, could protect European Jews from the coming calamity. In prophetic words, he described the problem this way: *"It is not the anti-Semitism of men,"* he said. *"It is, above all, the anti-Semitism of*

things, the inherent xenophobia of the body social or the body economic under which we suffer."

The world of 2010 is not the world of the 1930's. The threats Jews face today are different. But these threats are real. These threats are soaked in an ugly language familiar to anyone old enough to remember World War II. And these threats cannot be addressed until we see them for what they are: part of an ongoing war against the Jews.

* * *

STEPHEN HARPER'S SPEECH TO INTERNATIONAL PARLIAMENTARIANS. NOVEMBER 8, 2010

The following is a remarkable excerpt from Canadian Prime Minister Stephen Harper's speech on Parliament Hill to a gathering of international parliamentarians and experts attending a conference on combating anti-Semitism:

Two weeks ago I visited Ukraine for the first time. At the killing grounds of Babi Yar, I knew I was standing in a place where evil – evil at its most cruel, obscene, and grotesque – had been unleashed. But while evil of this magnitude may be unfathomable, it is nonetheless a fact. It is a fact of history. And it is a fact of our nature – that humans can choose to be inhuman. This is the paradox of freedom. That awesome power, that grave responsibility – to choose between good and evil.

Let us not forget that even in the darkest hours of the Holocaust, men were free to choose good. And some did. That is the eternal witness of the Righteous Among the

Nations. And let us not forget that even now, there are those who would choose evil, and would launch another Holocaust, if left unchecked. That is the challenge before us today.

In response to this resurgence of moral ambivalence on these issues, we must speak clearly.

Remembering the Holocaust is not merely an act of historical recognition. It must also be an understanding and an undertaking. An understanding that the same threats exist today. And an undertaking of a solemn responsibility to fight those threats.

Jews today in many parts of the world and many different settings are increasingly subjected to vandalism, threats, slurs, and just plain, old-fashioned lies.

Let me draw your attention to some particularly disturbing trends. Anti-Semitism has gained a place at our universities, where at times it is not the mob who are removed, but the Jewish students under attack. And, under the shadow of a hateful ideology with global ambitions, one which targets the Jewish homeland as a scapegoat, Jews are savagely attacked around the world – such as, most appallingly, in Mumbai in 2008. We have seen all this before. And we have no excuse to be complacent. In fact we have a duty to take action. And for all of us, that starts at home.

In Canada, we have taken a number of steps to assess and combat anti-Semitism in our own country. But of course we must also combat anti-Semitism beyond our borders, – an evolving, global phenomenon. And we must

recognize, that while its substance is as crude as ever, its method is now more sophisticated.

Harnessing disparate anti-Semitic, anti-American, and anti-Western ideologies, it targets the Jewish people by targeting the Jewish homeland, Israel, as the source of injustice and conflict in the world, and uses, perversely, the language of human rights to do so.

We must be relentless in exposing this new anti-Semitism for what it is. Of course, like any country, Israel may be subjected to fair criticism. And like any free country, Israel subjects itself to such criticism – healthy, necessary, democratic debate. But when Israel, the only country in the world whose very existence is under attack – Is consistently and conspicuously singled out for condemnation, I believe we are morally obligated to take a stand.

Demonization, double standards, delegitimization, the 3 D's, it is a responsibility, to stand up to them. And I know, by the way, because I have the bruises to show for it, that whether it is at the United Nations, or any other international forum, the easy thing to do is simply to just get along and go along with this anti-Israeli rhetoric, to pretend it is just being even-handed, and to excuse oneself with the label of *honest broker*. There are, after all, a lot more votes, a lot more, in being anti-Israeli than in taking a stand. But, as long as I am Prime Minister, whether it is at the UN or the Francophone or anywhere else, Canada will take that stand, whatever the cost. Not just because it is the right thing to do, but because history shows us, and the ideology

of the anti-Israeli mob tells us all too well, that those who threaten the existence of the Jewish people are, in the longer term, a threat to all of us.

Earlier I noted the paradox of freedom. It is freedom that makes us human. Whether it leads to heroism or depravity depends on how we use it. We are free citizens, but also the elected representatives of free peoples. We have a solemn duty to defend the vulnerable, to challenge the aggressor, to protect and promote human dignity, at home and abroad. None of us knows whether we would choose to do good, in the extreme circumstances of the righteous. But we do know there are those today who would choose to do evil, if they are so permitted. Thus, we must use our freedom now, and them and their anti-Semitism at every turn.

Our work together is a sign of hope, just as the existence and persistence of the Jewish homeland is a sign of hope. And it is here that history serves not to warn but to inspire. As I said on the 60th anniversary of its founding, the State of Israel appeared as a light, in a world emerging from deep darkness. Against all odds, that light has not been extinguished. It burns bright, upheld by the universal principles of all civilized nations – freedom, democracy, justice. By working together more closely in the family of civilized nations, we affirm and strengthen those principles. And we declare our faith in humanity's future, in the power of good over evil.

DAVID BEN GURION AT THE UNITED NATIONS, DECEMBER 5, 1949

As you know, the U.N. is currently discussing the issue of Jerusalem and the holy places. The State of Israel is a member of the U.N., not because of political convenience but because of its traditional, deep-seated commitment to the vision of world peace and the brotherhood of nations, as preached by our prophets and accepted by the U.N.

This membership obliges us, from the podium of Israel's First Knesset, to tell all the nations assembled at the U.N. and all those who love peace and justice in the world what has been in Israel's heart since it became a united nation under King David three thousand years ago as regards Jerusalem its holy city and as regards its attitude to the places which are holy to the other religions.

When we proclaimed the establishment of the renewed State of Israel, on 14 May 1948, we declared that, *"The State of Israel will guarantee freedom of religion and conscience, of language, education and culture. It will safeguard the Holy Places of all religions. It will be loyal to the principles of the United Nations Charter."* Accordingly, our delegation to the U.N. announced that Israel would honor all the existing rights regarding the holy places and sacred buildings in Jerusalem, assure freedom of worship and free access to all the holy sites under its control, recognizing the rights of pilgrims of all religions and nations to visit their holy places and assuring freedom of movement for clergymen. We agreed to allow effective

U.N. supervision of the holy places and the existing rights in a way that would be agreed to between Israel and the United Nations. At the same time we see fit to state that Jewish Jerusalem is an organic, inseparable part of the State of Israel, just as it is an integral part of Jewish history and belief. Jerusalem is the heart of the State of Israel. We are proud of the fact that Jerusalem is also sacred to other religions, and will gladly provide access to their holy places and enable them to worship as and where they please, cooperating with the U.N. to guarantee this.

We cannot imagine, however, that the U.N. would attempt to sever Jerusalem from the State of Israel or harm Israel's sovereignty in its eternal capital. Twice in the history of our nation were we driven out of Jerusalem, only after being defeated in bitter wars by the larger, stronger forces of Babylon and Rome. Our links with Jerusalem today are no less deep than in the days of Nebuchadnezzar and Titus Flavius, and when Jerusalem was attacked after the fourteenth of May 1948, our valiant youngsters risked their lives for our sacred capital no less than our forefathers did in the time of the First and Second Temples.

A nation that, for two thousand and five hundred years, has faithfully adhered to the vow made by the first exiles by the waters of Babylon not to forget Jerusalem, will never agree to be separated from Jerusalem. Jewish Jerusalem will never accept alien rule after thousands of its youngsters liberated their historic homeland for the third time, redeeming Jerusalem from destruction and vandalism. We do not judge the U.N., which did nothing when nations,

which were members of the U.N., declared war on its resolution of 29 November 1947, trying to prevent the establishment of Israel by force, to annihilate the Jewish population in the Holy Land and destroy Jerusalem, the holy city of the Jewish people. Had we not been able to withstand the aggressors who rebelled against the U.N., Jewish Jerusalem would have been wiped off the face of the earth, the Jewish population would have been eradicated and the State of Israel would not have arisen. Thus, we are no longer morally bound by the U.N. resolution of November 29, since the U.N. was unable to implement it. In our opinion the decision of 29 November regarding Jerusalem is null and void.

The attempt to sever Jewish Jerusalem from the State of Israel will not advance the cause of peace in the Middle East or in Jerusalem itself. Israelis will give their lives to hold on to Jerusalem, just as the British would for London, the Russians for Moscow and the Americans for Washington.

We hope that the religions which honor Jerusalem's sanctity and the nations which share our belief in the principles of peace and justice will honor Israel's rights in Jerusalem, just as Israel honors those of all the religions in its sacred capital and sovereign state.

* * *

THE CLOSING OF THE ACADEMIC MIND –
HOWARD JACOBSON

Academic boycotts are the antithesis of academic and scientific freedom. Academia should encourage the interchange of ideas and engage in the search for conflict resolution. Academia should be an open forum not a closed society. It should not be an incubator for propaganda, incitement, extremism, and hatred. When academia closes its ears it is no longer academia. This was elucidated so eloquently by the Booker Prize winning author, Howard Jacobson, when he spoke to a meeting of the Engage group in 2007. Here is an extract from his speech;

"Some defensive academics say it's not about gagging or boycotting Israeli academics. It's about not being prepared to listen to them. Not listening is a more brutal act than silence. It's a brutal act that you perform on yourself, knowingly, purposefully, and on principle. Not to listen is to wage war on your own faculties. To deny yourself, if you are a reasoning person, the tools with which you reason. Once you announce to the world that you stop listening is the moment you announce what you think, and that is the moment when you cease to be a scholar or a teacher. A university that will not listen causes more damage on itself than to the university that it will not listen to.

It is amazing how certain the boycotters are about absolutely everything. It is this unwavering certitude that is

271

almost religious or ethnic hatred where unreason battens down the mind.

As for the proposition that it's not anti-Semitic to be critical of Israel like the idea that those that want Israel closed down are being critical. Critical is a word we associate with measured argument, cool analysis, and fine distinction. Being critical is when you say *"the book works here, doesn't work there, bad plot, poor characterization, like some parts, hated others."*

What being critical is not in saying *"this is the most odious book ever written, should never have been published in the first place, must be banned and, in the meantime, should not be read."* For that, we need another word for critical. So, when we accuse the boycotters of bigotry, when we say they must be fired by an animosity they don't declare and perhaps don't even realize they possess. It's because we cannot understand the inordinacy of their language when they say that Israel is more fascist than the fascists, more Nazi than the Nazis, practicing an apartheid that exceeds the apartheid of South Africa, an Israel that is guilty of every crime against humanity, and doubtless one or two more we haven't yet discovered. torture, assassination, ethnic cleansing, colonization, genocide, massacre, indiscriminate slaughter, and even when it can be grudgingly seen to be retaliating it does so *"disproportionately."*

This is no country that ever was outside Hades. So let them tell us if Jew hating is not at the heart of it what is?

In what furnace of the mind is this nation evil beyond all others forged? And why, in its pitiless unheeding

malevolence does it so closely resemble the closed cosmos of the pariah Jew as it appears to the medieval imagination?

Let them not be anti-Semites. Let them love the individual Jew as much as they hate the Jewish conglomeration. That does not absolve them of every crime. You can be a bad man and not hate Jews. You can be a disgrace to the profession of teaching and not hate Jews.

We need a language free of issues of religion and ethnicity to describe the intellectual crime, quite simply, of picking on one nation state and loathing it above all others and against all reason, of simplifying history to fit a narrative that flatters your ideology of victim and oppressor, of imposing a Manichean view of good and evil on events that defy such categorization and can only be inflamed by it, and of shutting down every ingress of the intelligence through which the arguments of those who think differently to you or simply want to converse with you about it, can be heard.

In the end, it is not about Israel or Jews at all. It is about the way we practice thought in Britain. It is about the idea we have of a university and what constitutes the free play of ideas. It is about the closing of the English mind.

The boycott is their Dunciad. *'Thy hand great dullness let the curtail fall and let universal darkness cover all!'*"

The actual closing lines of Dunciad's - *"The Triumph of Dullness"* are:

See skulking Truth to her old Cavern fled,
Mountains of Casuistry heap'd o'er her head!
Philosophy, that lean'd on Heav'n before,
Shrinks to her second cause, and is no more.
Physic of Metaphysic begs defence,
And Metaphysic calls for aid on Sense!
See Mystery to Mathematics fly!
In vain! they gaze, turn giddy, rave, and die.
Religion blushing veils her sacred fires,
And unawares Morality expires.
Nor public Flame, nor private, dares to shine;
Nor human Spark is left, nor Glimpse divine!
Lo! thy dread Empire, Chaos! is restor'd;
Light dies before thy uncreating word:
Thy hand, great Anarch! lets the curtain fall;
And Universal Darkness buries All.

As Howard Jacobson reminded his audience, there is an ominous truth in Dunciad's words that seems to relate to unraveling world events today.

WHO NEEDS ISRAEL ANYWAY? PAT BOONE

Many Western and European political leaders, having heard the deprecations and the determination to wipe Israel off the face of the earth, from the likes of Palestinian Yasser Arafat, Saudi Arabian Osama bin Laden, Iraq's Saddam Hussein, Iran's Mahmoud Ahmadinejad, and so many other power brokers in the region have come dangerously close to deciding that little Israel is the *"thorn in the side"* of world order. The next logical thought is: *"Who needs Israel? Let her be erased, her people dispersed (or whatever), and the Middle East can settle comfortably into a harmonious Islamic community of states. Problem solved!"*

What folly. What suicidal blindness. I just returned from a momentous event in our nation's capital. An organization called Christians United for Israel, or CUFI, convened 4,000 people from all 50 states in several days of briefings and strategy sessions, culminating in an exhilarating, rousing rally in the D.C. Convention Centre featuring Jewish leaders and top Christian ministers celebrating the things we hold in common and the spiritual bonds that unite us.

The next day, several thousand of the participants fanned out over Washington and Capitol Hill, lobbying virtually every representative and senator on behalf of Israel and its sovereignty. Why? Couldn't we all see this is an exercise in futility - an unnecessary bother that we'd

all be better off if Israel didn't exist? No, we all see clearly that the world needs Israel - The whole world. What do I mean?

Consider: Israel, the 100th smallest country, with less than 1/1000th of the world's population, can make claim to an astounding number of society's advances in almost every direction!

Intel's new multi-core processor was completely developed at facilities in Israel. In addition, our ubiquitous cell phone was developed in Israel by Motorola, which has its largest development centre in the little land. Voice over Internet Protocol (V0IP) technology was pioneered in Israel.

AirTrain JFK the 8.1-mile light rail labyrinth that connects JFK Airport to NYC's mass transit is protected by the Israeli-developed Nextiva surveillance system.

Bill Gates calls Israel, *"a major player in the high-tech world."* Most of Windows NT operating system was developed by Microsoft-Israel; The Pentium MMX Chip technology was designed in Israel at Intel; Both Microsoft and Cisco built their only R&D facilities outside the U.S. in Israel; In addition, with more than 3,000 high-tech companies and start-ups, Israel has the highest concentration of high-tech companies in the world apart from the Silicon Valley.

Get this: Israel leads the world in the number of scientists and technicians in the workforce, with 145 per 10,000, as opposed to 85 in the U.S., over 70 in Japan, and less than 60 in Germany. With over 25 percent of its

workforce employed in technical professions, Israel places first in this category as well! It goes on and on.

The Weitzman Institute of Science has been voted *"the best university in the world for life scientists to conduct research."*

Israeli researchers have:

Discovered the molecular trigger that causes psoriasis.

Developed the Ex-Press shunt to provide relief for glaucoma sufferers.

Unveiled a blood test that diagnoses heart attacks by telephone!

Found a combination of electrical stimulation and chemotherapy that makes cancerous metastases disappear.

Developed the first fully computerized, no-radiation, diagnostic instrumentation for breast cancer!

Designed the first flight system to protect passenger and freighter aircraft against missile attack.

Developed the first ingestible video camera so small it fits inside a pill used to view the small intestine from the inside, enabling doctors to diagnose cancer and digestive disorders!

Perfected a new device that directly helps the heart pump blood, an innovation with the potential to save lives among those with congestive heart failure, synchronizing the heart's mechanical operations through a sophisticated system of sensors.

These are only a few of Israel's recent contributions to the welfare of the world. There are just too many to list here. Water shortage, global warming, space travel, anti-virus, anti-smallpox, blood pressure, solar power, paralysis, diabetes, data storage these and hundreds more are being addressed by Israel's scientists. They're pioneering in DNA research, using tiny strands to create human transistors that can literally build themselves and playing an important role in identifying a defective gene that causes a rare and usually fatal disease in Arab infants!

Who needs Israel? Who doesn't?

Israel produces more scientific papers per capita than any other nation by a large margin. It has the largest number of start-up companies globally, second only to the U.S. It is No. 2 in the world for venture capital funds, financing all these advances. Its $100 billion economy is larger than all of its immediate neighbours combined. Moreover, Israel is the only liberal democracy in the Middle East.

In addition, while it maintains, by far, the highest average living standards and per-capita income, exceeding even those of the UK.

Israel is the largest immigrant-absorbing nation on earth, relative to its population.

It is truly an unparalleled marvel of our time.

So, what's the point of all this? Simply that the very idea of eradicating or even displacing Israel from its historic home is suicidal to the rest of the world, not just

278

her Arabic neighbors. Though there are ominous biblical consequences pronounced on those who curse Israel, there are also wonderful blessings promised those who bless her and we're seeing those real, practical, humanitarian blessings proliferate around the world, blessing all humanity.

Stop just for a second and imagine a world today that never knew Israel. And then go further: Given their living standards, ideologies and attitudes toward all who dare to disagree with them, imagine what our world would be like if Israel's enemies held sway. Would you rather live in an Iran, Iraq, Syria or Afghanistan? Or an Israel?

Who needs Israel? Let's be honest. We all do."

* * *

USEFUL IDIOTS AND FIFTH COLUMNISTS: THE MEDIA ROLE IN THE WAR AGAINST THE WEST BY MELANIE PHILLIPS

Melanie Philips is an award winning author. This is a speech she made at the Honest Reporting Conference in Jerusalem on 14 December, 2010.

"We are living through a global campaign of demonization and delegitimization of Israel in which the western media are playing a key role. The British media are the global leaders of this campaign in their frenzied and obsessional attacks on Israel. In the BBC in particular, such virulence attains unparalleled power and influence since it is stamped with the BBC's global kite mark of objectivity and trustworthiness.

Israel's every action is reported malevolently, ascribing to it the worst possible motives and denying its own victimization. Instead of the truth, which is that every military action by Israel is taken solely to protect itself from attack, it is portrayed falsely as instigating the violent oppression of the Palestinians.

Tyranny around the world — such as the 20-year genocide in southern Sudan, or the persecution of Christians in Africa or Asia — goes almost unreported, as does Palestinian violence upon other Palestinians. Yet Israel is dwelt upon obsessively, Held to standards of behavior expected of no other country and, with its own

victimization glossed over or ignored altogether, falsely accused of imposing wanton suffering.

Time after time, otherwise cynical, reality-hardened journalists have published or broadcast claims of Israeli *"atrocities"* which are clearly theatrically staged fabrications or allegations. The false narrative of Arab propaganda is now so deeply embedded in the consciousness of journalists that they cannot see that what they are saying is untrue even when it is utterly egregious and indeed absurd.

The war against Hamas in Gaza in 2008/9 was a case in point. The British media had scarcely reported the constant rocket bombardment from Gaza. Most of the public were simply unaware that thousands of rockets had been fired at Israeli citizens. But when in Operation Cast Lead Israel finally bombed Gaza to put a stop to the attacks, it was denounced for a *"disproportionate"* response and for wantonly and recklessly killing *"civilians"* -- even though, according to Israel, the vast majority were targeted terrorists.

Nevertheless, the media gave the impression that the Israelis were a bunch of bloodthirsty child-killers. Israel is further accused of causing a humanitarian catastrophe in maintaining a blockade of Gaza. But there is scant mention of the many supplies Israel does allow through, nor the steady stream of Gazans being routinely treated in Israeli hospitals, nor the fact that it is Egypt which maintains a much tougher blockade on its own Gazan border.

This is because Israel's crime is to defend itself militarily. To much of the media, Israel's self-defense is regarded as intrinsically illegitimate. It is routinely described as *"vengeance"* or *"punishment."* Thus Sir Max Hastings wrote in *The Guardian* in 2004: *"Israel does itself relentless harm by venting its spleen for suicide bombings upon the Palestinian people."* Israel's attempt to prevent any more of its citizens from being blown to bits on buses or in pizza parlors was apparently nothing other than a fit of spiteful anger. The Israelis were presented by Hastings not as victims of terror but as Nazi-style butchers, while the aggression of the Palestinians was ignored altogether.

In short, Israel is presented as some kind of cosmic demonic force, standing outside of humanity.

To what should we ascribe such unique malice towards an embattled and besieged people? The first thing to say is that this phenomenon is characteristic not just of the media but the wider intelligentsia and political class.

In Britain, the established church, the universities, the Foreign Office, the theatrical and publishing worlds, the voluntary sector, members of Parliament across the political spectrum, as well as the media -- has signed up to the demonization and delegitimization of Israel. It's the home of the boycott, divestment and sanctions movement. It's where human rights lawyers threaten to arrest Israelis for war crimes as soon as they step off the plane at Heathrow. It's where an English judge virtually

directed a jury to acquit anti-Israel activists, who cheerfully admitted committing criminal damage against an arms factory because it sold equipment to the Israelis, on the grounds that the Israelis were making life in Gaza *"hell on earth,"* and were behaving like Nazis and that if they had done this during World War Two they *"might have got a George Medal."*

It's where Conservative Prime Minister David Cameron told the Turkish Prime Minister that Gaza was a prison camp, that the Israeli *"attack"* on the Turkish terror flotilla ship was *"completely unacceptable,"* and where the British Foreign Secretary *"deplored the loss of life"* in that Israeli attack.

Britain has effectively become a kind of global laundry for the lies about Israel and bigotry towards the Jews churning out of the Arab and Muslim world, sanitizing them

For further consumption throughout English-speaking, American and European society and turning what was hitherto confined to the extreme fringes of both left and right into the mainstream. Where Britain has led, the rest of the west has followed.

What is striking is the extent to which a patently false and in many cases demonstrably absurd account has been absorbed uncritically and assumed to be true.

History is turned on its head; facts and falsehoods, victims and victimizers have their roles inverted; logic is suspended, and an entirely false narrative of the conflict is now widely accepted as unchallengeable fact, from

which fundamental error has been spun a global web of potentially catastrophic false conclusions.

In Britain and much of Europe, the mainstream, dominant view amongst the educated classes is that Israel itself is intrinsically illegitimate. Its behavior is viewed accordingly through that prism. Much of the obsession with Israel's behavior is due to the widespread belief that its very existence is an aberration which, although understandable at the time it came into being, was a historic mistake.

People believe that Israel was created as a way of redeeming Holocaust guilt. Accordingly, they believe that European Jews with no previous connection to Palestine -- which was the historic homeland of Palestinian Muslims who had lived there since time immemorial -- were transplanted there as foreign invaders, from where they drove out the indigenous Arabs into the West Bank and Gaza. These are territories which Israel is now occupying illegally (even after its *"disengagement"* from Gaza in 2005), oppressing the Palestinians and frustrating the creation of a state of Palestine which would end the conflict. Every one of these assumptions is wrong.

Moreover, many of these errors and distortions not only promote falsehoods but actually turn the truth inside out. This is because the west has swallowed the Arab and Muslim narrative on Israel which acts as a kind of global distorting mirror, appropriating Jewish experience and twisting it into a propaganda weapon against the Jews.

Thus while Muslims deny the Holocaust, they claim that Israel is carrying out a holocaust in Gaza. Anti-Semitism is central to Jewish experience in Europe; Muslims claim that *"Islamophobia"* is rife throughout Europe. Israel gives all Jews the "right of return" to Israel on account of the unique reality of global Jewish persecution; the Muslims claim a "right of return" – not to their own putative state of Palestine, but to Israel. They even claim that the Palestinians are the world's *"New Jews."*

These and many other examples are attempts to negate Jewish experience and appropriate it for themselves to obtain what Muslims want from the world in terms of status, power and conquest. They are giving rise to hallucinatory levels of genocidal hatred towards the Jewish people as well as serial falsehoods, fabrications and distortions about Israel.

One might have thought that the supposedly rational west, so quick to condemn religious obscurantism or prejudice of any kind, would object. On the contrary: they ignore, dismiss or excuse it – and far worse, they have even internalized and reproduce many of these tropes which they appear to believe represent the truth.

The core reason that Muslims insist that *"Palestine"* is theirs is that they believe the Jews have no rights within any land Muslims have ever conquered. The western intelligentsia have bought so heavily into the Arab and Muslim narrative of *"Palestine"* in part because they fail to understand the fanatical theological sophistry from which it derives.

But it's also because the western intelligentsia has itself turned evidence and logic upside down. Moral and cultural relativism – the belief that subjective experience trumps moral authority and any notion of objectivity or truth – has turned right and wrong on their heads. Because of the dominant belief in victim culture and minority rights, self-designated victim groups - those without power - can never do wrong while majority groups can never do right. And Jews are not considered a minority because – in the hateful discourse of today – Jews are held to be all-powerful as they *"control"* the media, Wall Street and America.

So the Muslim world cannot be held responsible for blowing people up as they are the third world victims of the west; so any atrocities they commit must be the fault of their victims; and so the US had it coming to it on 9/11. And in similar fashion, Israel can never be the victim of the Arab world; the murder of Israelis by the Arab world must be Israel's own fault.

This inversion of reality and morality echoes the Islamic narrative. This holds that, because Islam is considered perfect, its adherents can never do wrong. All their aggression is therefore represented as self defense, while western/Israeli self defense is said to be aggression. So justice and injustice, oppression and freedom, truth and lies are reversed.

Instead of attacking Arabs and Muslims for such irrationality and falsehoods, it's the defenders of Israel whom the western intelligentsia accuse of lies and even

insanity. Instead of backing Israel against genocidal violence, the British left wingers took to the streets, while Hezbollah rockets were raining down on Israel's northern towns in 2006, with placards declaring *"We are all Hezbollah now!"*

Israel's perceived *"oppression"* of the Palestinians, its *"disproportionate"* attacks on them and its supposed violations of international law are actually the very opposite of the truth. This is behavior of which it is the *victim*, not the *perpetrator*. The treatment of Israel is a spectacular example of the phenomenon of psychological projection – when people ascribe their own bad behavior to others who are innocent of it and are even its victims -- through which the west is mirroring the murderously warped thinking of the Islamic world.

However, the animus against Israel can only be understood if it is set in a far wider context. It is part of a wholesale denigration and onslaught upon the west and its values by the media, progressive intelligentsia and political class.

The BBC, for example, acts not just as cheerleader for Hamas but for the Islamic world. During the Iraq war the crew of the British aircraft carrier Ark Royal threw their radios overboard because of the demoralizing effect that the defeatist and slanted BBC reporting was having on soldiers going to fight for the defense of the west.

The media has systematically presented war in Iraq in a distorted way. For example, it presented the reprehensible American humiliation of prisoners in Abu

Ghraib as infinitely worse than the bestial torture inflicted under Saddam Hussein's tyranny. Iraq has been misreported through distortion and omission. It has been repeated ad nauseam that we were *"taken to war on a lie"* on the grounds that Saddam possessed stockpiles of weapons of mass destruction. But glance at speeches made by President Bush or Tony Blair show this simply wasn't so. The reason was Saddam's continuing threat to the west posed by his terrorist record, regional aspirations and pursuit of WMD programs.

Or take the mantra that because no WMD found none had ever existed – a totally brainless non-sequitur. This also ignored the evidence that *was* discovered there of WMD programs. In his 2003 interim report as head of the Iraq Survey Group, Dr. David Kay reported that he had discovered *"dozens of WMD-related program activities"* that had been successfully concealed from the UN inspectors, and that right up to the end the Iraqis were trying to produce the deadly poison ricin. *"They were mostly researching better methods for weaponization,"* he said. Not only that, Saddam had re-started a rudimentary nuclear program. Kay also told Fox Television: *"We know there were terrorist groups in state [Iraq] still seeking WMD capability. Iraq, although I found no weapons, had tremendous capabilities in this area. A marketplace phenomenon was about to occur, if it did not occur; sellers meeting buyers. And I think that would have been dangerous if the war had not intervened."*

In other words, what Kay found bore out the concerns laid out by Bush and Blair as the case for going to war in Iraq. Yet this was presented as demolishing that case.

And even more absurdly the argument was then broadened to claim Saddam had no connections to terrorism at all, despite the fact he had been the godfather of international terrorism, and so posed no threat to anyone outside Iraq.

Such distortions, omissions and selective reporting over Iraq are all part of the much bigger media failure to report the really big story in the region that continues to this day. That story is the increasing dominance of Iran. Astonishingly, there has been virtually no reporting of the part Iran has played in Iraq – actually killing British and coalition troops and destabilizing the country.

There has been virtually no reporting of Iran's takeover of Lebanon, its grip on Gaza, its steady establishment as the regional hegemony, posing an ever greater threat not just to Israel but to the west. Instead the media present the wars in Iraq or Israel as discrete and unrelated events.

Strikingly, it is the intelligentsia, the people of reason, who are the main problem. Bigotry is now correlated with education and class. The lower down the social and educational scale, the more people are sane and realistic and decent about the Middle East and the threat to the free world from radical Islam. But as soon as you get people who've been through higher education,

you find that so often they're the ones who are bigoted and irrational about such matters.

They make truly ridiculous claims about Israel, such as its perpetration of apartheid or ethnic cleansing – claims which, to anyone with even a passing knowledge of the situation, are demonstrably ridiculous.

So how can it be that the most educated are now the most irrational? The short answer is that among the progressive intelligentsia, evidence and truth have been supplanted by ideology – or the dogma of a particular idea. Ideologies such as moral and cultural relativism, multiculturalism, feminism, environmentalism, anti-capitalism, anti-Americanism, anti-Zionism.

Across a wide range of such issues, it's no longer possible to have a rational discussion with the progressive intelligentsia, as on each issue there's only one story for them which brooks no dissent. This is because, rather than arriving at a conclusion from the evidence, ideology inescapably wrenches the evidence to fit a prior idea. So ideology of any kind is fundamentally anti-reason and truth. And if there's no truth, there can be no lies either; truth and lies are merely "alternative narratives."

So the way has been opened for mass credulity towards propaganda and fabrication. The custodians of reason have thus turned into destroyers of reason – centred in the crucible of reason, the university. Far from promoting enlightenment, western universities are not only the prime source of falsehoods about the Middle

East and hatred and bigotry towards Israel, but also of intimidation against those who try to present a balanced and factual picture and who find themselves professionally and socially ostracized as a result.

All these different ideologies utopian; in their different ways, they all posit the creation of the perfect society. That is why they are considered *"progressive"* and people on the progressive wing of politics sign up to them. That helps explain the distressing fact that so many Jews on the left also sign up to Israel-hatred, since they too sign up to utopian ideologies to which Israel is such an impediment.

But when utopias fail, as they always do, their adherents invariably select scapegoats on whom they turn to express their rage over the thwarting of the establishment of that perfect society. And since utopia *is* all about realising the perfect society, these scapegoats become enemies of humanity. For Greens, such enemies of humanity are capitalists; for anti imperialists, America; for militant atheists, religious believers. Anti-Zionists turn on Israel for thwarting the end to the *"Jewish question"*: the reproach to the world over Jewish suffering which Europe believes would be redeemed if there were peace in the Middle East. The key utopia that Israel's never-ending wars are thwarting is the redemption of European guilt for the persecution of the Jews in which they have been complicit through the centuries.

What these various very disparate ideologies of environmentalism, scientism, anti-imperialism, moral relativism, anti-Zionism and Islam also have in common is remarkably -- hostility to Judaism, Israel and the Jewish people.

It was Judaism that laid down the moral law which forms the very foundation of Western morality which is under attack from moral relativism. It is the Book of Genesis that draws the wrath of the environmentalists, who wrongly interpret the Biblical *"dominion"* of mankind over the earth as an example of divine imperialism or colonialism—a hierarchy which must be destroyed by removing man from the pinnacle of Creation and substituting the natural world itself in his place.

It is Jews who are the principal targets of the attacks by anti-Americans and anti-imperialists on the *"neoconservatives,"* the euphemism for those who were alleged to have formed a conspiracy to subvert American foreign policy in interests of Israel. And it is that issue, Israel, which is now the greatest symbol of Western irrationality. The hatred of Israel and the Jews that drives the Islamic jihad against the West is not acknowledged or countered by the West because its most high-minded citizens share at least some of that prejudice. Both western liberals and Islamists believe in utopias to which the Jews are an obstacle. The State of Israel is an obstacle to both the rule of Islam over the earth *and* a world where there are no divisions based on religion or creed. The

Jews are an obstacle to the unconstrained individualism of western libertines *and* to the onslaught against individual human dignity and freedom by the Islamists.

Both the liberal utopias of a world without prejudice, divisions or war and the Islamist utopia of a world without unbelievers are universalist ideologies. The people who are *always* in the way of universalizing utopias are the Jews.

So is this all hopeless? After all, irrationality cannot be fought with reason. And this is true. But no, it is not hopeless. First, many who spout this irrational discourse are not themselves irrational, merely profoundly ignorant. They are ignorant because no-one is telling them what it is they don't know and are getting so very wrong about Israel, the Middle East or Jewish history.

But for those who are indeed irrational, we have to change our approach. We have to stop trying to argue with bigots. We must instead set out to defeat them. To do that, we must first realize many of us are fighting on the wrong battleground. We are on the battleground selected by our enemies as the most conducive to victory.

The Arabs successfully redefined the Middle East conflict from a story about Arab aggression towards the Jews to a story about Palestinian suffering at the hands of the Jews. They reversed victim and victimizer by recasting an existential conflict as a battle between two peoples with rival claims to the land. Inevitably this casts Israel, which is reluctant to go along with the

implications of this false analysis, as the villain of the piece.

The problem that cannot be overstated is that Israel has lent itself to this false narrative. After all, forcing a country which has endured six decades of existential siege with no end to give any ground to its attackers amounts to forcing a victim to surrender. This is expected by the civilized world of no other country.

Yet for reasons of realpolitik Israel has meekly gone along with this mad pressure. It has never said it is totally unconscionable. It has never put the all-important argument for justice on its own account. So it has allowed its enemies to appropriate this argument mendaciously as its own. And if Israel doesn't make this case on its own behalf, how can anyone else?

There is therefore an overwhelming need for Israel to alter its strategy. Indeed, it needs to *have* a strategy. It needs to recognize that the battleground on which it is being forced to fight is not just military. It is also a battleground of the mind.

The Arab and Muslim world long ago realised if they set the narrative in their own image, they would recruit millions of fanatics to their cause and also confuse and demoralize their victims. In this they have wildly succeeded.

So both Israel and Diaspora Jews have to rethink. It's time to change the narrative. Time to stop conniving with the premise of their enemies that the Middle East impasse would be solved by establishing a state of

Palestine to which the settlements – and thus by extension, Israel -- are the obstacle. Time for them to stop agreeing that the Jews are to blame for their own predicament. Time to stop the hand-wringing. Time to stop fretting over how much better it is to play along with the narrative of Israel's enemies in clear English rather than a thick Israeli accent – almost totally irrelevant.

Both Israel and Diaspora Jews have to stop playing defense and go onto the offence. We should be demanding of the world why it expects Israel alone to make compromises with people who have tried for nine decades to wipe out the Jewish presence in the land and are *still* firing rockets at it. We should be demanding why America, Britain and the EU single Israel out for pressure which they apply to no other victims of genocidal aggression. For in any other such conflict, their cause of the aggressors would be deemed totally forfeit by their behaviour.

We should be asking so-called *"progressives"* – including Jewish *"progressives"* – why they support the racist ethnic cleansing of every Jew from a future state of Palestine. We should be asking *"progressives"* why they are not marching against Hamas on account of its tyrannical oppression of Palestinians in Gaza. Why they are not mounting a boycott, divestment and sanctions campaign against Mahmoud Abbas's Palestinian Authority on account of his Holocaust denial and the PA's continued incitement of Arab children to Jew-hatred, murder and genocide.

Why they are ignoring Arab and Muslim persecution of women and homosexuals. And we should be telling the Jews own story of refugees and ethnic cleansing – the 800,000 Jews expelled from Arab lands after 1948, and who now make up more than half of Israel's population. It's good to see that, at last, Israel is beginning to bring this to the world's attention.

In Britain, virtually no-one knows about it. At a stroke it takes the ground from under feet of those demanding *"right of return"* for Arabs.

We will never convince bigots that facts are as they are, or that the evidence of history tells a different story from the one they believe. We cannot fight prejudice with reason. But we have a duty to bear witness to the truth. And we have a duty to fight in our defense. We can best do this by getting off *our* back foot and putting western fifth columnists on *theirs*. We should accuse them, not of Jew-hating motives we cannot prove but of absurdities and contradictions and untruths they cannot deny. We should ridicule them, humiliate them, destroy their reputations; boycott them, not invite them to our houses, show them our disapproval and contempt. Treat *them* as pariahs. Turn their own weapons against them. In short, we must get up off our collective knees and fight. Justice, human rights and truth are on *our* side, not theirs. We must reclaim them as our own."

<p style="text-align:center">* * *</p>

SPEECH GIVEN BY PASTOR JOHN HAGEE RESTORATION WEEKEND, PALM BEACH, FLORIDA, NOVEMBER 19, 2010

I would like to begin by thanking David Horowitz and the David Horowitz Freedom Centre for all they have done for the freedom of America especially on our college campuses.

We all know how hard it is to stand up for truth on America's college campuses these days when pro-Israel speakers are being shouted down and pro-Israel students are being publicly ridiculed by professors, unbelievably.

This is why I am so very grateful to have friends like David Horowitz and the David Horowitz Freedom Centre providing invaluable information, training, and Support for those brave students who are willing to confront the lies and the religious hatred of radical Islam.

We meet tonight at a difficult and dangerous juncture for America and the cause of freedom around the world.

Like many of you here tonight I have subscribed to the concept that the Jewish People are the West's canary in the coalmine. History has repeatedly demonstrated that when the Jewish people are singled out for persecution the freedoms of all peoples is at risk.

Therefore, when the Jewish people are being attacked all Americans should stand up and express their outrage because we are next.

As Americans, we must snap out of this politically correct fog and admit that we are at war with radical Islam. This is a war of survival. This is a war of good against evil. This is a war of light against darkness. This is a war of those who love life against those who worship death.

It's an easy choice and the reality is, like it or not, you and your children and your grandchildren are in this war. There will be a winner and there will be a loser, and to the winner goes our children and our grandchildren.

Tonight we must commit ourselves to victory over radical Islam without exception.

Today the Jewish people are still our canary in the coalmine. It is the Jewish State in particular that serves as the West's warning system. America must wake up to the understanding that Iran fully intends to destroy the United States of America. When somebody threatens to kill you, you should take it seriously.

We must recognize that those who threaten Israel has the United States in their sites. To anyone who has the eyes to see and the ears to hear it is clear that Israel is in the greatest danger it has faced since six Arab armies tried to strangle the Jewish state at birth in 1948.

I know that in difficult days such as these when it seems that the whole world is against Israel many friends of Israel, such as yourselves, nervously scan the horizon for friends.

You look towards the United Nations which Dore Gold calls the *"Tower of Babel,"* and I agree. You look at

Europe where the ghost of Hitler is again walking across the stage of human history. You open your newspapers and read about American universities where Israel is being viciously vilified by students taught by American professors whose Middle East chairs are sponsored by Saudi Arabia, whose fees are paid with petrol dollars that went through our gas tanks. You look to America's mainline churches and their initiatives to divest from Israel. You go to the bookstore and you see scandalous titles from a former US President, and you feel very much alone.

I came here tonight to speak about Christians United for Israel and the millions of Evangelicals in America who have a deep faith based belief to love Israel, to speak up for Israel, to stand up for Israel, to once a year charge up Capitol Hill with five thousand plus delegates from every state in the Union visiting as much as 87% of US Congress saying *"stop pressuring Israel to give land to terrorists who will not recognize Israel's right to exist!"*

I came here tonight to deliver a message from every one of those fifty million Evangelicals, and I want to say this very clearly, tonight Israel is not alone. Your fight is our fight. Your enemies are our enemies. We're in this together to the end.

Ladies and gentlemen. It's a new day in America. The sleeping giant of Christian Zionism has awakened. Christians are joining Jews is speaking out against militant Islam.

As you know, Ahmadinajad poses a threat to the States of Israel that is nothing less than a nuclear Holocaust. I've been saying on national television, in churches and articles across America, it's 1938 all over again. Iran is Germany, and Ahmadinajad is the new Hitler of the Middle East.

We must stop Iran's nuclear threat and, candidly, toothless linguistic sanctions from Washington is not going to get it done.

The only way to win a nuclear war is to make certain it never starts. Iran's President has not limited his maniacal threats to Israel. He has also asked his fellow Iranians to imagine a world without America. That's pretty clear. It's a clear threat to destroy America.

I have something to say to the President of Iran.

"Mr. Ahmadinajad. Do not threaten the United States of America. Do not threaten the State of Israel, saying they will pass in a sudden storm. In the Bible when Pharaoh threatened Israel he became fish food in the Red Sea. Whenever Haman threatened the Jews in Persia, which is modern day Iran, he and his sons hung on the very gallows he built for the Jewish people.

Our message, Mr.Ahmadinajad, is that threats against Israel have a way of becoming self fulfilling prophesies. You may well be speaking of your own demise when you talk about Israel passing away in a sudden storm.

The God of Abraham, Isaac, and Jacob is watching you. King David writes that the God that watches over

Israel neither slumbers nor sleeps. Christians believe there is a spy in the sky, and he's Jewish.

Mr.Ahmadinajad. The Christians of America will not sit idly by and let you plan and plot a nuclear Holocaust. There will never be another Holocaust. Not on our watch. Not ever!"

Beyond the threat from Iran there is another, more subtle, threat that concerns me. I'm concerned that in the coming months yet another threat will be made to parcel out parts of Israel in a futile attempt to appease Israel's enemies in the Middle East.

I believe that the misguided souls in Europe, the political brothel that is the United Nations and, sadly, our own Administration, will once again try to turn Israel into what Churchill called *"crocodile food."* Winston Churchill, one of my favorite statesmen of all times, said *"an appeaser is someone who feeds a crocodile in the vain hope that it will eat him last."*

In 1938, Czechoslovakia's Sudetenland was turned into crocodile food for the Nazi German beast. The Nazi beast smelled the weakness in the appeasers, ate the food, and then marched on to devour most of Europe, and systematically slaughter six million Jews.

We are again hearing calls to appease the enemies of Israel. Once again those who would appease do so at the expense of Israel. Israel is always the one called upon to sacrifice. They tell us that if we want to Sunnis and Shiites to stop massacring themselves in Iraq then Israel must give up land. If we want the Syrians and Hizbollah to stop

301

murdering the Lebanese including their leaders then Israel must give up land. If we want the Saudis to permit women to drive or vote the obvious answer is that Israel must give up more land.

If we want to sun to rise in the West and not in the East then Israel must give up land.

Let's be very clear about this. Israel is not the problem. Scapegoating Israel is not going to solve the problem. The problem is Arab rejection of Israel's right to exist. The problem is that Israel does not have a legitimate partner for peace. The problem is radical Islam's bloodthirsty embrace of a theocratic dictatorship that believes they have a mandate from God to kill Christians and Jews.

The problem is the failure of the moderates in the Arab and Muslim worlds to stand up and rein in these Islamic terrorists. If the moderate Arabs believe that murdering Christians and Jews is wrong then stand up and speak up. Your silence is deafening.

Appeasement is not the answer. To quote the great Evangelical abolitionist, William Wilberforce *"Appeasement is nothing more than surrender on the installment plan."*

America should not pressure Israel to give up more land and America should never pressure Israel to divide the City of Jerusalem. What the Jewish people decide to do with the City of Jerusalem is for the Jewish people, not America.

I'm often asked this question. Why do Christians support Israel? We support Israel because the Bible is a Zionist text, and we believe in the Bible.

There are only two ways to live, the Torah way or the wrong way. We choose the Torah way.

Genesis 12:3 says: *"I will bless those who bless you, and I will curse those who curse you!"*

You don't have to be a rocket scientist or theologian to figure that out. Good happens to those who bless Israel. Bad happens to those who attack the Jewish people. History proves that.

Where are the nations who have persecuted the Jewish people? Where are the Pharaohs, the Babylonians, the Greeks, the Romans? Where is that goose stepping lunatic Adolph Hitler and his hordes? All are historic footnotes in the bone yard of history.

Where is Israel and the Jewish people? They are thriving. They are prospering. They are growing. Even in adversity they are advancing better than any other nation on earth.

Where is Israel? Where are those who are scattered throughout the Diaspora? The mighty hand of God has gathered them from the nations of the world and Israel was reborn in May 1948.

Therefore we can say Israel lives. We can shout it from the housetops that Israel lives. We can say it until every Islamic terrorist group hears it. Israel lives!

Let every tin pot dictator in the Middle East hear it. Israel lives!

Let it be heard from the hall of the United Nations. Israel lives!

Let it echo down the marble halls of the Presidential palace in Iran. Israel lives!

Let it ring in the terrorist camps of Osama bin-Laden. Israel lives! Israel lives! Israel lives!

So why do we support Israel? Not only because of biblical facts or because Christians owe a debt of gratitude to the Jewish people. Everything that we have you gave it to us. The Torah of God, the Patriarchs, Abraham, Isaac, and Jacob. The prophets, Ezekiel, Daniel, Isaiah, Jeremiah, Zachariah, Amos, Josiah, Joel – not a Baptist in the bunch, all of them Jewish. The first family of Christianity, Mary, Joseph, and Jesus. The Apostles.

That's why a rabbi named Jesus said *"Salvation is of the Jews!"* That's not a text you hear Christians quote but it's very much in the New Testament.

The point is if you take away the Jewish contribution to Christianity there would be no Christianity.

The point is Judaism does not need Christianity to explain its existence, but Christianity cannot explain its existence without the Jewish experience.

The bottom line is this. I support Israel for the same reasons that most Jewish people do. The fact is that what we have in common as Christians and Jews is far greater than the things we've allowed to separate us over the centuries.

But now, in the United States, for the first time in our history, Christians are rallying to the cause of Israel in

greater numbers with greater rapidity than ever in the history of the United States of America.

Let me give you just a short history of the birth of Christians United for Israel in America. For many years Christians went to Washington singing *"Amazing Grace"* out on the Mall. I didn't go because I told them it was a waste of time.

They asked why. I said because Congress couldn't care less about you singing *"Amazing Grace"* out on the grass. But when you walk into their office, seventy five or eighty of you, and say *"I live in your district and I'm for you or against you based on your support for Israel,"* now you're moving the ball down the field.

To accomplish this goal I launched Christians United for Israel in February 2006 and invited four hundred Christian leaders from around the country. They were pastors of the largest churches, owners of radio and TV networks, presidents of universities, and owners of publishing companies. If you'd have dropped a bomb on that church that day the Evangelical faith in America would have been set back a hundred years.

It was my wondrous privilege to ask them if they would join in this effort to assist the Jewish people, and listen what I'm about to say, without any conversionary attempt being made, and if they would will they please raise their hands. Four hundred strong immediately raised their hands and said they would stand with Israel unconditionally.

In less than five years we have grown to become the largest pro-Israel organization in the world. We currently have five hundred thousand members, including thousands of America's top spiritual leaders. Through these leaders our message concerning Israel reaches millions of Christians in America and around the world. Not through the New York Times, but through Christians United for Israel.

I spoke with Dore Gold and I told him it would be good if the Israeli Government would form a media war room where they would release the stories they have first to four hundred thousand spiritual leaders in America that would distribute it to our people, and then send it to the New York Times and see what they could do with it to destroy it.

This year there will be two important initiatives. A Hispanic outreach to bring America's growing Hispanic churches into the pro-Israel camp, and African American outreach to bring even more American black churches into America's pro-Israel camp.

We have formed an alliance with over two hundred and fifty thousand Hispanic churches in one year. Listen to this. Many of these new Christians United for Israel members are committed Democrats, and that's important. We are a One Issue organization – Israel.

When I looked at those four hundred leaders and said that we're not going to Washington to discuss all the hot button issues we like to get hot under the collar about. We're going to talk about one thing from the time we arrive

to the time we leave. Israel. Then we can recognise that as these new Christians United for Israel members are coming on and many of them are Democrats that they must confront those in their political party who would abandon the Jewish state in their time of need.

Our campus program, Christians United for Israel on Campus, has continued to grow and flourish. We have currently presence on three hundred and fifty college campuses and are continuing to grow daily.

We have sent two student groups on leadership missions to Israel and, next month, we will be hosting seventy student leaders in San Antonio for our first Winter Student Leadership Session.

Christians United for Israel conducts an average of forty pro-Israel events across America every month. That's *every month*! In church after church, pastor after pastor, they're telling their congregations for the first time the truth about Israel.

Our members are then leaving those churches and sharing that truth with their family, their friends, and their neighbors. That's why, today, our membership grows by over twenty thousand members a day.

Every July we let Congress know that we are standing with Israel through thick and thin.

In conclusion I want to say this. It was over twenty five years ago that President John F. Kennedy flew to the divided city of Berlin at the height of the Cold War.

He flew there at a time when West Berlin was a tiny outpost of freedom surrounded by communist tyranny. He

flew there at a time when West Berlin was surrounded, hounded, boycotted, and hungry. He flew there with a strong message of solidarity, and resolved to the brave people of West Berlin. Here is what Kennedy said in that place at that time.

"Two thousand years ago the proudest boast was "Civis Romanus Sum," I am a Roman citizen! Today, in the world of freedom the proudest boast is "Ich Bin Ein Berliner, I am a Berliner!

All free men wherever they may live are citizens of Berlin and, therefore, as a free man I take pride in the words 'Ich Bin Ein Berliner!'"

We need to remember President Kennedy's actions and words now more than ever.

Today, I stand in the greatest nation on the face of the earth, the United States of America. I'm here with people who cherish our nation, a people who cherish our Judeo-Christian heritage and our ally, Israel. I stand here at a time when Israel is a tiny outpost of freedom and democracy is a sea of tyranny. I stand here as Israel is surrounded, hounded, boycotted, and threatened. I stand here with a strong message of solidarity with my Jewish brethren, the apple of God's eye, people of the Covenant, and the Cherished people, and that Covenant has not been broken.

At this difficult juncture in our history permit me to say something straight from the heart.

Today, in the world of freedom, the proudest boast is *"I am an Israeli!"* All free men, wherever they may live are citizens of Israel.

Therefore, as a free man, I take pride in the words *"I am an Israeli!"* When an international body ignores the worlds genocides, massacres, and racism to attack Israel we must stand together and proclaim as one body *"I am an Israeli!"*

When college professors teach lies about Israel and students loudly call for Israel's destruction we must proclaim *"I am an Israeli!"*

When flotillas filled with militants seek to turn Gaza into an Iranian port we must proclaim *"I am an Israeli!"*

When the world condemns Israel for defending itself from thousands of terrorist missiles and mortars to kill Israel men, women, and children we must proudly proclaim *"I am an Israeli!"*

When mad men threaten to destroy the Jewish state we must proudly proclaim *"I am an Israeli!"*

Israel and America share the same love of freedom. Israel and America share the same passion for democracy. Israel and America share the same Judeo-Christian values. Israel and America share the same love of life.

Israel's enemies are our enemies. Israel's fight is our fight. If a line is drawn draw it around Christians and Jews. We are united. We are one. We are indivisible. We will not be discouraged. We will not be defeated.

In the end, when the last bullet has been fired the flag of Israel will still be flying over the ancient walls of the holy city of Jerusalem, the lion will lay down with the lamb, men will beat their swords into ploughshares and study war no more, and Israel will still be the praise of all the earth. May God bless each one of you. May God bless Israel, and God bless the United States of America.

CONCLUSION

If this book has contributed anything it has attempted to show the disproportion between the accepted Palestinian narrative and the truth.

By doing so it also highlights the disproportion of the abuse and total lack of understanding of Israel's position vis-a-vis the Palestinian problem highlighted by the wholesale condemnation of my country.

As hinted in the chapter dedicated to the boycotter, Israel has contributed greatly to both the developed world and to the underachieving nations.

Israel is a country that has not known one year without war or terror. It has had international abuse and misguided disapproval hurled at it since its inception.

Israel is a study course for nation builders. In such a short period of time it has grown from a mere 600,000 Jews to a nation of over seven million.

Within a short time span and under immense difficulties, it has managed, out of necessity, to raise one of the most powerful and effective armies in the world, absorbed a massive immigration without becoming an economic basket case, and yet has developed a cutting hi-tech, scientific, medical research, industrial nation, and become a world leader in agricultural development. It has a rich cultural life and the beat goes on.

One would think that savvy business people would avoid the Middle East like the plague. In Israel's case the opposite is true.

Warren Buffett made boycotters look like impotent gnomes in May 2006 when he invested eight billion dollars into the Iscar industrial company in northern Israel.

Buffett is not a Jew. He describes himself as an agnostic, yet he has faith in the advanced Jewish state and its people.

In a video interview in 2010 he told an audience of business men and women: *"If you are looking for brains – stop in Israel. Israel as a state has proven that it has an exceptional amount of brains and energy and, in my eyes, it works. I love the place!"*[1]

People in the know have a profound admiration for Israel. Israel is an incubator of ideas. The pressure cooker of necessity forces an Israeli entrepreneurialship to come up with solutions to immediate and pressing problems.

In a meeting with 45 selected students during a one day visit to Israel in October 2005 Bill Gates, founder of Microsoft told them: *"Israel is a major player in the high tech world, which explains the considerable contribution of the country not only in the field of high tech start-ups but also through the R&D centers for companies like Microsoft, Intel and Motorola. We're super-satisfied with the contributions of our R&D centre in Haifa. There are*

[1] Video interview screened at the Israeli Ministry of Trade, Industry, and Labour Social Economic Conference at Airport City, Tel Aviv, October 13 2010.

specialists in Israel in fields like information security who get much of their experience from their service in the army. The science and technology curriculum in Israeli universities is also of a very high standard. The level of technological integration in the country is evident. The use of fast speed internet, lap tops and cell phones is advanced here and puts Israel at cutting edge of world technology. The quality of the people here is quite fantastic." Microsoft's biggest investment outside of the United States is in Israel.

Behind the scenes Israel is developing the world's first major national network for electric vehicles.

As ex-CIA chief, James Wolsey, said at the 2010 IDC Herzlia Conference, *"If you want to wean the world off its dangerous dependency on oil then electric vehicles is the logical way to go."*

Israel's Shai Agassi's Better Place is leading the way. His vision was inspired by a question posed at the world economic forum in 2005, *"How do you make the world a better place by 2020?"*

Agassi sought to answer this question with a pragmatic solution to free cars from oil, reduce harmful tailpipe emissions, and usher in an era of sustainable transportation.

He founded Better Place in 2007 and the following year Israel became the first nation to embrace the Better Place model of building open network infrastructure to enable mass adoption of electric vehicles and delivering

transportation as a sustainable service. Denmark, Australia, California, Hawaii, and Ontario have followed suit.

Try as they may the Arabs, Palestinians, Iranians, Islamists, anarchists, anti-Zionists, anti-Western Far-Left activists, boycotters, demonizes, delegitimizers cannot stop the burgeoning power of Jewish ingenuity that has percolates in the Jewish State of Israel.

This power house of creativity is there to serve not only Israel but the region and the world at large.

As soon as the Palestinian leadership can come to its senses and adopt a reasoned pragmatism all problems will be solved giving a more secure and prosperous future to everyone in the region.

The ball is in their court. Meanwhile, we are standing guard, eyes wide open, fully aware of the ultimate intention of our enemy, and prepared to defend our nation.

The flag may be battered and torn but it is still flying proudly over Israel.

RECOMMENDED READING

A History of Israel from the rise of Zionism to our time - *Howard Sachar. Alfred A. Knopf*

Israel. A History - *Martin Gilbert. Harpers Perenial.*

The Israel-Arab Reader - A Documentary History of the Middle East Conflict. *Walter Laqueur* and *Barry Rubin*. Penguin Books.

The Case for Israel - *Alan Dershowitz*. Wiley & Co.

Myths & Facts - A Guide to the Arab-Israeli Conflict. *Mitchell Bard. Eli E.Hertz*

From Time Immemorial - The Origins of the Arab-Israel Conflict over Palestine. *Joan Peters*, JKAP Publications.

Saving Israel - How the Jewish People Can Win a War That May Never End, *Daniel Gordis*, Wiley

This Land is My Land. - "Mandate for Palestine." The Legal Aspects of Jewish Rights. *Eli. E.Hertz*

The Israel Test - *George Gilder*, Richard Vigilante Books.

Palestine Betrayed - *Efraim Karsh*, Yale University Press.

A State Beyond the Pale - *Robin Shepherd*, Phoenix

Londonistan - *Melanie Phillips,* Gibson Square.

The Finkler Question - *Howard Jacobson*, Bloomsbury.

The Force of Reason - *Oriana Fallaci,* Rizzoli International Publications.

The Case for Democracy - *Natan Sharansky*, Public Affairs, New York.

Start Up Nation - *Dan Senor & Saul Singer*. Twelve, New York.

A Twice Promised Land – *Isaiah Friedman*. Translation Publishers.

ISRAEL & Palestine. Assault on the Law of Nations – *Professor Julius Stone*. John Hopkins University Press.

WEBSITE REFERENCES

HONEST REPORTING:
www.honestreporting.com

PALESTINE MEDIA WATCH:
www.palwatch.org

NGO MONITOR:
www.ngo-monitor.org

CAMERA:
www.camera.org

INTELLIGENCE & TERRORISM INFORMATION CENTRE:
www.terrorism-info.org.il

JERUSALEM CENTER FOR PUBLIC AFFAIRS:
www.jcpa.org

INTERDISCIPLINARY CENTER (IDC) HERZLIA:
www.idc.ac.il

MIDDLE EAST FORUM:
www.meforum.org

GLORIA CENTER:
www.gloria-center.org

CHRISTIAN FRIENDS OF ISRAEL:
www.cfi.org.uk

CHRISTIANS UNITED FOR ISRAEL:
www.cufi.org

ISRAEL MINISTRY OF FOREIGN AFFAIRS:
www.mfa.gov.il

GOOD NEWS ISRAEL:
www.verygoodnewsisrael.blogspot.com